The ALTE PINAKOTHEK

of Munich and the Castle of Schleissheim and Their Paintings

Edited by
EDI BACCHESCHI

With a foreword by
ERICH STEINGRÄBER

JOHN BARTHOLOMEW & SON LIMITED: Edinburgh

Great Galleries of the World

Collection directed by
ETTORE CAMESASCA

Editing and Graphics
CLAUDIA GIAN FERRARI
SERGIO TRAGNI
GIANFRANCO CHIMINELLO

Picture collection
CARLA VIAZZOLI

Secretaries
MARISA CINGOLANI
VERA SALVAGO

Graphic and Technical Adviser
PIERO RAGGI

Printing and Binding
ALEX CAMBISSA
CARLO PRADA
LUCIO FOSSATI

Color editing
FIORENZO BERNAZZANI
FELICE PANZA

Foreign editions
FRANCESCO TATÒ
FRANCA SIRONI

Editorial Committee
MILTON GLADSTONE
DAVID GOODNOUGH
JOHN SHILLINGFORD
ANDREA RIZZOLI
MARIO SPAGNOL
J. A. NOGUER
JOSÉ PARDO

The present volume has used the valuable assistance of
MRS. LISELOTTE CAMP
of the Direction of the Bayerische Staatsgemäldesammlungen

Contents

Photographic Sources

Color plates: Blauel, Münich; Radnický, Emmering; Scala, Florence. Black and white illustrations: Photographs Department of the Bayerische Staatsgemälde-sammlungen.

First published in Great Britain 1974 by
JOHN BARTHOLOMEW AND SON LTD.
12 Duncan Street, Edinburgh, EH9 ITA
and at 216 High Street, Bromley, BR1 1PW
Copyright © by Rizzoli Editore, Milano 1974

ALL RIGHTS RESERVED
ISBN 0-85152-931-3

PRINTED IN ITALY

Alte Pinakothek, Castle of Schleissheim: an Art and History Experience

The fame of the city of Munich is closely linked to the cultural achievements of the Wittelsbach dynasty and the treasures of its galleries. The Alte Pinakothek (the Old Gallery), considered the gem, is one of the largest and most distinguished collections of paintings in Europe. Not even the most hasty of tourists should forego a visit and whoever has observed, even on one occasion, the impression made on the numerous visitors from all parts of the globe cannot possibly agree with those who bewail the lack of social significance of galleries in this day and age of constant crisis.

In order to profit from a visit to a gallery it is necessary to have an open mind, a great desire to acquire new visual experiences, and, at least, a modest disposition to cultivate things of the spirit. Like other cultural centers, a gallery cannot and does not wish to compete with the crowds which flock to the "Oktoberfest" of Munich and other traditional feasts; nor can the number of those who frequent the galleries be measured with the same stick as those who flock to the cheaper forms of mass entertainment. The work of art makes spiritual demands on the visitor, and therefore will interest only an elite. As Pauli wrote: a gallery, "inasmuch as it is the product of modern social mentality, is the most democratic among all cultural institutions, because it offers to all, without qualifications and tests, the advantage of its silent education."

The Munich Pinakothek, whose name is linked to the gallery of painting on the ancient Acropolis of Athens, was built during the last century, after the amalgamation of the collections of the Wittelsbachs of Düsseldorf, Mannheim, and Zweibrücken with those of the Electoral Principality of Munich. The great building, reminiscent of the Italian Renaissance, was destroyed during the Second World War, but the art collection, which had been stored elsewhere for safe keeping, did not suffer substantial losses. It was rebuilt following the plan of the 19th century building. On the 7th of June, 1957, the Gallery was solemnly reopened in all its old splendor and returned to the new generation which eagerly flocked to its portals.

Like most galleries born of princes' passion for collecting, the Alte Pinakothek owes its special character to central works of art which cannot be found in other collections such as: examples of old German painting; in the field of the 17th century paintings, the magnificent works of Rubens; the surprising primitives of the Low Countries; the Dutch paintings of the "Golden Century" as well as the Italian paintings, which are quite unique. But over and above these, the visitor can gain an exhaustive view of all the various aspects of European painting, from its beginnings to the end of the 18th century. Considering their age, these works are of high quality and are in a perfect state of preservation that leaves little to be desired.

Of the 20,000 paintings owned by the Gallery, only the most outstanding are on display. In order to give the public an ample view of 17th and 18th century painting, recourse has been made to the not-so-distant Castle of Schleissheim, erected by the Prince elector, Maximilian Emanuel. To this surprising gallery of European Baroque, which is an extension of the Pinakothek, the second part of this monograph is directed.

A tour of the Alte Pinakothek should not be a mere stroll into the past or a flight from our "disenchanted" present. Is not the essence of tradition, artistic or otherwise, its continual influence on man, whether he realizes it or not? Besides its particular aspect, which is linked to the society and moment of history in which it was conceived, a great work of art possesses a force which, over and above stylistic convention, affects us directly. It gives joy or pain, challenges us and questions or confirms the meaning of our passage on earth. This voice can reach even the visitor who knows little or nothing of the place of a work of art in history ... provided his curiosity is not turned solely to the *hic et nunc* and he still feels the necessity of formulating the ancient question regarding the meaning of existence.

Erich Steingräber
Director General of the Bavarian State Galleries

History of the Museum
and Its Paintings

1528-40. The beginning and progressively rapid extension of the collections which now constitute the great artistic heritage of the Alte Pinakothek is closely linked to the patronage of the ruling family of Bavaria, the Wittelsbach. The nucleus of the Alte Pinakothek was the group of paintings commissioned by Wilhelm IV, Duke of Bavaria, to decorate the Lusthaus (the House of Pleasure) in the Rosengarten of the Munich Residenz. The Duke decided the iconographic theme was to be the exaltation of the virtues, alluded to in different ways by the experiences of illustrious men and women. Many artists of varying merit participated. At the side of Altdorfer's masterpiece *The Victory of Alexander the Great* can be found many other renowned works: *Esther and Ahasuerus* by Burgkmair the Elder, *The Death of Lucretia* and *The Battle of Zama* by Breu the Elder, *The Capture of Rhodes* by Breu the Younger, *The Finding of the True Cross* by Beham (painter of a series of royal portraits including that of Wilhelm IV himself), *Porsenna before Rome* and *The Siege of Alesia* by Feselen, *The Death of Virginia* by Hans Schöpfer the Elder, *Susanna and the Elders* by Refinger. All these works are still exhibited in the Alte Pinakothek; another group can be seen at Schleissheim, and some others, carried off by the Swedes

(see the year 1632), are preserved in the National Museum of Stockholm.

Wilhelm's initiative was the beginning of a general reawakening of interest in the arts in Munich, which, until this time, had remained isolated from the lively artistic activity taking place in other German cities. (The nearby rich Nuremberg had also been without an influence.)

1536. Wilhelm IV commissioned Hans Wertinger to paint his portrait and that of his wife. (She surely took an interest in her husband's artistic activities, since she had set up a small gallery to house a collection of portraits of her ladies-in-waiting.)

1550-79. It was in the reign of Albrecht V, Wilhelm IV's son, that collecting became a serious business. Surrounded by connoisseurs and collectors, among whom were Jacopo Strada, Goltzius, and Samuel Quickelberg, the Duke became the prime mover of a systematic collection of works of art. According to the taste of the time, his attention was directed primarily to antiques, medals, and curios. As a result no outstanding examples of painting were acquired.

1563-67. Albrecht had a bulding constructed to house the enormous number of objets d'art which were streaming

into Munich as a result of his efforts. These items were not selected with aesthetic criteria in mind, but rather as specimens of a great *Theatrum mundi,* according to the theories held by Samuel Quickelberg in his *Inscriptiones Vel Tituli Theatri Amplissimi.*

1569-71. To house this collection the Antiquarium of the Residenz was built according to the plans of Jacopo Strada and Wilhelm Egkl, the latter having recently designed the art gallery. The building, long in plan and vaulted, was later converted into a banqueting hall.

1579-97. A lull in collecting took place during the reign of Wilhelm V because of the financial situation and the Duke's fondness for religious architecture, which militated against the collecting of paintings.

1597. Maximilian I, reared under the wise and watchful surveillance of Johannes Fickler (a man of vast culture and a passionate collector) continued the activity of collecting, combining great political perspicacity with a love of the arts.

1598. Fickler drew up the first inventory of the collections; among the 3407 objects listed there were already 778 paintings, the majority of which (579) were portraits. Some objects from the Wunderkammer, such as the giant boots

of Johann Friedrich, Duke of Saxony, the half skull of a satyr, and a little of the Manna fallen from Heaven, were included.

1611-17. Maximilian I had a large gallery with windows on the north side built behind the new apartments of the Residenz in which the most valuable items of the art collections and his own acquisitions were housed.

1613. As a result of protracted negotiations and a little pressure, Maximilian obtained from the city of Nuremberg the Paumgartner Altarpiece by Dürer, (which the Emperor Rudolf II had requested in 1596 but did not obtain).

1614. Continuing as Rudolf's rival, Maximilian obtained from the city of Frankfurt the lost central panel of the Heller Altarpiece by Dürer, showing the *Coronation of the Virgin,* the only part which can now be considered as painted by the Master himself.

1618. Maximilian's interest was also in contemporary masters; he already owned the *Lion Hunt* by Rubens and acquired three other works of the same type by the artist (see the year 1800). Works by Sandrart and Elsheimer appeared in his collection.

1627. By this time Maximilian I was a prince elector, and was thus able to exert more pressure in acquiring works of art. Nuremberg warned that "she would have fallen into disgrace" had she not sold him the requested painting. "Since his highness considers a refusal tantamount to a great lack of respect" she was compelled to cede the *Four Apostles* by Dürer. Recourse was made to the strategy of sending the Prince the originals, which were in a rather poor condition, accompanied by copies in mint condition. It was hoped that he would choose the latter or say that the inscriptions at the foot of the paintings were anti-Catholic and that Catholic Munich would reject them. These strategies were of no avail; the Prince had the inscriptions carefully sawn off and sent back to Nuremberg with the copies. (The panels were reassembled in their original state in 1922.)

1628. An inventory of Maximilian's gallery was drawn up listing the many antiques collected by his predecessors and 117 paintings (only 68 of which had any indication of the artist's identity). The most important place was reserved for the eleven works by Dürer. Over and above those mentioned (see the years 1613, 1614, and 1627) were the *Virgin with the Carnation, Hercules and the Birds of Stymphalus* (on loan to the National Museum at Nuremberg), and *The Death of Lucretia* which Maximilian

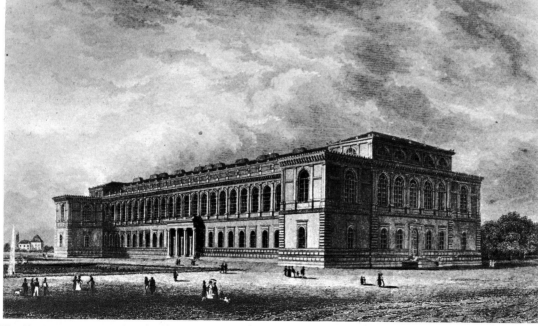

The Alte Pinakothek from a print of around 1850 by Johann Poppel.

inherited. He admired this painting so much that he determined to keep it in his private gallery despite the scantily clad figure. He had to resort to the subterfuge of hiding it under another painting of the same subject by Cranach the Elder. The Prince showed less interest in other German masters; however, part of the collection consisted of works by Cranach the Elder and several works by Burgkmair and Holbein the Elder. The Dutch and Flemish schools were well represented by the Lucas van Leyden diptych, *Saint Constantine and Saint Helena* by Engelbrechtsen, *St. John the Baptist Preaching* by Swart van Groeningen, *The Tax Collector and his Wife* by Roymerswaele, *Lamentation of Christ* by Key, *Christ Blesses the Children* by Sellaer, *Jonah Coming Out of the Whale* by Jan Brueghel the Elder, and *Isaac Blessing Jacob* by Jan Sanders van Hemessen.

1632. Munich was occupied by the Swedes who, in spite of an agreement to respect private property, did not hesitate to pillage Maximilian's art collections. Of the 21 paintings taken (this number is mentioned in a list compiled at that time), only five were recovered, in spite of the formal protests and the prompt intervention of the Prince Elector. Among these were the *St. John Altarpiece* by Burgkmair, *Caesar before Alesia* by Feselen and *Isaac Blessing Jacob* by Hemessen. By this time, the political and economic situation of the country had changed a good deal and, consequently, so had the position and attitude of Maximilian, who, completely absorbed by affairs of state, was compelled to abandon the happy pursuits of a collector.

1651-79. Maximilian's patronage did not find a worthy successor in his son, Ferdinand Maria, who was more interested in worldly affairs.

1665. The only initiative taken during this period, with regard to the art collections, was the stay in Venice of a Carmelite Father, sent from the Court at Munich to make arrangements for the acquisition of paintings. Perhaps the works of Veronese, the Carracci, and Bassano, which adorned the Castle at Schleissheim not many years later, were the fruit of this visit.

1679. With the accession of Maximilian Emanuel, a very active interest in the arts was resumed. (He made arrangement for the exemption of artistic corporations from taxation.) A generous patron and a lover of luxury, he dedicated himself immediately to the acquisition, not only of paintings, but of a great number of items in gold and bronze, precious textiles, tapestries, and furniture.

1684. The construction of the Lustheim Pavilion, the nucleus of the new residence of Schleissheim, was begun near the old architectural complex founded by Wilhelm V at the end of the 16th century. The architect Zuccalli was responsible for the project.

1691-1701. Maximilian Emanuel, governor of the Low Countries, drew on the rich artistic markets of the region, especially at Brussels and Antwerp. It seems his choice was not always happy; he did not look at works of art with the expert eye of the connoisseur but rather with a vague feeling for external appearances, display, and prestige. (A noble at the court relates how one morning the Prince decided to visit Antwerp's most important painters. In less than an hour, he bought paintings valued at 200,000 francs. Later, these were estimated to be worth only half this amount.)

1693. A porcelain gallery was created at the Munich Residenz. The porcelain collection was the favorite of the Prince.

1698. Maximilian Emanuel concludes a very important deal with Gisbert van Ceulen of Antwerp, the art dealer — 101 paintings for 90,000 florins. In this group were 12 by Rubens, 13 by Van Dyck (among these was the *Portrait of Charles I*), 8 by Brouwer, 4 by Claude Lorrain, 10 by Jan Brueghel the Elder, 5 by Wouwermans, the *Boys Playing Dice* by Murillo, and works by Snyders, Jan Fyt, Pieter Bol, de Vos, and de Heem. The perilous state of his finances delayed the payment of the entire sum, which was finally settled by Maximilian Joseph in 1774.

1706. During the exile of Maximilian Emanuel in France, the *Portrait of Charles I* by Van Dyck was conceded to the Duke of Marlborough by the Emperor in token of his gratitude for services rendered to the Empire. (The portrait is now exhibited in the National Gallery, London.)

1714. With the Treaty of Rastatt, Maximilian Emanuel returned to his charge. Although weighed down by debts, he did not abandon the work at Schleissheim, which had been interrupted for years. He ordered new projects, which were not used.

1719. The work of construction at Schleissheim was resumed and quickly brought to a finish under the direction of Effner. According to the ambitious plans of the Prince, Schleissheim was to rival the magnificence of Versailles. A great gallery in which a representative selection of the collections would be housed was envisaged; other precious works were to be exhibited in the various apartments of the castle, and, as a last word in refinement, the design of the frames was to be entrusted to the same architect, Effner.

1722. By now the collection had been transferred to Schleissheim and Peter, Abbot of Britanny, testified to its renown when he stated that it was considered the largest and richest in Europe by the greatest connoisseurs of the time. In the gallery could be seen the *Portrait of Charles V* by Titian, seven works by Veronese, the work of Rubens, among which was the *Portrait of Jan Brandt*, and many works by Van Dyck, Seghers, Snyders, and Brockhorst. The Prince's bedroom contained the *Massacre of the Innocents* by Rubens and the *Rest on the Flight into Egypt* by Van Dyck. The collection was completed by 163 works by Dutch and Flemish artists who were particularly dear to Maximilian. Not of minor interest were some precious examples in the Residenz in Munich, in the Castle of Nymphenburg, and in the other residences of the Prince. It is enough to mention the sketches for the great cycle of paintings which Rubens dedicated to Maria de' Medici, and the two groups of paintings done by Tintoretto for the Gonzaga family.

1726-45. Karl Albrecht, the son and successor of Maximilian Emanuel, took hardly any interest in the collections and concentrated instead on architectural activities. Economic motives also compelled him to abolish the post of inspector of the galleries, which had been created by Maximilian.

1729. A fire broke out in the Residenz and the *Crowning of the Virgin* by Dürer was lost (see the year 1614).

1733. The sum of 12,000 florins was spent for the purchase of the collection of paintings by Baron Malknecht von Mühlegg. Details of this collection are not known, but it can be said that it consisted mainly of Dutch and Flemish works patiently collected by the courtier, following the taste of Maximilian Emanuel.

1745. The financial situation had become more serious and when Maximilian Joseph III became head of state, debts had risen to forty million florins. Consequently, the acquisition of works of art had to be abandoned, but, in compensation, greater care and attention, on an unprecedented scale, was taken of the existing collections. An inventory of Schlessheim was made which revealed the loss of 100 paintings and the damage to many others as a result of the fire of 1729. To look after the collections, whose numbers had greatly increased (925 paintings at Schleissheim, 307 at Nymphenburg, 550 at Dachau, 700 in the Residenz at Munich, and many others among the smaller properties of the Prince), the post of inspector of the galleries was revived and offered to the painter Balthasar Augustin Albrecht.

1768. The Elector's collections were enriched with the bequest of the legate Dufresne in which appeared two works by Murillo, *Domestic Toilet* and *The Little Fruit-seller*, Rubens' *Susanna and the Elders*, and *Family Portrait* by an unknown Flemish painter of around 1630 (then attributed to Frans Hals).

1775. The first catalogue of the Schleissheim Gallery was drawn up by Von Weizenfeld, then inspector of the galleries, and listed 1050 works.

1777. When, on the death of Maximilian III (Joseph), the Bavarian branch of the House of Wittelsbach came to an end, the succession to the Electorate of Bavaria was conferred on Karl Theodor, Elector Palatine, a well-known patron and protector of the sciences and arts. The union of the two electorates seemed a basis for the amlgamation of the art collection in the official seat, which had been established at Munich; but Karl Theodor continued to prefer Mannheim and so the amalgamation did not take place until much later (see the years 1798 and 1806).

1779-81. Karl Theodor made the architect Lespilliez erect the Hofgartengalerie (The Gallery of the Royal Gardens) in Munich, where 700 of the most valuable paintings from Schleissheim, Nymphenburg, and the Munich Residenz were displayed in eight halls. The arrangement of the gallery testifies to the new conception of art, which was no longer considered solely for mere decoration, but also for its cultural values and significance. The paintings were laid out according to chronological principles. The Elector, a truly enlightened prince, was so desirous of making the public participate in the acquisition of culture that he opened the gallery to them.

1791-92. A series of acquisitions on the part of Karl Theodor increased the already large collection of Dutch masters with works by Van Goyen, Hobbema, Artois, the *Still Life with Pewter Jug* by Pieter Claesz., and *Woman Reading* by Pieter Janssens, then attributed to Pieter de Hooch.

1796. Munich was threatened by Jacobin troops and the collections were quickly despatched, first to Linz, then to Straubing, where they remained for a year.

1798. The collections of the Mannheim gallery were transferred to Munich to remove them from a new French advance. This collection had been founded in 1716 by Karl Philipp, the Elector Palatine, and already in 1756 numbered more than 200 pictures, among which were works by Rubens and Rembrandt. On the occasion of the transfer, the inventory of paintings showed that the number had increased to 758 owing to the presence of works by Dutch and Flemish masters (Aert de

Gelder, Nicolaes Maes, Aelbert Cuyp, Adriaen van de Velde, Jan van der Heyden, Abraham van Beyeren, Rachel Ruysch, Gerrit Dou, Frans van Mieris the Elder, Caspar Netscher, Karel Dujardin, as well as Van Dyck Brouwer, Jan Brueghel the Elder, Hendrick van Balen, and many others). There were also works of the German School (Holbein the Younger), the Italian School (Luca Giordano, Bernardo Cavallino, Alessandro Magnasco), and the Spanish School (Zurbarán, Murillo).

1799. On the death of Karl Theodor, the Palatine, the branch of the Wittelsbachs became extinct; Maximilian IV succeeded in Bavaria and brought the contents of the Zweibrücken gallery to Munich. This was a relatively recent collection, begun by the Elector Karl August (who governed from 1775 until 1795). He acquired the entire collection of Christian von Mannlich (at that time the court painter) and quickly augmented it to reach, in two decades, the great number of 2000 paintings. According to the taste of the time, works of the Dutch school prevailed (*Portrait of an Oriental* by Rembrandt, the *Prodigal Son* by Honthorst, *Forest Landscape* by Ruisdael, *The Cook* by Metsu and also works by Van Ostade, Esaias van de Velde, Jan Steen, Benjamin Cuyp, Wouwermans, Heda, Adriaen van de Velde; and others). Flemish painters were represented by Brouwer, Joos de Momper the Younger, Siberechts, Pieter Boel; the German school by the *Holy Family* by Schongauer and the Altarpiece by Memling; and the French school by the two stories of Hagar by Claude Lorrain, the *Troop of Hunters* by Le Moine, the *Woman Peeling Turnips* by Chardin, the *Portrait of the Count Palatine Friedrich Michael von Zweibrucken-Birkenfeld* by Toque, and *La Jeune Fille en Repos* by Boucher.

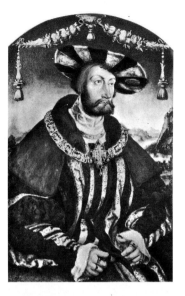

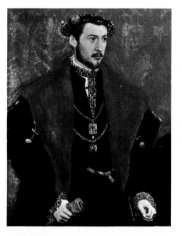

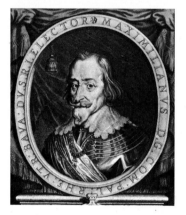

The founder of the collection and two dukes who did most to enlarge it: from the top, Wilhelm IV of Bavaria, Albrecht V and Maximilian I, portraits by Hans Wertinger, Hans Muelich and M. Natalis respectively.

1799-1800. On the resumption of the French offensive in Germany, the Munich paintings (including those recently acquired) had to be moved again. At this time the inspector of the galleries was Georg von Dillis, a scholar and artist as well as a capable organizer; he took personal charge of the transfer of part of the collections to Ansbach (where they remained for about a year), while von Mannlich, recently named director, occupied himself with the remaining works in Munich, looking for hiding places wherever he could. These precautions, did not, however, suffice to safeguard the entire artistic patrimony; the unrelenting Napoleonic commissioners requisitioned 72 paintings, among which was the *Battle of Alexander* by Altdorfer

(which Napoleon himself had set his eyes on) and two hunt scenes by Rubens.

1803. The dissolution of the religious congregations and the confiscation of their property caused a considerable influx of works to the collections at Munich. These included works of art preserved in churches and convents in the Tyrol (annexed to Bavaria by Napoleon). Mannlich and von Dillis were put in charge of the work of requisition; their orders were to choose the items of value and dispatch them to Munich.

This undertaking took about ten years to carry out and resulted in the addition of approximately 1500 paintings to the Munich collections, a great number being German primitives: the *Kaisheim Altarpiece* and the *St. Sebastian Altarpiece* by Holbein the Elder, two panels of an altarpiece by Wolf Huber, *The Mater Dolorosa* by Dürer, the wings of the *St. Lawrence Altarpiece* and the *Altarpiece of the Fathers of the Church* by Pacher, the *Altarpiece of Sts. James and Stephen* and the *Altarpiece of the Virgin* by Reichlich, the *Sts. Erasmus and Stephen* and the *Christ Scorned* by Grünewald, the *Crucifixion and the Virgin and St. John* by Cranach the Elder, the *Virgin and Child in Glory* by Altdorfer, the *Portrait of the Count Palatine Philipp*, a *Nativity* by Hans Baldung Grien, and a *Crucifixion* by Pleydenwurff.

By now it was impossible to display such a great number of works at Munich, so it was decided to set up new galleries in the surrounding cities and enlarge existing ones. The evacuation of the castles and the requisition of the galleries of the annexed towns during this period resulted in a series of exchanges. The galleries of the castles of Aschaffenburg and Ansbach, like those of Nuremberg, Augsburg, and Würzburg (the residence of the hereditary Prince Ludwig) were allowed to remain; paintings from the gallery of Zweibrucken went to enrich the episcopal castles of Bamberg and Seehof; Innsbruck acquired its own gallery. The administration of these galleries remained (and still does) with Munich.

1805. Maximilian IV Joseph (who was about to assume the title Maximilian I, King of Bavaria, by wish of Napoleon) acquired the *Self-Portrait* by Dürer.

1806. Under the threat of the French advance, the collection at Düsseldorf was dispatched to Munich. Although it was not a large collection (348 paintings), it boasted some items of such great value that it was considered among the richest of the time. Its first and most important nucleus was formed by Johann Wilhelm, Elector Palatine, who was initiated into collecting by Jan Frans Douven, who, from 1682, was his very capable agent and expert adviser. In spite of the lack of finance, the Prince had made some prudent acquisitions with the help of his vast and illustrious circle of relations: his wife, Annamaria Ludovica, daughter of Cosimo III of Tuscany, in her dowry brought, among other things, the *Canigiani Holy Family* by Raphael, and the *Holy Family and Saints* by Andrea del Sarto; Cardinal Francesco Maria de' Medici and the Pope himself, were of considerable help in obtaining paintings from the religious communities; his brother-in-law, Charles II, King of Spain, was also a valuable source of gifts. By the time the first catalogue was made in 1719, from a total of 341 paintings, forty-six were by Rubens, twenty-five by Van Dyck, and two by Rembrandt the *Scenes of the Passion* and the *Adoration of the Shepherds*. Succeeding acquisitions were made by Karl Theodor.

1808. Georg von Dillis' journey to Italy began two decades of fruitful enrich-

ment of the collection of Italian works. He dedicated himself to an enthusiastic "hunt" for works of art on the orders of the Crown Prince, Ludwig, who had a passion for the arts and with whom he was on friendly terms. There seemed to be an immense number for sale in Florence, where, "even the most simple household seems to have its collection of paintings," he wrote. His first acquisition was the presumed *Self-Portrait* of Raphael, which was badly received by the art experts in Munich, who denied the attribution. This portrait, probably depicting *Bindo Altoviti*, is now in the National Gallery, Washington; it was one of the foreign paintings which were exchanged, under Hitler's direction, for paintings by German masters.

During this same year the *Virgin and Child* by Filippo Lippi was acquired.

1814. The engraver Johan Metzger, an agent of the Prince in Florence, succeeded in buying the *Lamentation of Christ* by Botticelli.

1814-15. After the fall of Napoleon, negotiations took place to recover the paintings which had formed part of the French booty; this proved no easy undertaking and resulted in the return of only twenty-seven works. Among these were *The Victory of Alexander* by Altdorfer, the *Crowning with Thorns* by Titian, three paintings by Rubens, and others by Burgkmair, Jannsens, and Lastman. The difficulties and expense to be met in order to pursue just claims compelled von Dillis to desist from the undertaking; thus, many items were left scattered in various galleries and churches of France (among others were canvases by Rubens and Van Dyck).

1815. Von Dillis, who was in France for the recovery of the paintings, bought from General Sebastian (the commander of the French troops in Spain) the *Virgin and Child in an Evening Landscape* by Titian and *St. Thomas of Villanueva Distributing Alms* by Murillo. Both pictures had come from the Escorial. Moreover, the capable inspector was able to purchase the *Virgin and Child* by Cima da Conegliano, and the *Virgin in the Rose-Garden* by Francia, from the collection of the Empress Josephine.

1816. The *Birth of the Virgin* by Altdorfer and the *Adoration of the Kings* by Gerard David were acquired. From Florence there arrived the *Intercession of Christ and the Virgin* by Filippo Lippi, its related "predella," and the altarpiece from the high altar of Santa Maria Novella depicting the *Virgin in Majesty, Venerated by Four Saints*.

1818. From Florence came another precious acquisition — a panel from the predella of the altarpiece of San Marco depicting the *Deposition* by Fra Angelico.

1819. Maximilian I bought the *Viscount of Turenne* by Philippe de Champaigne, and the Crown Prince Ludwig acquired fram a London dealer the *Madonna della Tenda* by Raphael (a picture he had admired three years before in the collection of Sir Thomas Baring in London).

1822. The steady increase in the number of collections in Munich and the addition of the galleries of Mannheim, Zweibrücken, and Düsseldorf made imperative the construction of a suitable building in which they could all be gathered. The initiative was taken and fostered by von Dillis who made Maximilian aware of the necessity of offering a complete assembly of the masterpieces (which until then had been scattered in different annexes) to students and art lovers, who kept coming in large numbers. The decision was quickly made. On the 20th of April the court architect Leo von Klenze was commissioned to draw up plans for the new building, in which 1300 paint-

ings of various schools were to be housed. In his project von Klenze was particularly careful with the problems of exhibiting and lighting the paintings and with the requirements of visitors. In structure the gallery was an elongated shape, with the exhibition rooms on the first floor, arranged in such a manner that access could be had to the single rooms and visits to individual collections could be made. A scheme of decoration, suitable to the high quality of the exhibits, was envisaged, and as a source of inspiration and model of magnificence and elegance, the Pitti Palace was chosen.

1824. The Prince presented the galleries with the *Virgin and Child* by Lucas Cranach the Elder.

1826. On the 7th of April (the birthday of Raphael), Count von Armansperg, Minister of the Interior and of Finance, laid the foundation stone in the construction of the Alte Pinakothek.

1826-27. Shortly after his accession to the throne Ludwig I resumed and concluded the negotiations for the acquisition of the Boisserée collection, which were begun a few years earlier, and to which the cities of Berlin and Frankfurt had also aspired. The price agreed on was 240,000 florins, which Ludwig drew from his private treasury. It was a very large sum, but not excessive if related to the exceptional items which formed part of the collection. Almost by chance Sulpice and Melchior Boisserée began this collection and rapidly enlarged it with care and love. Within a period of twenty years it totaled 216 works by early Dutch and German Masters. These included the *Altarpiece of the Kings* by Rogier van der Weyden, the *Resurrection* and *St. John the Evangelist* by Dieric Bouts the Elder, the *Pearl of Brabant* altarpiece by Dieric Bouts the Younger, the *Seven Joys of the Virgin* by Memling, an *Altarpiece* by Joos van Cleve, the *Rest on the Flight into Egypt* by Isenbrant, the *Jehan Carondelet* and *St. Ambrose Preaching* by van Orley, the *Lamentation of Christ* by Engelbrechtsz., and also two wings of the *Jabach Altarpiece* by Dürer, *St. George and the Dragon* by Altdorfer, and *St. Anna, the Virgin and the Infant Christ* by Cranach the Elder.

Ludwig I was about to realize his ambition of creating a complete panorama of ancient art.

1828. Ludwig I bought the 219 paintings of the Wallerstein collection with the sum of 80,000 florins, once again paid from his private treasury.

1829. The protracted negotiations for the *Tempi Madonna* by Raphael were concluded with the Marchese Tempi in Florence. These were begun in 1808, when, following information from von Dillis, the Prince had charged Metzger to contact the Marchese in order to persuade him to sell the painting. The long and protracted business which followed was solved only by the patience and perseverance of the intermediaries, accompanied by complicated intrigues and subterfuges. The price agreed on, 15,000 Tuscan crowns, was considerable.

1829-30. The *Vision of St. Bernard* by Perugino was purchased in Florence.

1836. The new building of the Alte Pinakothek was completed and on the 16th of October the exhibition rooms were opened to the public. Many valuable works from Schleissheim were transferred to the gallery.

1838. The first catalogue made its appearance; however, it was not compiled on scientific lines.

1840. The internal decoration of the exhibition halls, which had been entrusted to Peter Cornelius, was completed.

1841. On the death of Georg von Dillis the post of Gallery Director was entrusted to persons less and less qualified, until it dwindled in importance over the next few decades.

1845. Ludwig I, through his agent in Rome, succeeded in acquiring from the Fesch collection *Christ in the House of Martha* by Le Sueur in spite of competition from French, English, and Russian sources.

1846-53. Ludwig's desire for a gallery in which to exhibit works by contemporary painters was fulfilled with the building of the Neue Pinakothek (see the years 1911-13, 1944).

1848. The abdication of Ludwig I saw the end of the golden period of the Munich collections. Lack of funds and incompetence not only prevented enrichment, but directly threatened to impoverish the treasures already collected.

1852. The directorate of Robert Lange was probably the unhappiest period in the history of the Munich collections. It was decided to complete the series of portraits of the members of the house of Wittelsbach, which was kept in Schleissheim. The task would be entrusted to contemporary painters who would have sought likenesses in contemporary prints. Since the state refused to finance the projects, it was decided to auction 971 works, the property of the gallery. Among these was Dürer's *Saint Ann, the Virgin and the Infant Christ* (today in the Metropolitan Museum of Art, New York) and the works by Altdorfer and Grünewald.

1865-75. The situation was not improved very much under the direction of Philipp von Foltz, a historical painter who was more interested in his own studio work than in the gallery. He caused damage in attempting to restore several works.

1875. The post of Gallery Director was given to Frans von Reber, professor of art history, who dedicated himself to the reorganization of the gallery (enlarged during this period by the appropriation of other rooms in the building). The Association of Munich Artists attempted to participate in this reorganization by proposing to relegate the works of Italian and German "primitives" to storerooms. But these questionable propositions were countered by von Reber's perseverance.

1885. The first scientifically compiled catalogue of the gallery was published under the authorship of von Reber.

1888. An annual allocation of 20,000 marks from state funds was set aside for acquisitions for all Bavarian collections.

1889. Dr A. Haug of Günzburg sold the *Virgin and Child* by Leonardo da Vinci to the Gallery; he received 800 marks and the Knight's Cross of the Order of St. Michael.

1890. The annual grant to the Alte Pinakothek alone was fixed at 10,000 marks.

1894. The *Virgin and Child* by Signorelli was acquired from Florence.

1897. The *Virgin of the Annunciation* by Antonello Da Messina was acquired.

1900. The annual state grant for the gallery was increased to 30,000 marks, a sum which was not yet great enough to permit important acquisitions. Two portraits (husband and wife) by ter Borch were acquired.

1906. The *Portrait of a Man* by Frans Hals was bought from the van Stolk collection in Haarlem.

GENERAL INFORMATION
ON THE ALTE PINAKOTHEK AND ON SCHLEISSHEIM CASTLE

Organization – Together with four other galleries in Munich and nine in various cities of Bavaria, the Pinakothek constitutes the Bayerische Staatsgemäldesammlungen (Bavarian State Galleries). The administration consists of a central council with presidential function, a director general, experts and various heads of departments.

Related departments – The Pinakothek is equipped with a photographic studio, a photographic library and a library for internal use only, a restorations department, and gilding and woodworking departments.

Lighting and Air-conditioning – The exhibition halls are east-west oriented and are lit by indirect natural lighting and neon lighting. The temperature is maintained at 68° F and the relative humidity at 55 per cent.

Security – Security measures are active day and night and are linked to fire alarm and other warning systems.

Admission – The Pinakothek is open every day except on Mondays, from 9 : 00 a.m. to 4 : 30 p.m. and on Tuesdays and Thursdays also between the hours of 7 : 00 p.m. and 9 : 00 p.m. It is closed on the following days: New Year's Day, Good Friday, Easter and the following Tuesday, the 1st of May, Pentecost and the following Tuesday, Corpus Christi, All Saints Day, and the 24th and 25th of December. On public holidays admission is free. Once a week there is a conducted tour by one of the officers of the Gallery and guided tours are available on request. Visits to the storerooms can also be made by special arrangement with the head of the department.

Cultural services – Since July 1971 there have been available guide books with descriptive texts which follow the order of the exhibits. Continual lectures with slides can be heard in the lecture hall. Tape-recordings are also available.

Catering – The Pinakothek is provided with a small bar and restaurant.

Special exhibitions – In two halls of the ground floor, small exhibitions of works taken from storage are periodically mounted.
The Castle of Schleissheim is open to the public every day except on Mondays from 10 : 00 a.m. to 12 : 30 p.m. and from 1 : 30 p.m. to 5 : 00 p.m. During the Winter season (that is, from the 1st of October to the 31st of March) the Castle is open until 4 : 00 p.m. It is closed on the following days: New Year's Day, Shrove Tuesday, May 1st, November 1st, December 24th, 25th and 31st.

CHARACTERISTIC

1,025 paintings

VISITORS

	1st quar.
	2nd quar.
	3rd quar.
	4th quar.

40,000 80,000 120,000

9

RELATIVE IMPORTANCE OF THE SCHOOLS
REPRESENTED IN THE MUSEUMS

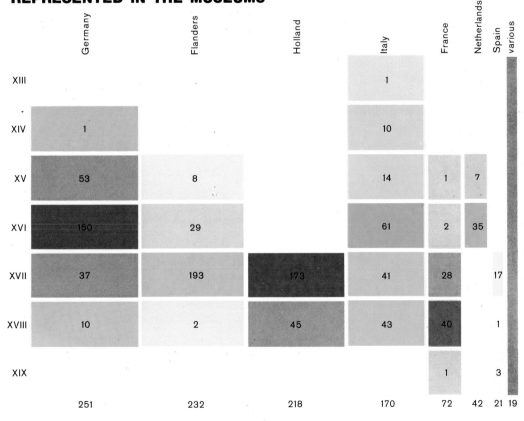

	Germany	Flanders	Holland	Italy	France	Netherlands	Spain	various
XIII				1				
XIV	1			10				
XV	53	8		14	1	7		
XVI	150	29		61	2	35		
XVII	37	193	173	41	28		17	
XVIII	10	2	45	43	40		1	
XIX					1		3	
	251	232	218	170	72	42	21	19

Sketch illustrating the importance of the various schools: each school is divided into centuries and indicated by a different color; the length of the strips is proportional to the number of paintings belonging to each school with regard to the other schools; the color intensity is proportional, within each school, to the importance of the paintings for each century. The figures referring to the paintings have been indicated with the nearest possible approximation.

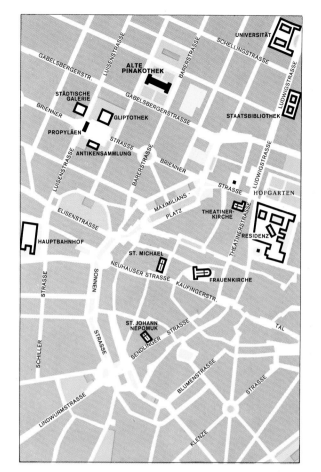

1909. Reber was succeeded by Hugo von Tschudi who had worked in the galleries in Berlin, but had been forced to leave because of his avant-garde ideas. He quickly set about the re-organization of the gallery, reduced the number of paintings (then 1433) by a third, brought together all the important works scattered in the various other galleries, and attempted, as far as he could, to assemble the altarpieces whose panels had been separated. To him are due the acquisitions of notable works: the *Disrobing of Christ* by El Greco, the *Plucked Turkey* by Goya, and the *Venetian Gala Concert* by Francesco Guardi.

1911. On the death of von Tschudi the function of director was temporarily undertaken by his capable assistant, Heinz Braune, but his youth prevented his nomination to the post. This resulted in the absence of a worthy successor to the work begun by Tschudi.

1911-13. Modern works were brought together in the Neue Pinakothek. Many of these came from Schleissheim where some decades previously a collection of works by living artists had been constituted.

1914-33. The direction of the gallery was entrusted to Friedrich Dornhöffer. Although no direct damage was inflicted on the gallery during the First World War, the difficulties of the situation made themselves felt. In order to make further acquisitions, recourse was made to the sale of less important items kept in storage.

Two new galleries, dependent on the Alte Pinakothek, were set up in Bayreuth and Fussen. During this period acquisitions consisted mainly of early German works: Strigel, Schaffner, Cranach the Elder, Kulmbach, and Amberger. Among the most outstanding acquisitions were the *Land of Cockayne* by Pieter Brueghel the Elder, *Don José Queralto* by Goya, the *Extensive Landscape* by Koninck, the *Members of the Wine Merchants' Guild* by Ferdinand Bol, and from the Italian School works by Cariani, Tintoretto, and Fetti.

1933. The successor to Dornhöffer was his pupil, Ernest Buchner, who was a student of German Primitives, to which section he dedicated himself.

1935. The *Angelica and Medorus* of Spranger was acquired.

1936. An important acquisition in the sphere of Italian Primitives was the *Last Judgment* by the "Master of the Lively Child."

1938. The gallery acquired the *Portrait of a Strasburg Knight of St. John* by Hans Baldung Grien.

1939-45. Buchner's greatest service of the Pinakothek was saving the collections from the perils of war. The gallery was quickly closed and most of the paintings transported to the castles of Neuschwanstein and Herrenchiensee. The fact that the building was severely damaged and whole rooms destroyed proved how providential was his action.

1940. The *Virgin and Child with Musician Angels* by the "Master of the Aachen altarpiece," and the *Still Life with Delft Jug* by Willem Kalf were acquired.

1942. The *Landscape with Village Church* by Jacob Ruisdael was acquired to enrich the collections.

Ground Floor

I, IIa, IIb, III, 1-3, 4-10	16th and 17th century Flemish and Dutch Schools
XI, XII, XIII, 19-23	German Primitives
II, IIb, XII	16th century German School
A	Information
B	Cloak-room - Telephone
C	Toilets
D	Restaurant - Bar
E	Elevators

First Floor

IV, V, VI, VII, VIII, 1-9, 11-14	16th and 17th century Flemish and Dutch Schools
VI, VII, 12-14	Rubens
VIII, 14	Van Dyck
I, II, IIa, IIb, III	16th century German School
23	Italian Primitives
X, 21, 22	Italian Renaissance
21	16th century Italian School
XII	Titian
IX, 18-21	18th century Italian School
XI, 15	17th century Spanish School
XIII, 16, 17	17th and 18th century French School

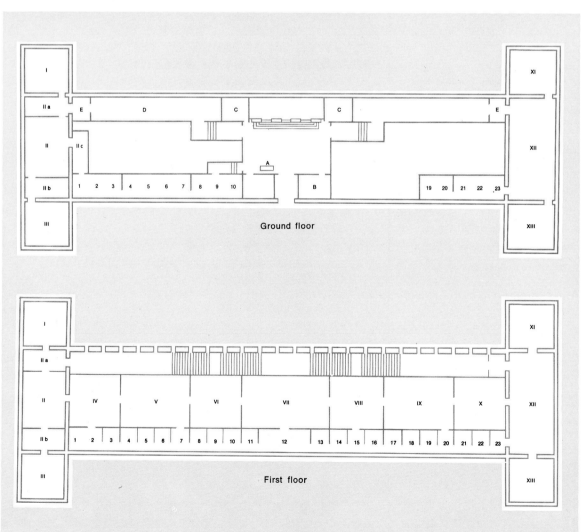

Ground floor

First floor

1944. The Neue Pinakothek was completely destroyed by bombing and the Alte Pinakothek suffered severe damage in which only the outside walls were spared.

1946-50. While waiting for the reconstruction of the Alte Pinakothek, some of the paintings, recalled by the Director, Eberhard Hanfstaengl, were exhibited in the Haus der Kunst.

At the same time, in order to raise funds to augment the gallery's meager budget during the postwar years, Hanfstaengl organized a series of exhibitions of the Munich masterpieces in the principal European cities.

1953. The youthful *Self-Portrait* by Rembrandt was an acquisition of particular interest.

Ernest Buchner returned to the post of Director and devoted all his efforts to the reconstruction of the Alte Pinakothek. He entrusted the project to the architect Hans Dölgast. A greater area for the exhibition of the paintings was created by taking over the ground floor which had previously been occupied by offices and collections of antiques.

1954. The *Landscape with Farm* by Cornelis van Dalem was acquired.

1957. The first floor of the Alte Pinakothek was finally completed and opened to the public.

1960. The *Death of Virginia* by Hans Schöpfer the Elder, which had belonged to the cycle of historical paintings commissioned by Wilhelm IV of Bavaria, was recovered.

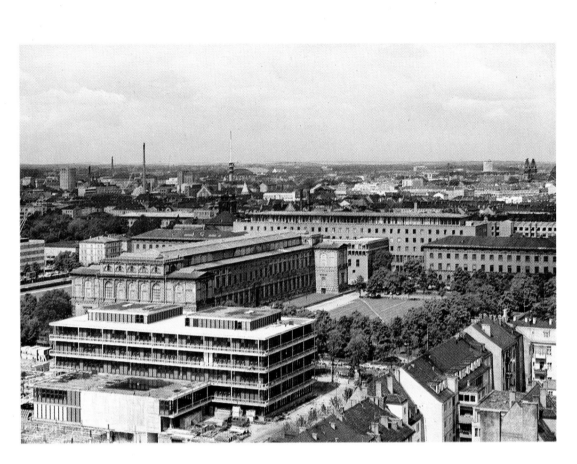

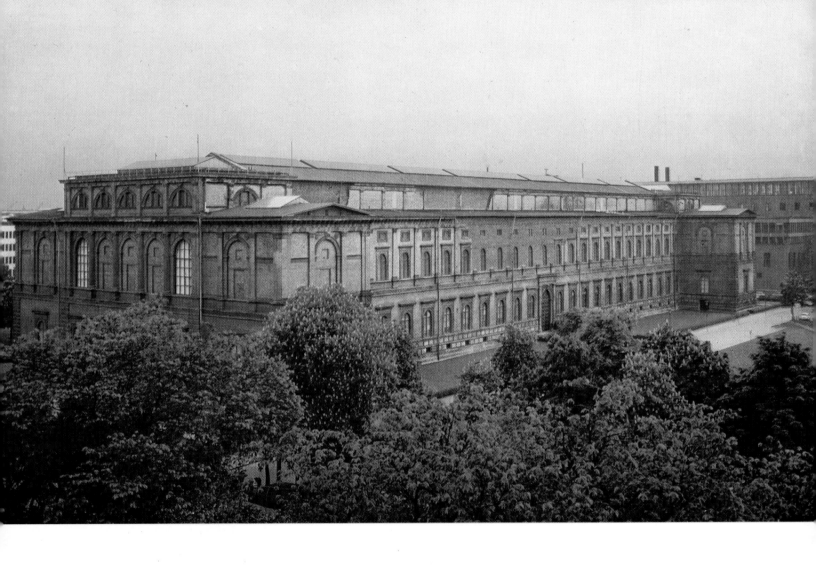

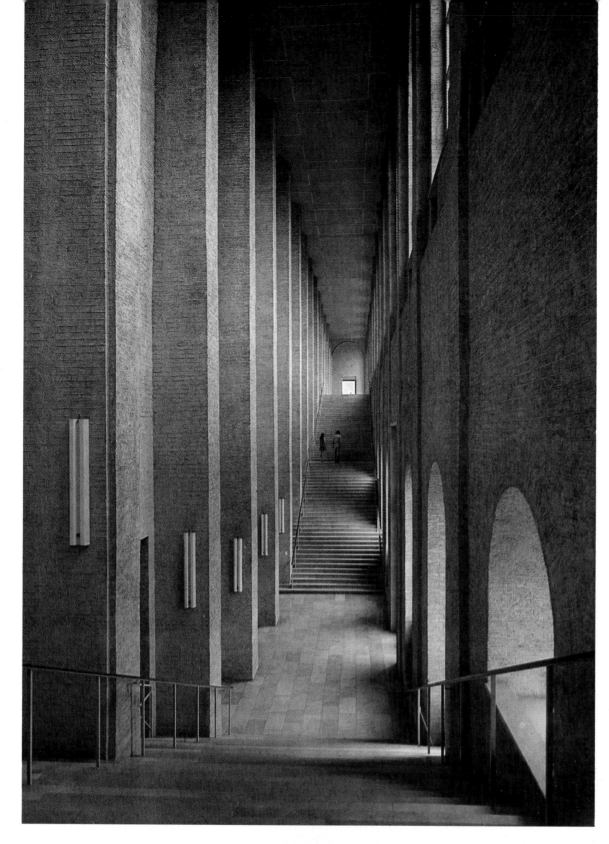

1961. The east wing of the ground floor of the gallery was completed.

Among the collections belonging to the Nazi leaders which were taken over by the state was that of Hermann Göring. *The Golden Age* by Cranach the Elder, and the *Adoration of the Christ Child* by Stefan Lochner were brought to the Alte Pinakothek.

1963. The *Still Life with Melons* by Meléndez and the fragment by Pieter Aersten showing a *Market Scene* were acquired by the gallery.

1964. The reconstruction work of the gallery was terminated by the conclusion of operations in the west wing.

The *Death of Cleopatra* by Liss was acquired.

1964-68. The post of Director was entrusted to Halldor Soehner, a noted specialist in the French and Spanish Baroque. He devoted the brief period of his activity (which was interrupted by his premature death) to the enlargement of the Neue Pinakothek.

1966. Soehner obtained the support of Bayerische Hypotheken und Wechselbank for some important acquisitions; the bank purchased the works and gave them to the gallery on permanent loan. The works included the *Portrait of Doña Maria Teresa de Vallabriga* by Goya, *The Bird Cage* by Lancret, the *River Landscape* by Boucher, the *Lament of the Watch* by Greuze, two portraits by La Tour, the *Joys of Country Life* by Pater and also five works by Guardi, an outstanding enrichment of the 18th century painting section.

1968. The Hypotheken und Wechselbank added the *Portrait of the Marquesa de Caballero* by Goya to the list of works on permanent loan to the gallery.

1970. A further loan from the bank was made in the form of the gallery's first painting by Pietro Longhi, *The Visit or The Game of Cards.*

1971. The Hypotheken und Wechsel-Bank purchased and gave to the gallery the *Portrait of Marchioness of Baglion* by Nattier, *The Marchioness of Sorcy of Thélusson* by Jacques-Louis David and the *Portrait of the Marchioness of Pompadour* by Boucher.

Description of the Alte Pinakothek

The Alte Pinakothek is situated in the northeast part of the city. Leo von Klenze drew up the plans of the building, and the construction work took place between 1826 and 1836. According to the plan, the building is the shape of an elongated H, 127 by 37 meters.

(Above) The entrance to the gallery as it now appears after the restorations, finished in 1963, with the two great staircases which lead to the exhibition rooms on the upper floor. (Facing page) The VII room, dedicated to the largest and most important canvases by Rubens: on the right foreground can be seen the Great Last Judgment *and on the far wall the* Fall of the Rebel Angels *and the* Drunkenness of Silenus.

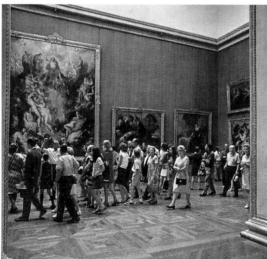

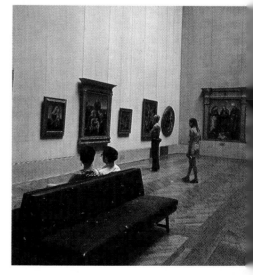

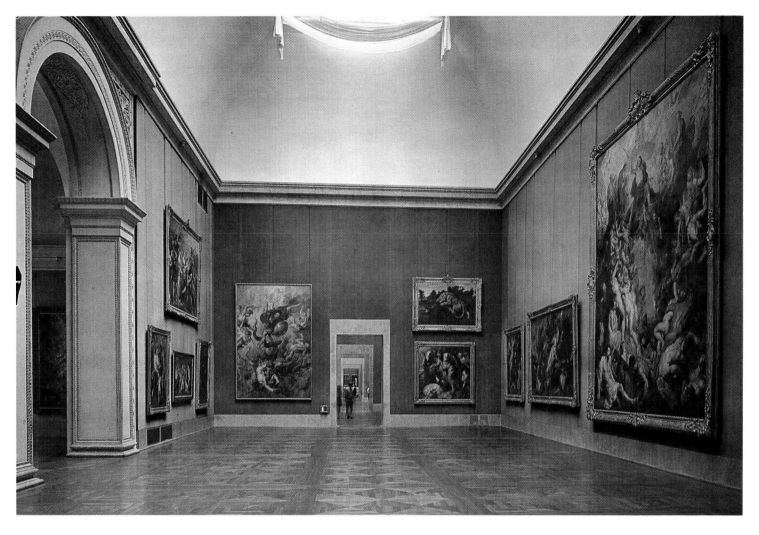

The building has an east-west orientation, with the principal façade on the south side. It stands in a square of ornamental gardens.

The exterior, which still shows signs of the bombing it suffered during the last war, has the characteristic appearance of neo-classic architecture, heavy in appearance because of its rather massive construction. A rustication of large hexagonal blocks serves as a base for the whole structure. The façade is enlivened by a fenestration which covers about three quarters of its surface. The illumination was carefully studied according to criteria based on the purposes for which the building was established. The upper floor contains the exhibition rooms of the gallery. The sequence of windows (which are wider than those on the ground floor) is enlivened by Doric columns set in the spaces between

the windows and standing on lightly projecting cornices. All this serves the function of lessening, with the play of light and shade, the apparent length of the building. The roof area is slightly recessed in relation to the mass of the building in order to allow a series of skylights to illuminate the exhibition space immediately below.

The decoration of the rooms was planned by Peter Cornelius, and was carried out by his workshop in 1840. Hardly any of this decoration has survived, as the bombing of 1944, which severely damaged the city of Munich, destroyed 80 per cent of the gallery and left only the outside walls standing. The work of reconstruction began between 1953-54 (see the *History* for the year 1953) and was finished only in 1963 with the opening of the exhibition rooms on the ground floor.

Although the exterior of the building

does not present, as yet, a definitive appearance, since it still shows the scars of the bombing, the interior reconstruction as planned by Hans Döllgast creates a completely different arrangement of the vestibule and the staircase complex. It now rises in two flights, linking the entrance directly to the exhibition rooms on the floor above. It is an imaginative solution despite its apparent simplicity.

In Leo von Klenze's plan, only the upper floor was destined to be used for exhibition rooms, but in the present reconstruction a number of rooms on the ground floor have been laid out for this purpose. Two staircases and elevators situated in the east and west ends of the building permit communication between different parts of the interior. Offices, a restaurant, and the various services are situated on the entrance floor of the gallery.

Layout of the Gallery

Sixteenth and Seventeenth Century Flemish and Dutch Schools: ground floor I, IIa-b, III, 4-10, 1-3; upper floor IV, V, VI, VII, VIII, 1-9, 11-14.

Rubens: upper floor, VI, VII, 12-14.

Van Dyck: upper floor, VIII, 14.

Early German School: ground floor, XI, XII, XIII, 19-23.

Sixteenth Century German School: ground floor, II IIb, XII; upper floor, I, II, IIa, IIb, III.

Early Italian School: upper floor, 23.

Renaissance: upper floor, X, 21, 22.

Sixteenth Century: upper floor, XII, 21.

Eighteenth Century: upper floor, IX, 18-21.

Seventeenth Century Spanish School: upper floor, XI, 15.

Seventeenth and Eighteenth Century French School: upper floor, XIII, 16, 17.

Masterpieces
in the Alte Pinakothek

GERMAN MASTERS

1 – 3. In the first half of the 15th century there flourished in Cologne an important school of painting whose greatest exponents were Stephan **Lochner** and the unknown **Master of St. Veronica**. This school is characterized by its complete detachment from the international Gothic tradition, whose influence was only marginal, while its compositional structure acquired a clearer and more solid basis of narration. In the panel on the ertreme left of the *Last Judgment Altarpiece* by Stephan Lochner, a work of about 1430, attention is concentrated on the three saints, who appear on a background lacking in decorative elements, and on the tiny figure of the donor, which already hints at portraiture. The female figure in soft rich robes, whose presence dominates the other figures, is characteristic. In the *Adoration of the Christ Child*, a more mature work, Lochner displays a more knowledgeable compositional structure, in which the decorative elements – angels, shepherds, sheep, and distant castle – form a sort of commentary on the solid figure of the Virgin. The painting (from which the Master of St. Veronica takes his name) is, because of its dominating lyrical expression, a typical work of late Gothic German painting. The gold of the background does not diminish the solidity of the figure of St. Veronica.

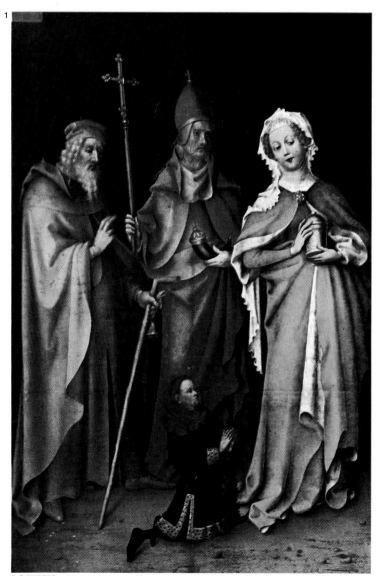

LOCHNER Saints Anthony Hermit, Cornelius Pope, Magdalene and a Donor

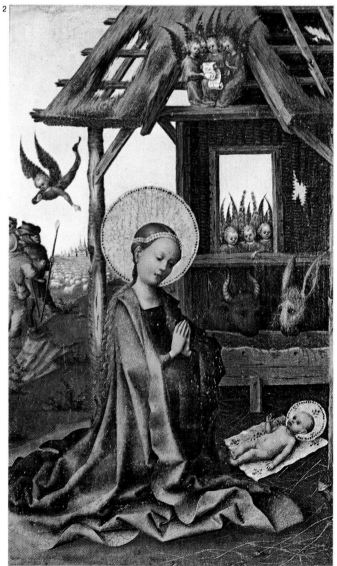

·LOCHNER Adoration of the Christ Child

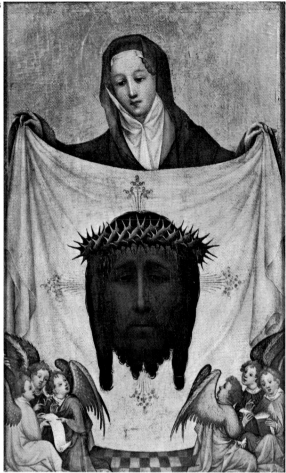

MASTER OF ST. VERONICA St. Veronica with the Veil

4 – 6. With the works of the **Master of the St. Bartholomew Altarpiece** and the **Master of the Life of the Virgin**, in the second half of the century, the School of Cologne presents a great variety of themes, with figures set in landscapes or interior backgrounds. In the central panel of the St. Bartholomew altarpiece a sumptuous drapery acts as a backcloth to the figures of the three saints. It is, however, cut off in order to allow an imaginative landscape conceived in depth to be seen. In the *Birth of the Virgin*, one of seven panels of the altarpiece from which the unknown artist takes his name, we have reached an orderly arrangement of objects and figures set within a clear architectural framework; the midwife who tests the temperature of the water and the woman who withdraws the clothes from the chest are elements in which classic tradition and contemporary costumes are fused. The same Master shows proof of this power of observation in his *Portrait of a Master Builder* by both capturing the sitter's physical expression and at the same time making us aware of his social standing.

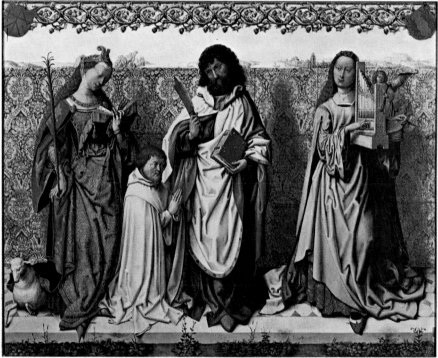

MASTER OF THE ST. BARTHOLOMEW ALTARPIECE The St. Bartholomew Triptych

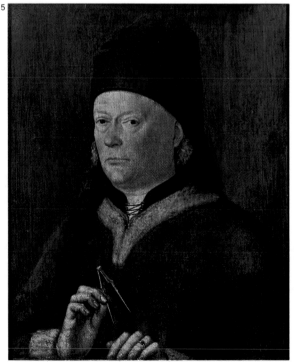

MASTER OF THE LIFE OF THE VIRGIN Portrait of
a Master Builder

MASTER OF THE LIFE OF THE VIRGIN Birth of the Virgin

7. In Martin **Schongauer**, active within the sphere of the School of Cologne in the second half of the 15th century, we find the subjects of Stephan Lochner rendered in a more modern naturalism. The paintings of this Master, which for the most part were executed by pupils in the great workshop he directed, took second place to his engravings, which were known and copied all over Europe.

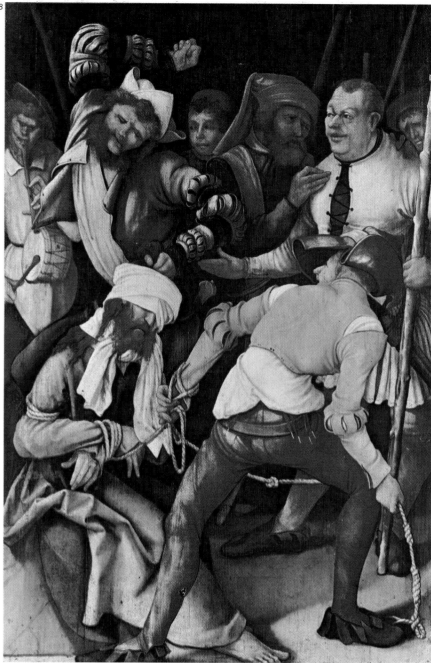

GRÜNEWALD CHRIST SCORNED

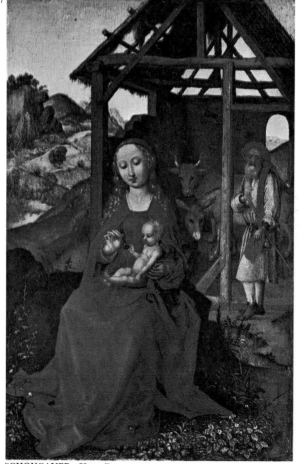

SCHONGAUER HOLY FAMILY

8 – 9. With Matthias **Grünewald**, the first great individual personality (from a critical point of view) we can single out, we pass beyond the naturalistic rendering of elements taken from real life to a more profound vision which discovered in those same elements contrasts of great dramatic value. Such a contrast, evident in *Christ Scorned*, becomes more subtle in *Saints Erasmus and Maurice*. To the varied colors and costumes of the participants are added allegorical and symbolic values. *Saint Erasmus* is dressed as a bishop and bears the sign of his martyrdom (the spindle he holds is wound about with his intestines). Represented in the picture is Albrecht of Brandenburg, Archbishop of Magdeburg, who during Grünewald's lifetime was well known for his fight against the Reformation. In the black saint wearing a silver breastplate is represented the first Christian soldier martyred in Egypt with the Theban Legion. This work, notably rich in religious allusions, is considered particularly important in connection with the unsolved problem of the effect the religious wars had on Grünewald.

10. To the same School of Cologne belongs also the unknown painter of the *Legend of the Saint Hermits Anthony and Paul* where the principal figures are set in an imaginative landscape full of particulars more appropriate to miniature painting.

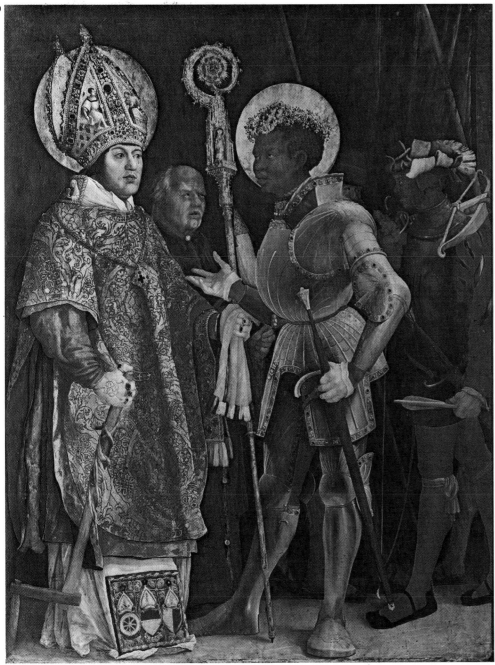

GRÜNEWALD St. Erasmus and St. Maurice

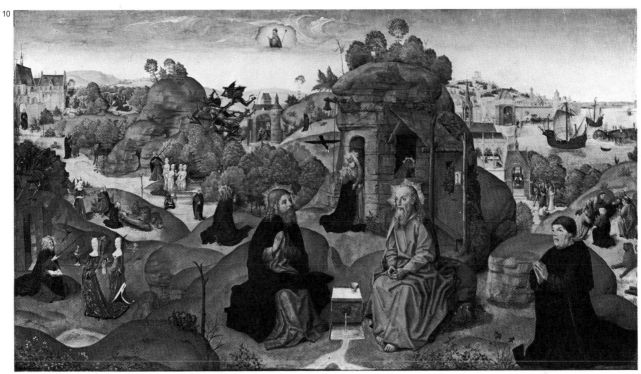

PAINTER OF COLOGNE Legend of the Saint Hermits Anthony and Paul

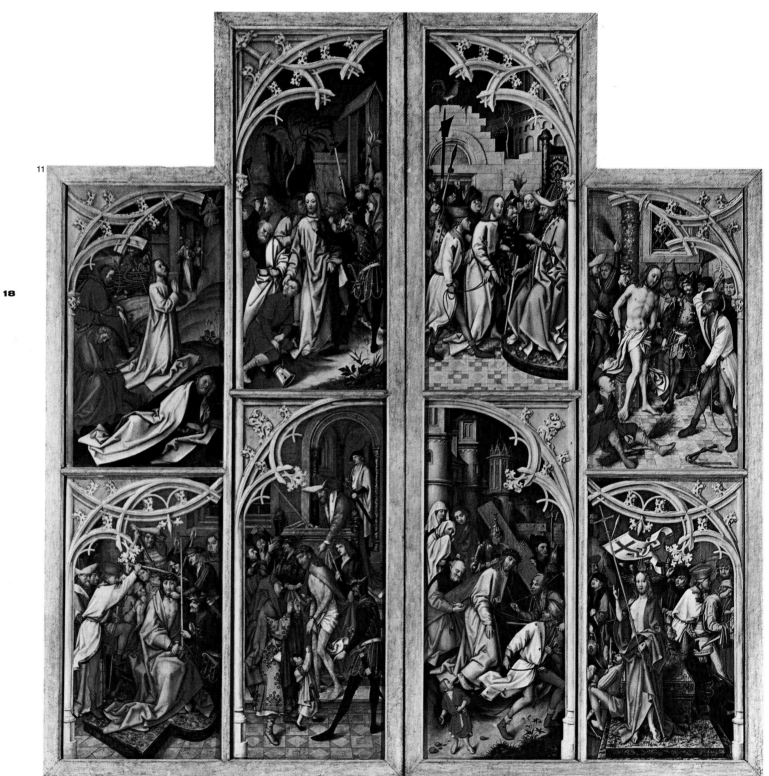

HOLBEIN THE ELDER Wings of the Kaisheim Altarpiece

11. Among German Masters of the Southern School during the second half of the 15th century, Hans **Holbein** the Elder shows, in the individual panels of the Kaisheim Altarpiece, the first breakaway from medieval forms, in an ensemble still archaic in conception. The altarpiece consists of eight panels showing events from the life of Christ on the outside and events from the life of the Virgin on the inside.

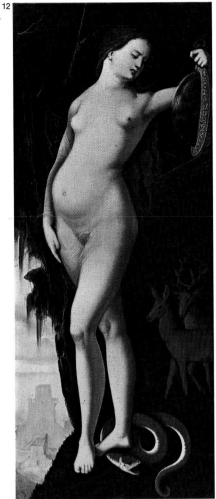

12

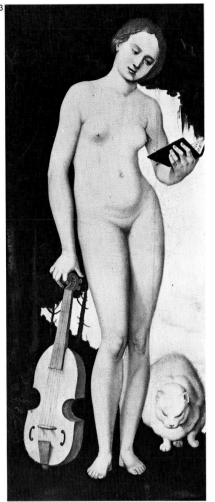

13

12 – 15. The training which Hans **Baldung Grien** received in Dürer's workshop at the beginning of the 16th century permitted him to show, in his personal way, his grasp of Renaissance culture acquired through the Master's influence. This can be seen in the two *Allegorical Figures* of Prudence and Muisc. This same personal translation of the art of Dürer can be noted in the portrait, where the sitter is depicted with great attention to psychological reality. The *Portrait of Sibylla von Freyberg* by Bernhard **Strigel**, portrait painter at the court of the emperor Maximilian in Vienna, shows this same tendency.

BALDUNG GRIEN Allegorical Figure: Prudence

BALDUNG GRIEN Allegorical Figure: Music

14

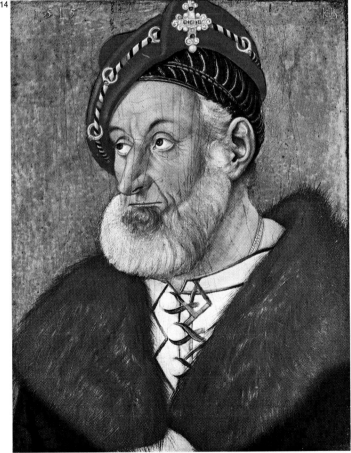

15

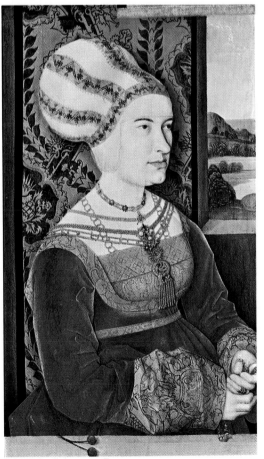

BALDUNG GRIEN Portrait of the Margrave Christopher I of Baden

STRIGEL Sibylla von Freyberg

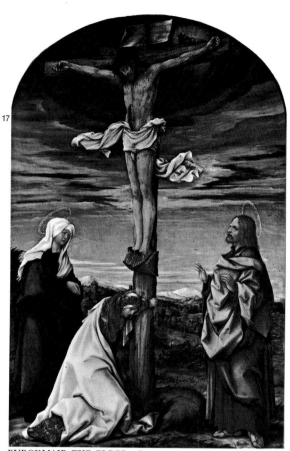

BURGKMAIR THE ELDER Crucifixion

16 – 17. With Hans **Burgkmair** the Elder, who worked in Augsburg, there is an obvious alignment with the new Renaissance culture, whose structural and decorative elements were introduced into his paintings and engravings. This is evident both in the *St. John at Patmos* and the *Crucifixion*, where borrowings from Italian art are evident. The former is the central panel of the St. John Altarpiece of 1518, where the clean-cut sign of the engraver prevails, and the latter is the central panel of the altarpiece of the same name.

18 – 20. Hans **Holbein** the Younger's *Portrait of Derich Born*, who was an Augsburg merchant active in England, and Christoph **Amberger**'s *Portrait of Christoph Fugger*, member of an important banking family, also of Augsburg, can both be placed in the middle of the 16th century. They show a sense of monumentality which link them to the Italian Renaissance. The experience gained by Hans Holbein the Younger in his travels to England and Italy, where he was present at the height of the Renaissance and at the beginnings of Mannerism, were welcomed in Augsburg, where Amberger succeeded him as portrait painter to the great merchants. It can be seen in the portrait of Fugger which is reminiscent of well-known paintings of Florentine Mannerism. George **Breu** the Elder was a painter of historical subjects at the court of Wilhelm IV, Duke of Bavaria. The *Death of Lucretia*, of 1528, belongs to a series of commemorative works which the Prince commissioned from various artists for his residence. Outstanding in these works is the obvious humanistic and classical influence, as shown in the architecture and in the costume of the figures. This is justified when one considers the destination of the paintings.

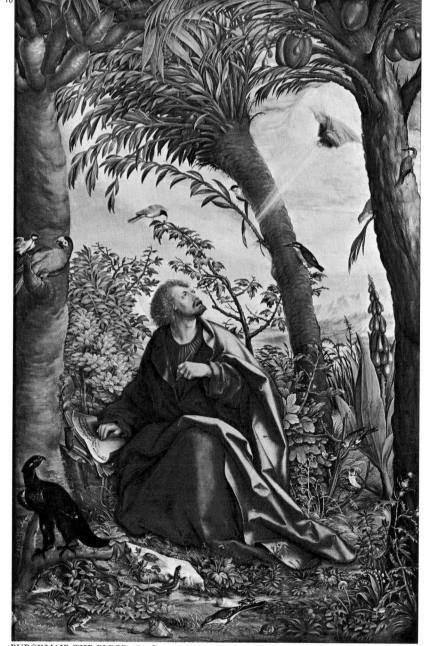

BURGKMAIR THE ELDER St. John at Patmos

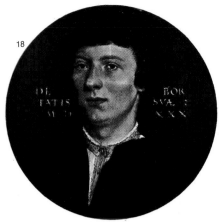

HOLBEIN THE YOUNGER Derich Born

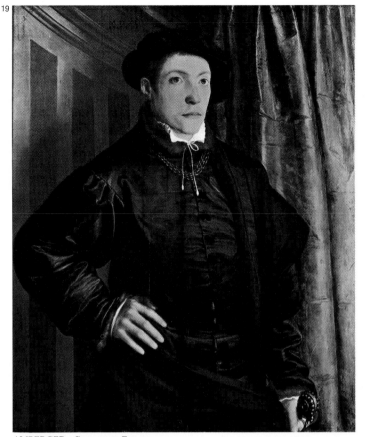

AMBERGER Christoph Fugger

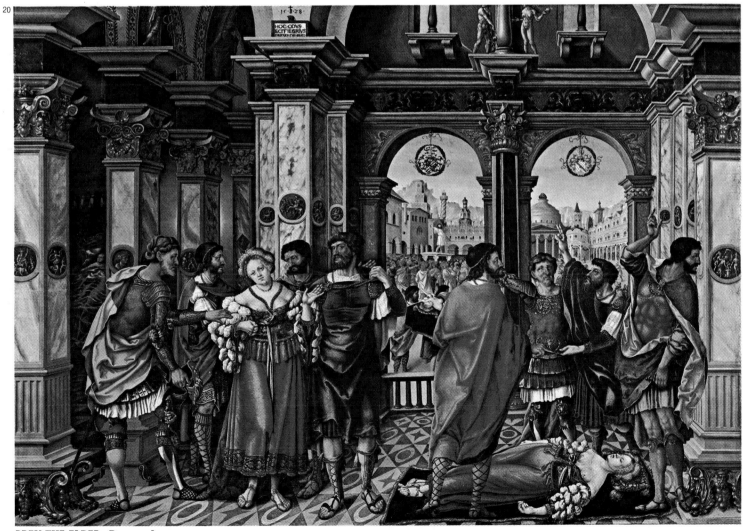

BREU THE ELDER Death of Lucretia

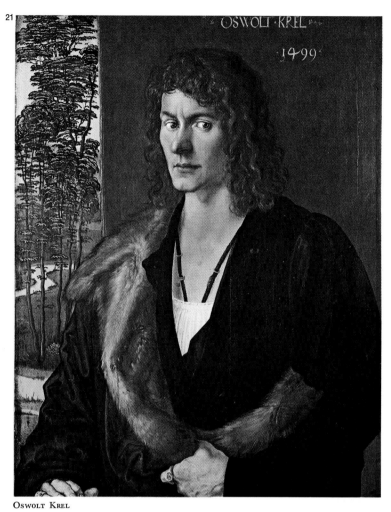

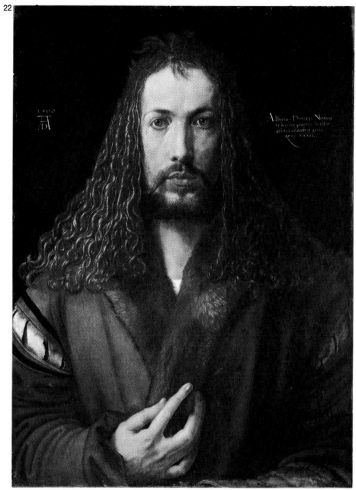

OSWOLT KREL

SELF-PORTRAIT

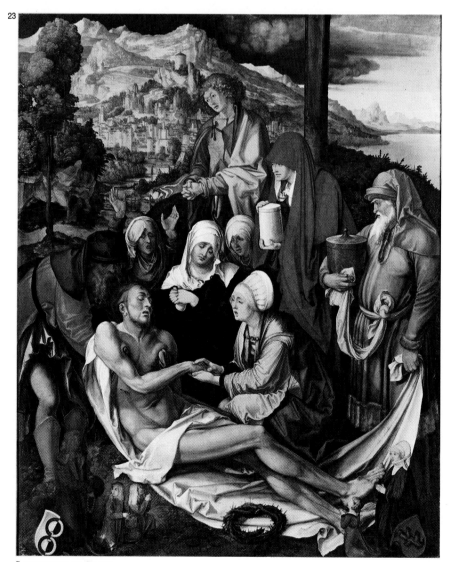

LAMENTATION OF CHRIST

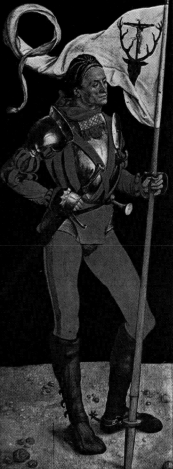

THE PAUMGARTNER TRIPTYCH

DÜRER

21 – 22. Albrecht Dürer is the greatest German painter of the early 16th century. Through his work as painter, engraver, and draftsman, he brought the contribution of the Italian Renaissance, known at first hand by the artist in the course of two journeys in Italy, to German painting. This is particularly evident in the portraits, like that of *Oswolt Krel*, which the artist executed in 1499, a little after his first Italian journey. This is characterized by the extreme expressive intensity with which the nervous and sinister character of the sitter, a member of an important Swabian family, is rendered. The splendid *Self-Portrait* of 1500, in its full-face hieratical pose, is clearly inspired by the representations of the "Salvator Mundi," and almost symbolizes the derivation of the artist's creative power from that of the Divine.

23 – 25. The *Lamentation of Christ*, painted in 1500 by Dürer, for the family of the goldsmith Glimm, is portrayed with the emblems of the Crucifixion in the lower part of the picture. A landscape, northern in character, can be seen above the pyramid of the figures, which are solidly constructed and inspired, in their violent expression of suffering, by a dramatic religious feeling. Of a much more peaceful and calm character is the composition of the triptych carried out for the Paumgartner family. The donors are shown as tiny figures in the central *Nativity* scene and dressed as *St. George* and *St. Eustace* in the side panels, where the anatomy and proportion of the figures show Renaissance influence. In the *Four Apostles* of 1526 the Master arrives at an imposing monumentality of figure construction while preserving, in the facial expression, a feeling more in keeping with the tradition of German painting.

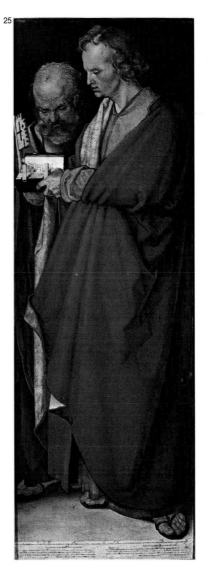

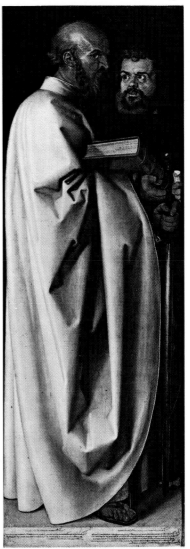

FOUR APOSTLES

ALTDORFER

26 – 27. Albrecht Altdorfer, a native of Regenaburg, was the initiator of the Danubian School of landscape painters. His first artistic experience as a graphic artist and miniaturist was gained under the influence of the engravings of Dürer and the works of Cranach the Elder. His achievement was the series of works in which the prime element is the imaginary and minutely detailed landscape which, in the work of the other masters of the early 16th century, had the modest function of serving as an accompaniment to the main subject. Even the Biblical subject of *Susanna Bathing* is worked out in a landscape of sumptuously decorative architecture set in a vast space filled with trees, fields, and distant hills and sky, in which the light can almost be felt. The great *Victory of Alexander*, which belongs to the series of historical paintings carried out by various artists for Wilhelm IV of Bavaria, constitutes a happy synthesis of those characteristics of the work of the Master, from the miniaturistic rendering of the two armies, the encampment, and the city with its many towers in the background, to that of the water, the hills, and the dense rays of light.

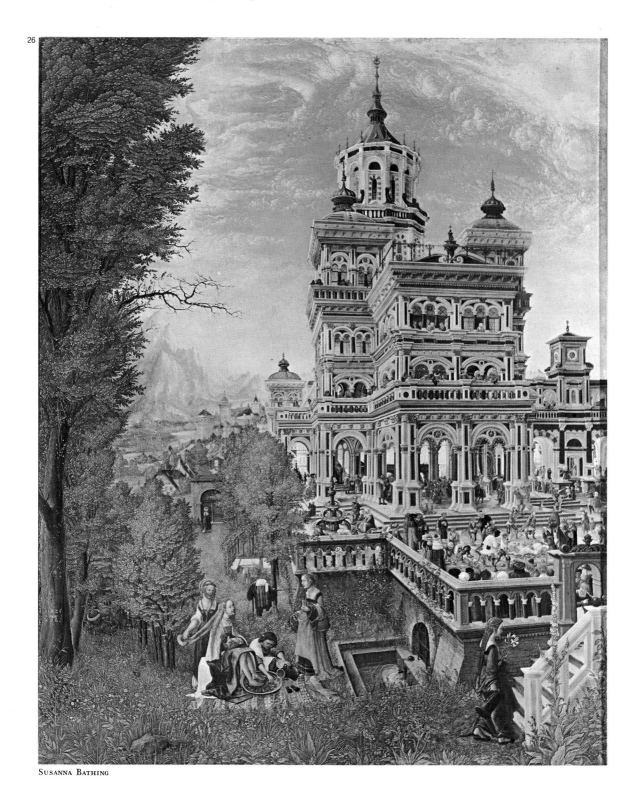

26

Susanna Bathing

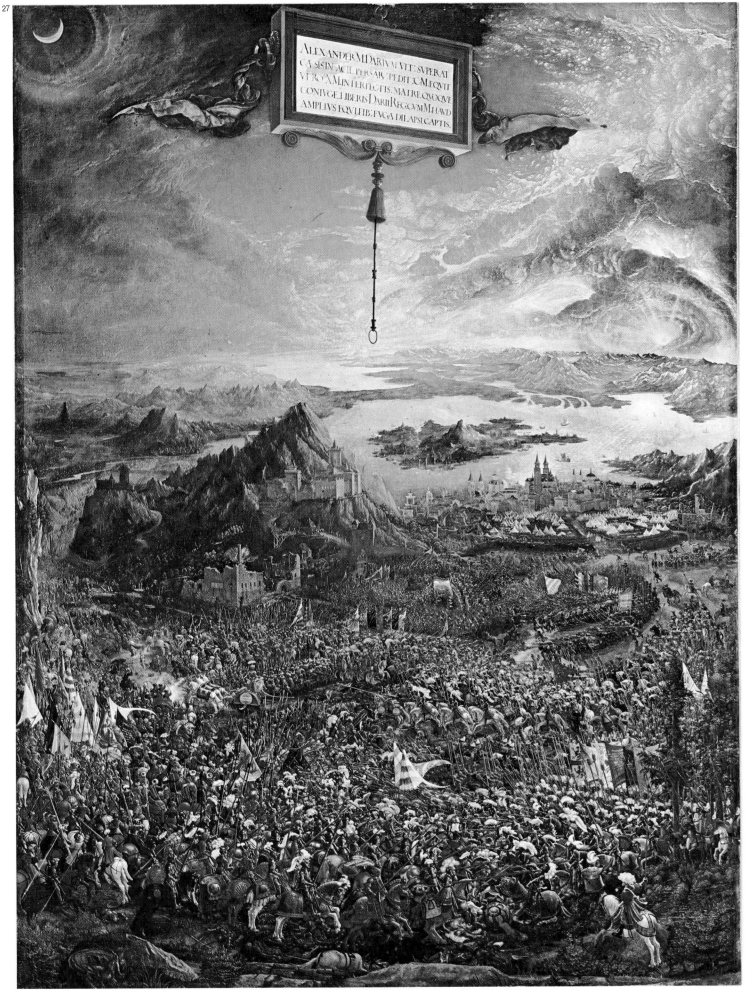

ALEXANDER M DARIVM VTE SVPERAT
CA SIS IN ACIE PERSAR PEDIT CM EQVIT
VERO X M INTERFECTIS MATRE QVOQVE
CONIVGE LIBERIS DARII REGCVM M HAVD
AMPLIVS EQVITIB FVGA DILAPSI CAPTIS

VICTORY OF ALEXANDER THE GREAT

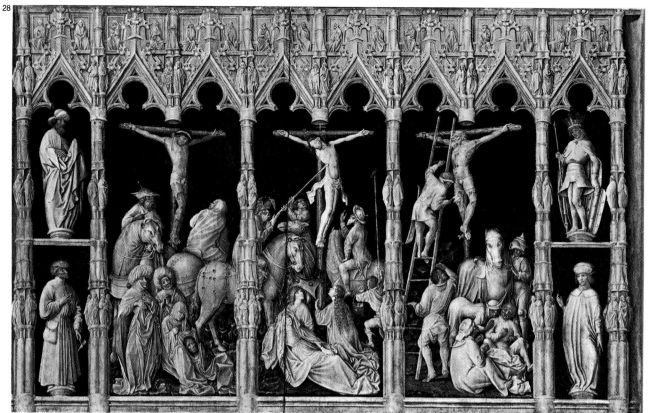

MASTER OF THE TABULA MAGNA OF TEGERNSEE CALVARY

REICHLICH STORIES FROM THE LIFE OF THE VIRGIN

28 – 32. On this page and the following are shown works by German Masters from the 15th to the 16th century. The *Calvary* by an unknown Bavarian artist of about the middle of the 15th century achieves dramatic effects reminiscent of miracle plays by means of the judicious placing of the groups of figures in grisaille, which emerge solidly from the background. To a slightly later period belongs the *Stories from the life of the Virgin*, part of an altarpiece which has now been dismembered. It is the work of Marx **Reichlich**, who worked mainly in Salzburg, as did Rueland **Frueauf** the Elder, painter of the *Christ crowned with Thorns* on the following page. The portrait of the *Duchess Maria Jacoba*, wife of Wilhelm IV, is by Hans **Wertinger**, who worked in Bavaria in the early years of the 16th century. The *Altarpiece of the Fathers of the Church* is by Michael **Pacher**, a well-known Tyrolean painter of the second half of the century. The figures are shown in late Gothic niches, viewed from an angle which relates the work to Italian painting, particularly the works of Mantegna. Beside each are events with which each figure is linked; they are depicted in a realistic manner: St. Jerome with the lion from whose paw he removed a thorn; St. Augustine and the child who attempted to empty the sea using a spoon; St. Gregory, who saves the Roman emperor Trajan from the flames; and finally the child in the cradle who recalled an episode linked to the election of St. Ambrose as Bishop of Milan.

PACHER ALTARPIECE OF THE FATHERS OF THE CHU

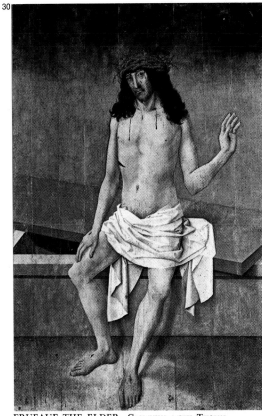

FRUEAUF THE ELDER Crowning with Thorns

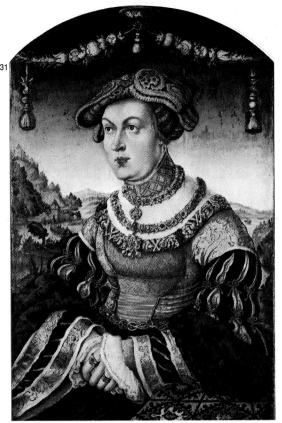

WERTINGER Portrait of the Duchess Maria Jacoba

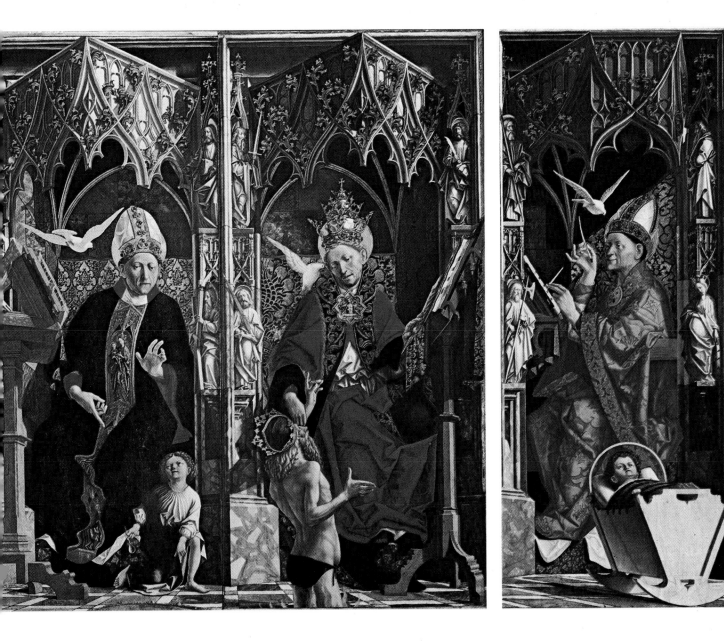

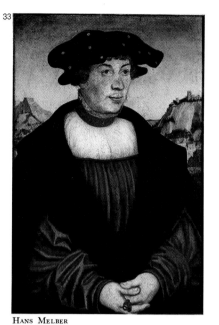

HANS MELBER

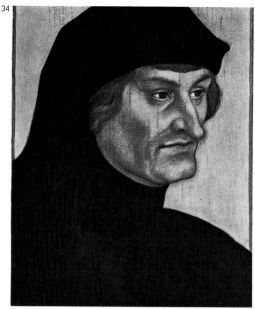

GEILER VON KAYSERSBERG

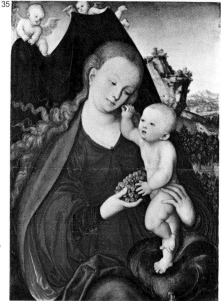

VIRGIN AND CHILD

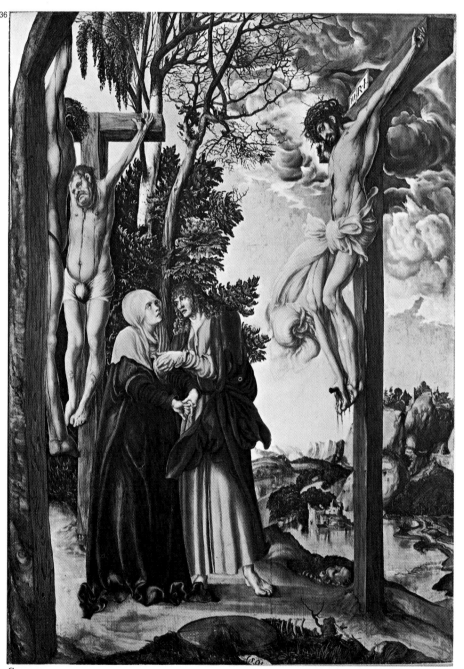

CRUCIFIXION

CRANACH

33 – 37. Lucas Cranach the Elder was a contemporary of Dürer's, with whom he shared the fame as a great master at the beginning of the 16th century. His vast output, resulting from his direction of a large workshop with many assistants, spans the first half of the century. He was active in the Imperial Court at Vienna, where he painted numerous portraits. He adopted an original compositional treatment, as in the portraits of *Hans Melber*, where the sitter is shown against a landscape background. The posthumous portrait of the Strasbourg preacher and humanist *Geiler von Kaysersberg* is typical of his later production, where he expresses himself in nervous lines and severe colors. This can probably be related to the Lutheran environment and the spirit of the Reformation. In this period there are a number of portraits of Luther, who was a friend of the artist. The *Virgin and Child* reflects a more idealized treatment, which shows that even Cranach at times was influenced, probably through Dürer, by a suggestion of Italian Humanism. The distant landscape on the right will form the basis of the art of Altdorfer and the Danubian School of painters. In the *Crucifixion*, one of his most significant works, a dramatically incisive force invests the landscape and the monumental figures which are disposed in a manner which is totally new with respect to the accepted traditional treatment of this sacred theme. *The Golden Age*, with its Germanic nudes, shows how the elements of Italian culture remained episodic in the work of this master.

38. The *Portrait of a Lady* is by Lucas Cranach the Younger, the most active of the sons in the paternal workshop and the only recognizable hand in the circle of his assistants.

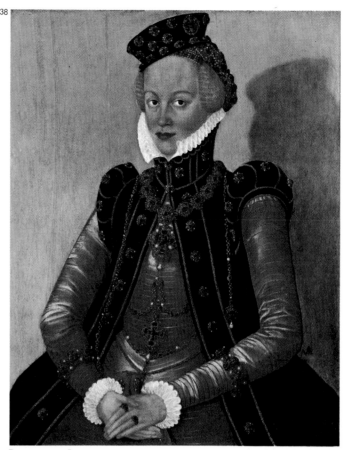

Portrait of a Lady

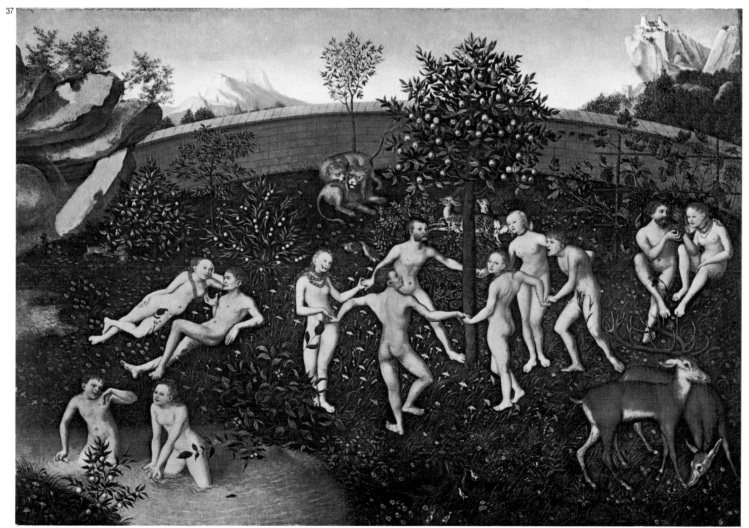

The Golden Age

ELSHEIMER FLIGHT INTO EGYPT

39. Adam **Elsheimer** of Frankfurt travelled in Italy and his experience, particularly in Rome, formed the basis of a new treatment of landscape painting where the naturalistic appearance is invested with a new force by the treatment of light. This is shown in the *Flight into Egypt*, painted in Rome in 1609.

40. Hans von **Aachen** of Cologne, active in the years between the 16th and 17th centuries, was attached to the Court at Prague where he adopted, as a basis of his art, the Mannerism which in the *Triumph of Truth* is evident in the angle from which the subject is viewed and in the serpentine form of the female nude.

AACHEN TRIUMPH OF TRUTH

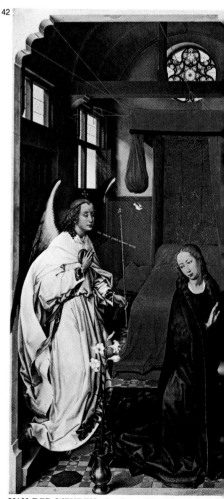

VAN DER WEYDEN ST. LUKE PAINTING THE VIRG

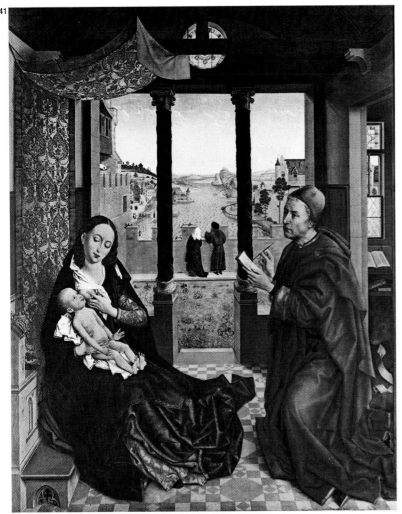

VAN DER WEYDEN Triptych of the Adoration of the Kings

FLEMISH AND DUTCH MASTERS

41 – 42. Together with Jan van Eyck, Rogier **van der Weyden**, born in Tournai in 1399, is one of the founders of the School of Painting in the Low Countries. His *St. Luke Painting the Virgin* owes its inspiration to a work of van Eyck, the *Virgin of Chancellor Bolin*, whose balanced placing of figures and architecture van der Weyden maintains, while letting the minutely observed landscape recede gradually in depth. The *Triptych of the Adoration of the Kings* was painted for the Chapel of Saint Colomba in Cologne after his journey to Italy in the middle of the 15th century. The treatment of the composition seems even more solid, but in the very clear light and in the wealth of detail in the setting, the basic elements of Flemish painting are stated.

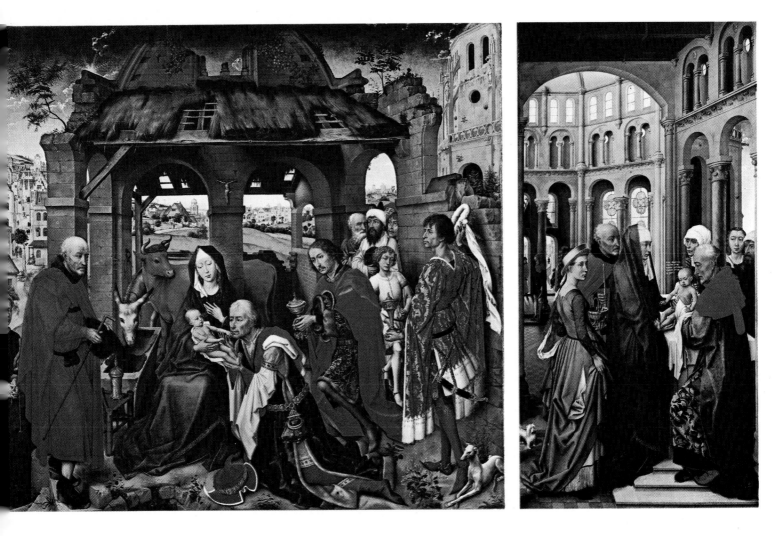

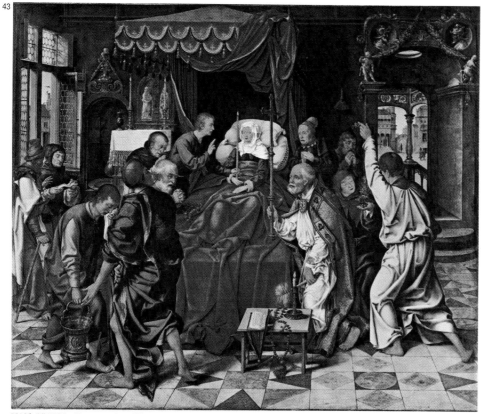

VAN CLEVE Death of the Virgin

MEMLING St. John the Baptist

43 – 45. Joos **van Cleve** was active in Italy, France, England, and Antwerp during the first half of the 15th century. The *Death of the Virgin*, the central panel of an altarpiece painted for the Hackeney family of Cologne, reveals the eclectic nature of his cultural formation. Hans **Memling** was a pupil in the workshop of van der Weyden in Brussels, and his output, based on that of his master, lasts until the end of the 15th century. Solidity in the construction of the figures and a Flemish analysis of the landscape characterize the *St. John the Baptist*, which formed part of a diptych. More interesting and typical of Memling, who will repeat the compositional treatment over and over again, is the work titled *The Seven Joys of the Virgin*, in which are shown a number of episodes in the life of the Virgin and Christ in an enchanting detailed landscape pervaded by a very clear light.

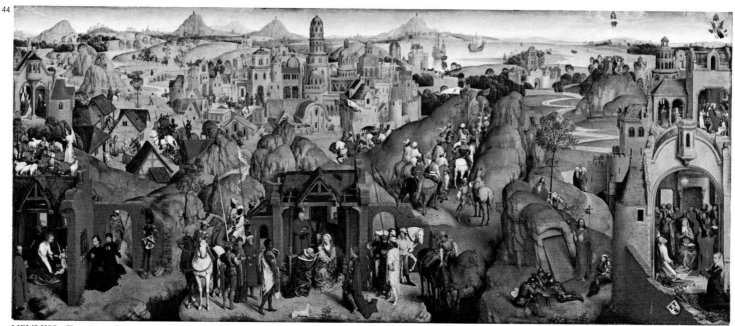

MEMLING The Seven Joys of the Virgin

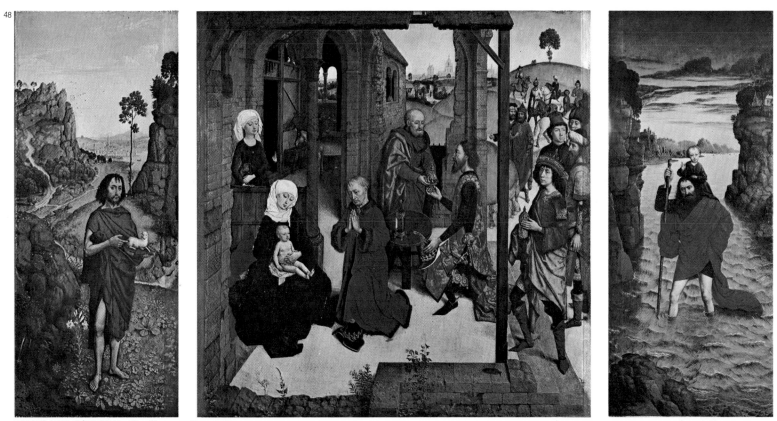

BOUTS THE YOUNGER . The Pearl of Brabant

46 – 48. Dieric **Bouts** the Elder of Haarlem was also a pupil of van der Weyden and painter of two panels showing the *Betrayal of Christ* and the *Resurrection*, both painted around 1460. His work was particularly renowned in Louvain where he directed a flourishing art business. His son, Dieric **Bouts** the Younger succeeded him in the direction of the business and maintained the style of his father. His most celebrated work is the *Altarpiece of the Adoration of the Kings*, the so-called *Pearl of Brabant*, because of the clarity of its construction and, above all, for the extraordinary vivacity of its colors.

BOUTS THE ELDER The Betrayal of Christ

BOUTS THE ELDER The Resurrection

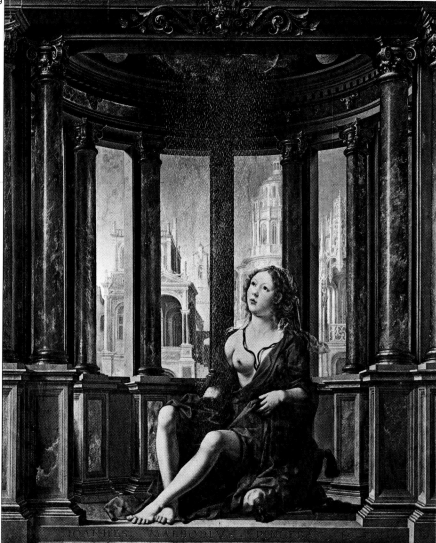

GOSSAERT Danae

VAN DER GOES Virgin and Child with an Angel

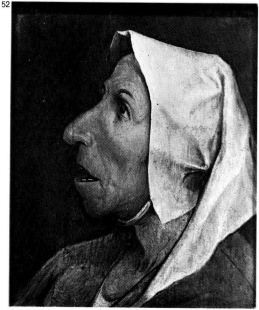

P. BRUEGEL THE ELDER Head of an Old Peasant Woman

49 – 53. Jan **Gossaert**, called Mabuse, a Flemish Master of whom there seems to be no documentary evidence, painted the *Danae* in 1527. It is an extraordinary work because of its architectural layout and a refinement of color which appears almost monochromatic. The *Virgin and Child* of Hugo **van der Goes**, who was active in Gand in the second half of the 15th century, is more directly connected to the art of van der Weyden and Hans Memling. Marinus **van Roymerswaele**, who was active in Seeland in the early 16th century, was the painter of the *Notary*. It is a good example of a subject he was to take up on other occasions, always treating it with a subtle humor. There exist many copies. Pieter **Bruegel** the Elder, one of the greatest Flemish masters of the 16th century, reached his personal style starting from the work of Hieronymus Bosch. His happiest and most prolific period was between 1550 and 1569, the year of his death. The *Head of an old woman*, characterized by a pitiful and worried expression, is reminiscent of the work of Bosch. His output consists mainly of landscapes and narrative works of a satirical and moralistic character which are not always easy to understand but which made him famous, such as *Land of Cockayne*. This shows a very much simplified layout, compared to similar works, but it is full of interesting detail: pancakes grow on the roof and laden tables are set on trees; a soldier, a peasant, and a cleric lie on the ground, sated, while an egg runs towards them to be eaten; a roast chicken lays itself on a plate and a roast piglet runs around with a carving knife in its back.

51

VAN ROYMERSWAELE Notary

53

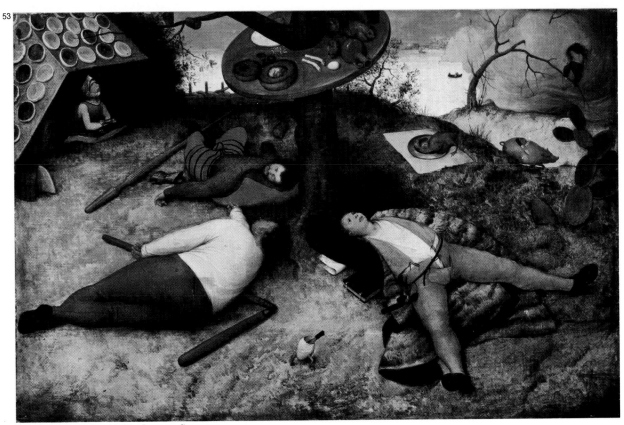

P. BRUEGEL THE ELDER Land of Cockayne

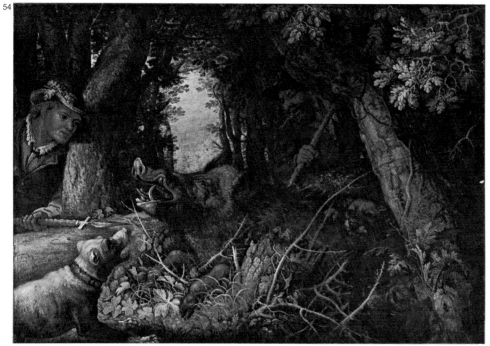

54

SAVERY Boar Hunt

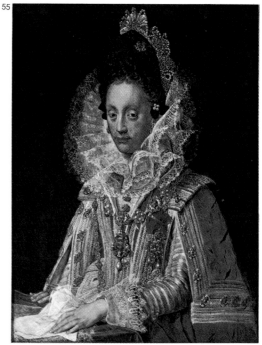

55

CANDID Magdalene, Duchess of Bavaria

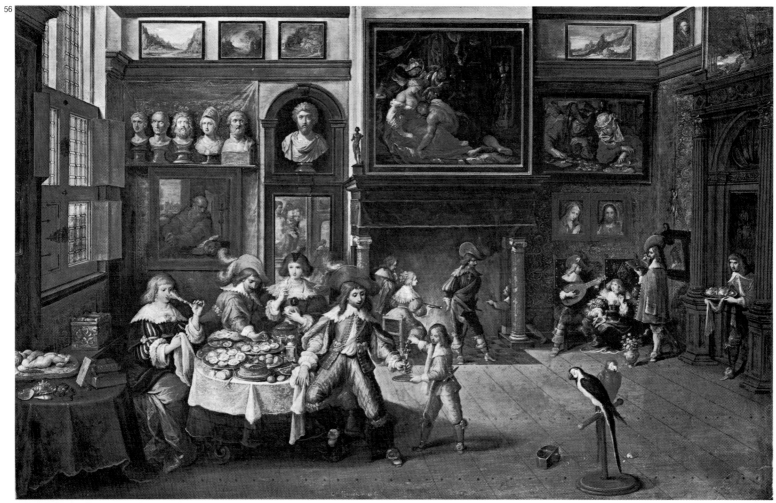

56

FRANCKEN II Banquet in the House of Burgomaster Rockox

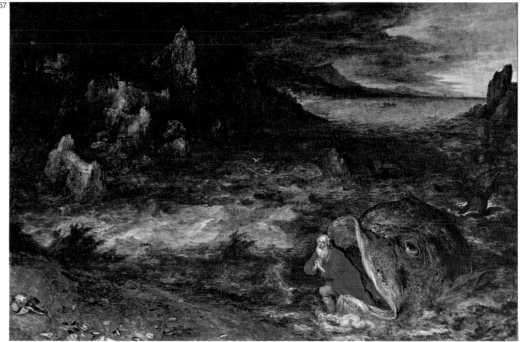

J. BRUEGHEL THE ELDER Jonah Leaving the Whale

54–56. Some of the favorite subjects of Flemish and Dutch painting in the 17th century are landscapes treated in a modern manner, as in the *Boar Hunt* by Roeland **Savery**; portraiture, which in the work of Pieter de Witte, called **Candid**, reflects an almost exclusive attention to costume; and interiors, filled with every possible curiosity and furniture, as in the *Banquet in the House of Burgomaster Rockox* by Frans **Francken II**, where the happy convivial reunion and the musicians could have allegorical overtones.

57–58. Jan **Brueghel** the Elder, son of Pieter Bruegel, turned out a vast number of works whose main subjects were landscapes and flowers. His landscapes at times contain Biblical or religious references – see *Jonah Leaving the Whale* and *Seaport with Christ Preaching* – compositions in which colors and their luminosity create a joyful effect which earned for him the name of Velvet Brueghel. Many European countries sought his works and he often collaborated with Rubens and other contemporary artists.

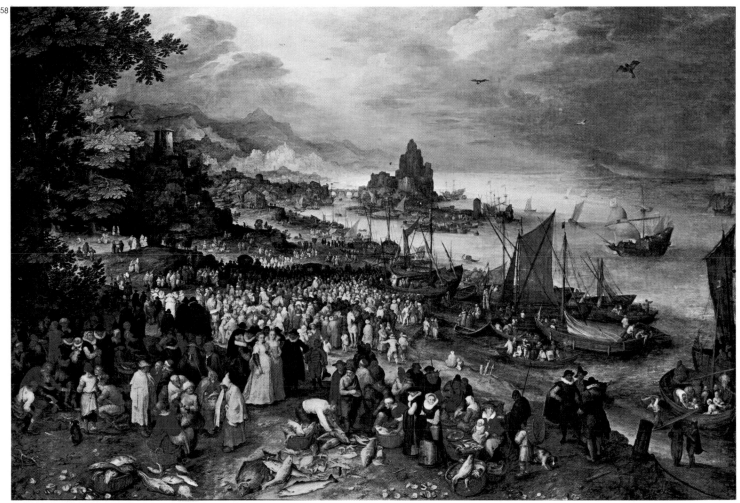

J. BRUEGHEL THE ELDER Seaport with Christ Preaching

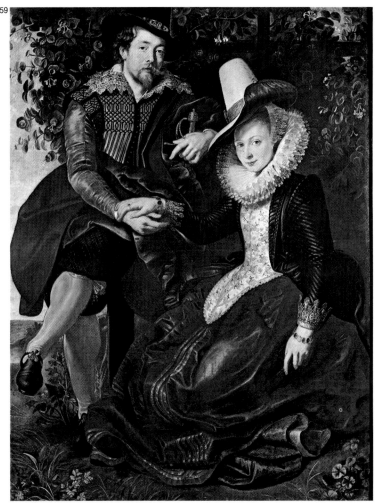

SELF-PORTRAIT WITH ISABELLA BRANT

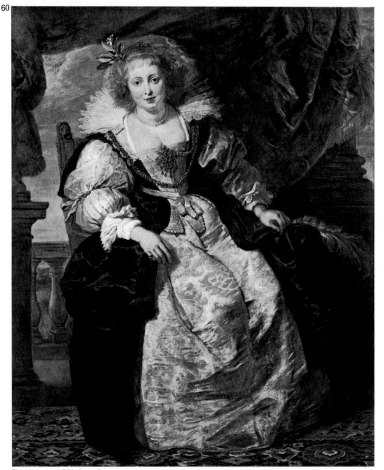

PORTRAIT OF HÉLÈNE FOURMENT

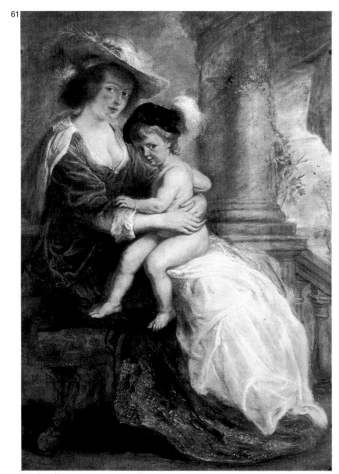

HÉLÈNE FOURMENT AND HER FIRSTBORN

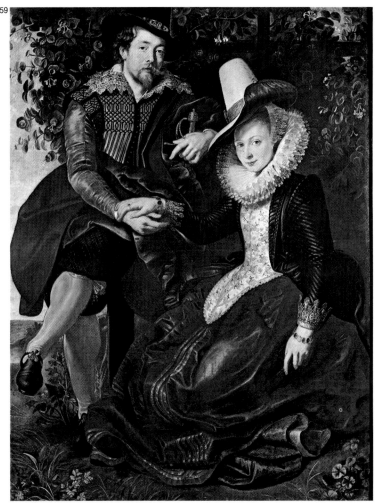

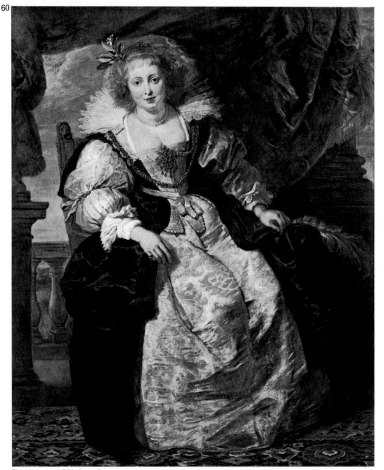

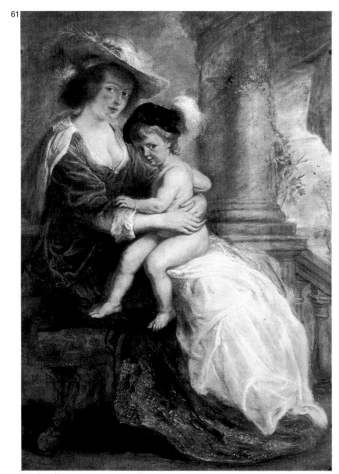

38

RUBENS

59 – 62. Peter Paul Rubens went from Flanders to Italy at the beginning of the 17th century. He brought to Italian painting of the time two fundamental elements of northern painting – portraiture and landscape; he, in turn, gained ideas and experience which are reflected in his later work. In his *Self-Portrait with Isabella Brant*, possibly painted in the same year they were married, 1609, a clearly northern character is imprinted in the calm atmosphere. The figures and the symbolic honeysuckle bower are united in a naturalistic rendering rich in details and colors. Through his successive stays in Italy and his experience with the great Venetian paintings of the 16th century, Rubens arrived at a mature synthesis of Baroque art. In the portrait of his second wife *Hélène Fourment*, whom he married in 1630, and in that of her and his son, the figures and background have a more vital impact, achieved through a brush which seems laden with light and color. Soon the master became the official painter to the courts of Europe, due to his mastery in the treatment of Biblical, mythological and historical subjects as large, animated theatrical scenes. The *Rape of the Daughters of Leucippus* (c. 1617), depicting the mythological episode of the rape of the two maids by Castor and Pollux, is a well-known example of his capacity to give a

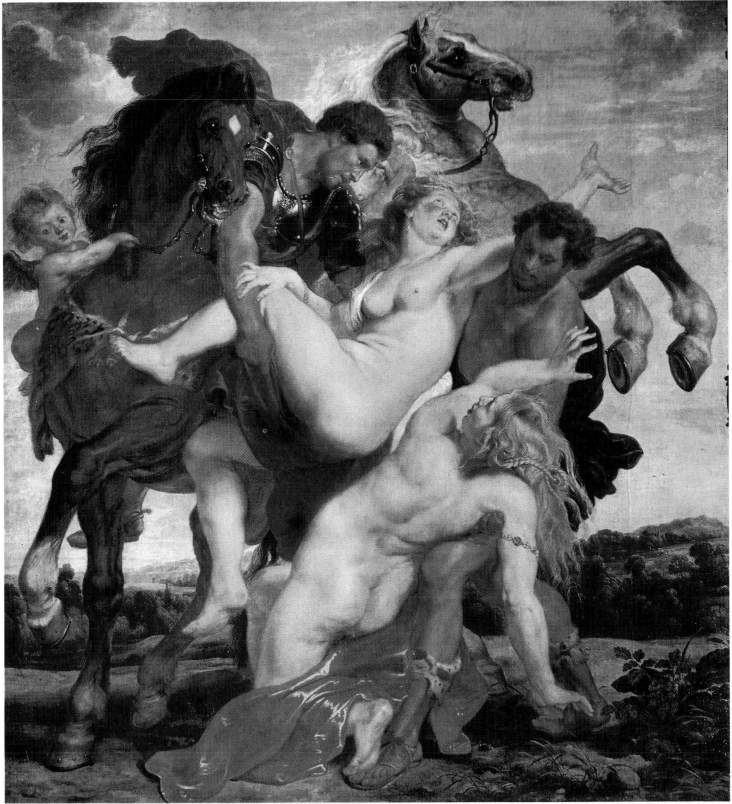

RAPE OF THE DAUGHTERS OF LEUCIPPUS

heroic quality to both figures and setting and to create a generous harmony of movement and gesture. Typical of the art of Rubens are the female nudes which seem formed by pictorial matter composed of light and color which the artist obtained by applying flesh colors over diagonal areas of charcoal and gum laid on a gesso ground, a traditional Italian technique. This attention to technical problems is typical of the Baroque culture of which Rubens was one of the greatest exponents. Another aspect of his "Baroque" personality was the great demand, in the courts of Europe, for his services as a man of culture and a diplomat as well as an artist.

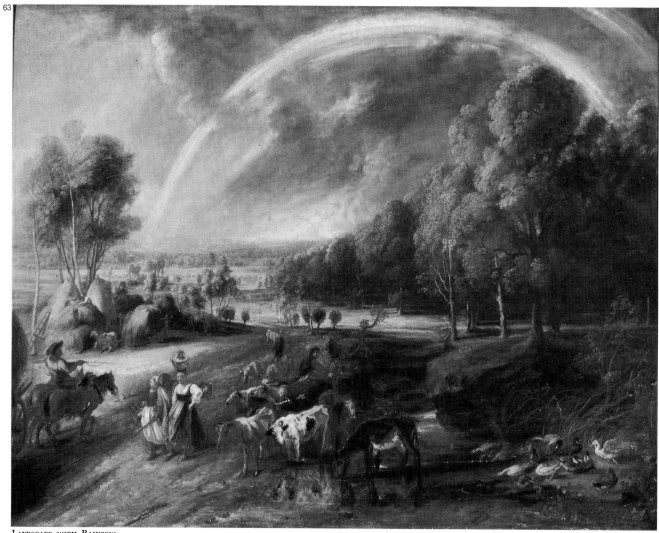

40

LANDSCAPE WITH RAINBOW

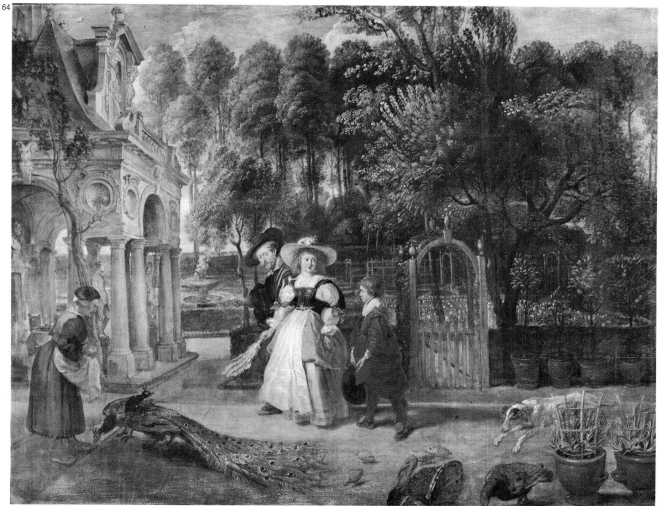

RUBENS AND HÉLÈNE FOURMENT IN THEIR GARDEN

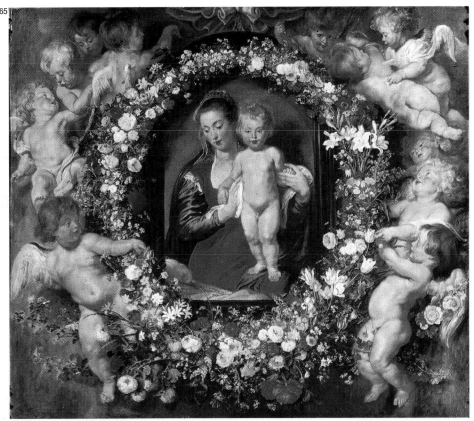

VIRGIN IN A GARLAND OF FLOWERS

63 – 66. In the intervals between his journeys and constant moving to fulfill great official commissions, **Rubens** returned to his native country where in his last period he had set up a house not far from Antwerp. It was here that the master was able to return to his old subject of landscape, treating it as the main element in a picture and depriving it of all heroic motives. At times he availed himself of the help of his friend Jan Brueghel the Elder. The *Landscape with Rainbow* and the domestic scene where the artist portrays himself accompanying his new wife, Hélène Fourment, into their home, take place in real surroundings, probably part of his own property. The *Virgin in a Garland of Flowers*, a characteristically Flemish work, is one of the works he produced with the help of Jan Brueghel. The *Reception of the Princess at Marseilles* belongs to a complete series of preparatory sketches – painted in oil, according to a traditional Venetian method – for the paintings of the cycle ordered by Marie de' Medici, between 1622-25, for the decoration of the Palace of Luxemburg in Paris.

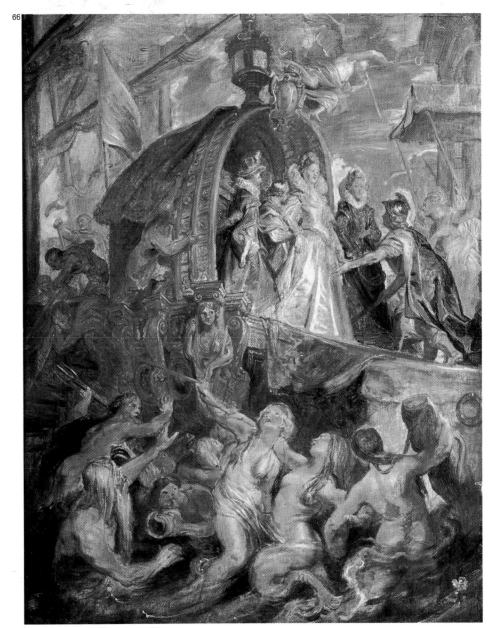

RECEPTION OF THE PRINCESS AT MARSEILLES

VAN DYCK SELF-PORTRAIT AS A YOUNG MAN

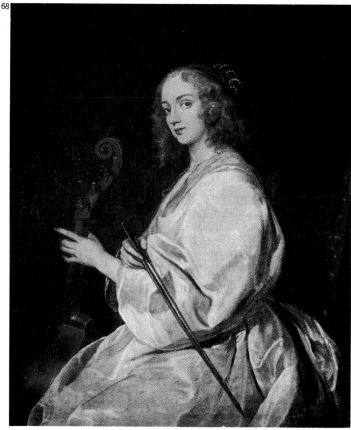

VAN DYCK LADY PLAYING A VIOL

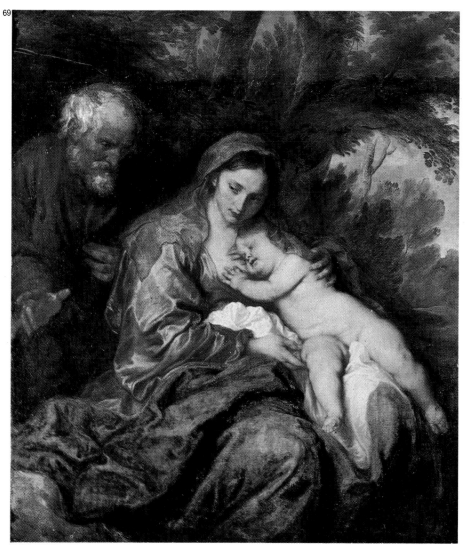

VAN DYCK REST ON THE FLIGHT INTO EGYPT

67 – 69. Anthonis **van Dyck** formed his style on that of Rubens, since he was also linked to the city of Antwerp, where both artists had worked on the same projects some years before 1620. The *Self-Portrait* was painted around 1621 by van Dyck, who, following in Rubens' footsteps, went to Italy where he became official portrait painter to the great Genoese families. Portraiture suited him best and to this he owed his fame, even more so when he went to England. The *Lady Playing a Viol*, a subject which he treated with supreme grace in a subtle compositional equilibrium, happily sums up the very human and scholarly character of his art, while the *Rest on the Flight into Egypt* of around 1627 betrays Rubens' unmistakable flavor.

70 – 71. Among Flanders' "little masters" of the 17th century, Adriaen **Brouwer** represents those who specialized in genre scenes, most often of tavern interiors. This brings to mind the influence of the much greater Frans Hals, with whom Brouwer became acquainted during a youthful stay in Holland. Another interior, based on realistic observation, is seen in the *Satyr with Peasants* by Jacob **Jordaens** of Antwerp, characterized by the surprising introduction of the mythological figure of the satyr.

BROUWER TWO QUARRELLING PEASANTS

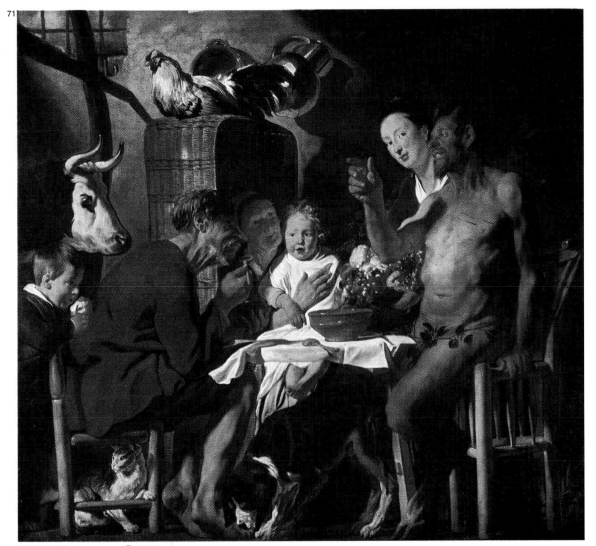

JORDAENS SATYR WITH PEASANTS

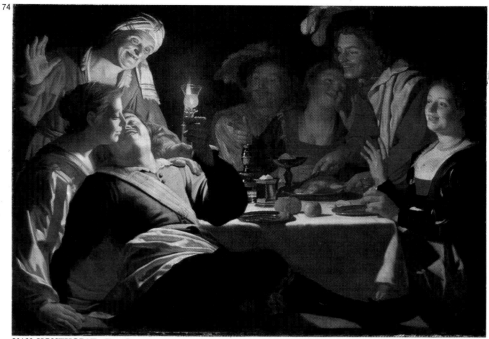

VAN HONTHORST The Prodigal Son

HALS Portrait of a Man

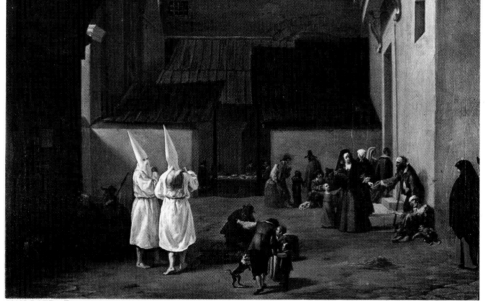

VAN LAER Flagellantes

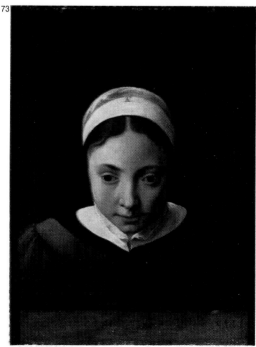

POELENBURGH Portrait of a Little Girl

72–79. Some of the many different aspects of Dutch painting are here illustrated. Portraiture is represented by the masterful rendering of the person, perhaps identifiable as *Willem Croes*, by Frans **Hals**, one of the greatest Dutch masters of the time; and the calm image of a *Young Girl* by Cornelis **Poelenburgh**, a painter from Utrecht. Genre painting is represented by the typical Dutch interior of *The Prodigal Son* by Gerrit **van Honthorst**, who was called "Gerard of the Night" in Italy because of his use of light and shade, which corresponds with that of Caravaggio. On the facing page, the same setting is represented by Adriaen **van Ostade**, but treated in a manner more faithful to the northern style. The same kind of realism is evident in the *Flagellantes* by Pieter **van Laer**, who made a great success in Rome with this type of composition. Jan **van Goyen** and Salomon **van Ruysdael** initiate the 17th century rendering of that type of Dutch landscape where a vast expanse of sky dominates a plain open to infinity. Jacob **van Ruisdael** will confer on this vision a heroic and, at the same time, melancholic character of an unmistakable pre-romantic tone.

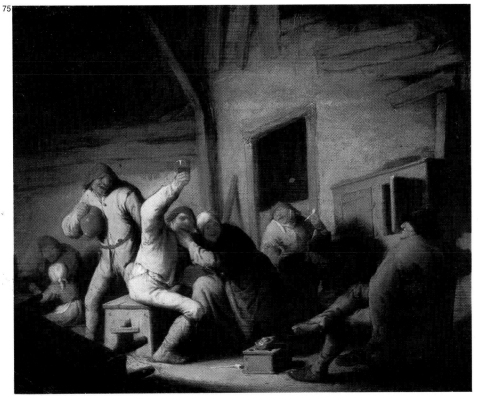

VAN OSTADE Rowdy Peasants

77

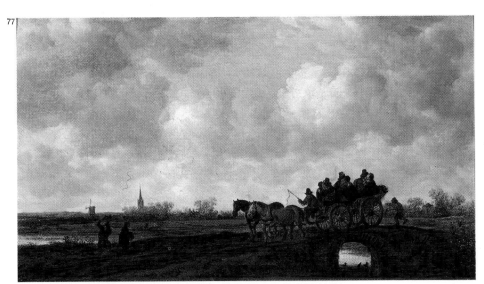

VAN GOYEN Coach and Horses on a Bridge

78

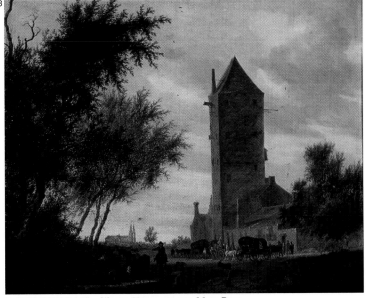

S. VAN RUYSDAEL Watch Tower on the Main Road

79

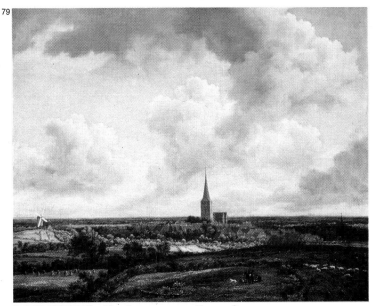

J. VAN RUISDAEL Wide Landscape with Village Church

REMBRANDT

80 – 83. The originality of the vision of Rembrandt van Rijn, the greatest master of Dutch 17th century painting, rose above the mere depiction of everyday 17th century Dutch life. Painting in the same mundane idiom, he achieved a statement of universal values which can be noted even in his youthful works. In his *Self-Portrait*, painted when he was 23, the head is modelled in the same brownish tones which he was to use as a basis for all his output. Shadow – the other characteristic element of his painting – invests the forehead and eyes and reveals the interior personality of the subject more intensely. These two elements are used in his search for psychological individuality even in paintings which are more narrative in character, such as the *Portrait of a Man in Oriental Costume*, a subject to which he returned several times. The *Holy Family* is represented in contemporary costume in a typical Dutch setting. Rembrandt's need to express religious values in terms of reality can particularly be seen in the face of the Virgin, to whom he seems to have given his own sister's likeness, a likeness he had studied in numerous portraits. The *Deposition* of 1634 – the latest of the works shown – stamped with an intense yet restrained dramatic quality, formed part of a series of five paintings dedicated to Christ's Passion. It was painted by the Master for Frederick Henry of Orange Nassau, *stadtholder* of the United Provinces.

46

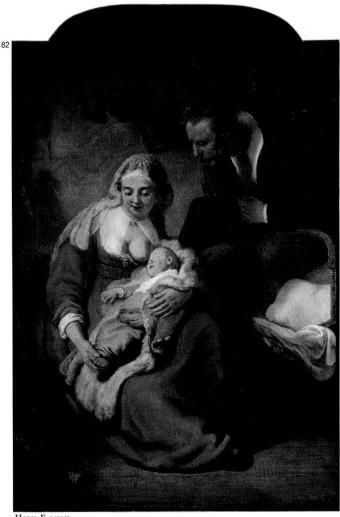

HOLY FAMILY

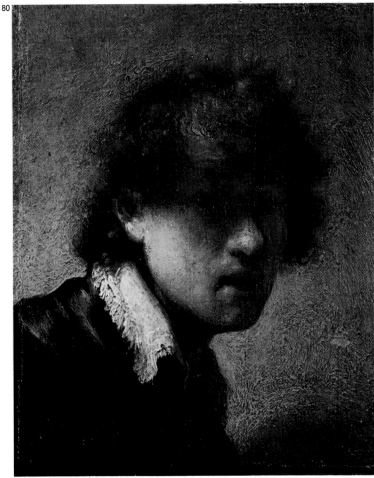

SELF-PORTRAIT

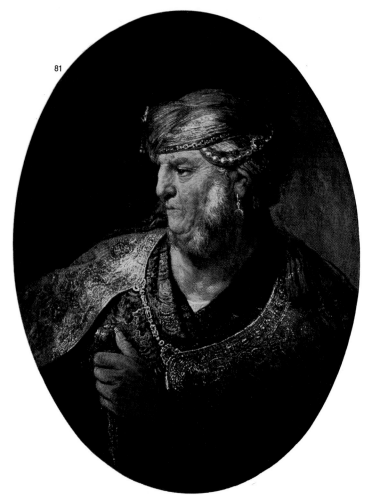

PORTRAIT OF A MAN IN ORIENTAL COSTUME

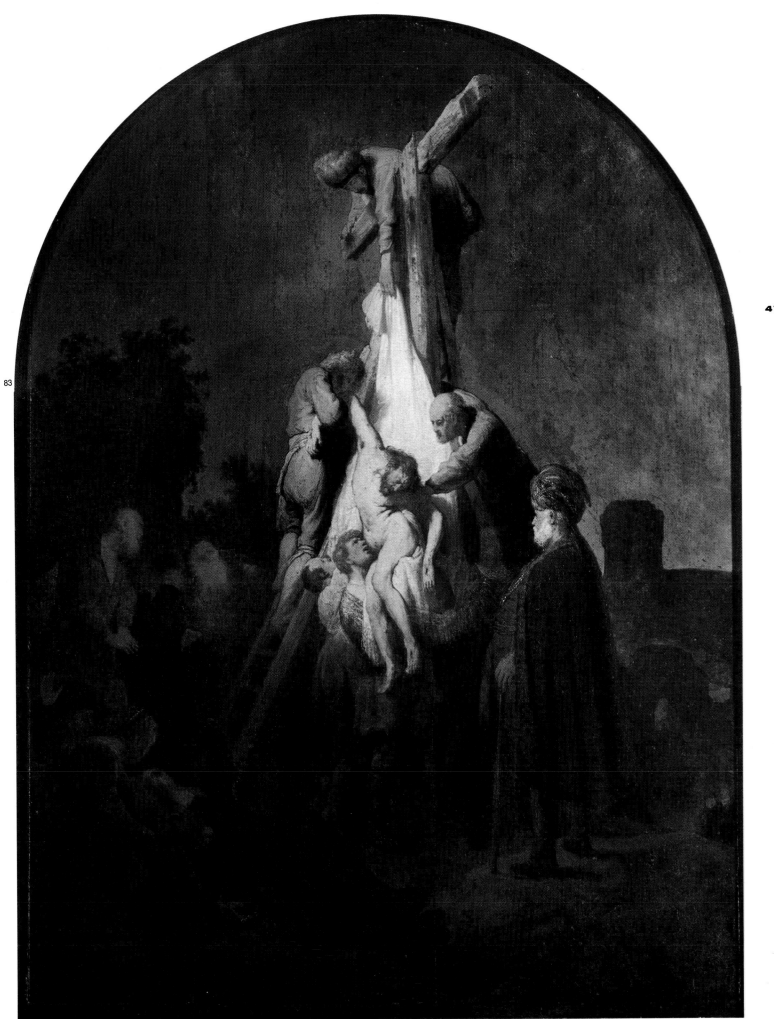

Deposition

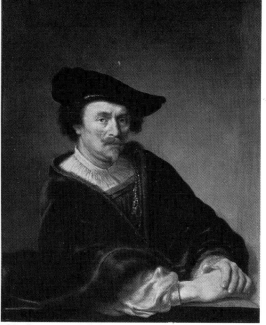

BOL Portrait of a Gentleman

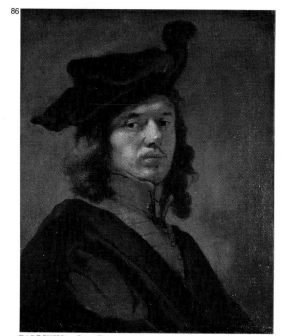

FABRITIUS Self-Portrait

84 – 86. Ferdinand **Bol** was a pupil and friend of Rembrandt. In his *Portrait of a Gentleman* and in the picture dedicated to a craft guild, he shows that he has learned the Master's lesson in the severe rendering of the subject; however, he has treated it in a more superficial and narrative manner. Carel **Fabritius** was also a pupil, and in his youth was an assistant to Rembrandt, whose style the presumed *Self-Portrait* re-echoes in the impasto of the light and in the depth of the shadows.

87 – 90. The interiors of the homes of the middle-class burghers are a frequent subject in the 17th-century Dutch painting: the *Lovesick Woman* by Jan **Steen**, a leading figure in this branch of genre, and

the *Lady at a Mirror* by Frans **van Mieris** the Elder, a native of Leyden. These two subjects which have been attempted over and over again by Dutch artists and are treated with taste and an affectionate wealth of detail in the setting and costumes. The same kind of inspiration found in a more humble subject characterizes the *Boy Picking Fleas from a Dog* by Gerard **ter Borch**, who, despite travel in Italy and all over Europe, was not estranged from genre and portrait painting perceived in the manner of contemporary Dutch painting, but without the insistence on detail. In the *Lady Reading* by Pieter **Janssens Elinga**, where light and shade appear to be the main protagonists, we approach the art of Vermeer.

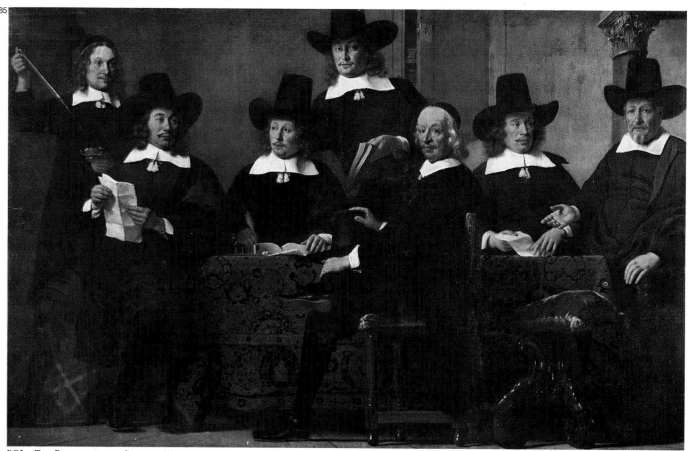

BOL The Rectors of the Guild of Wine Merchants

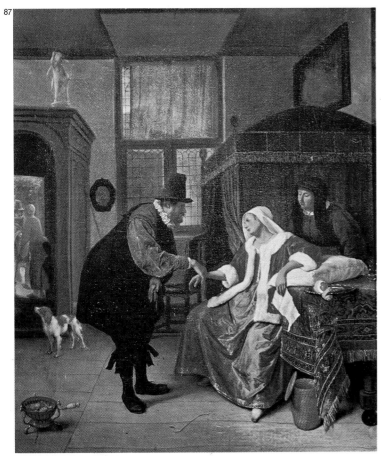

STEEN Lovesick Woman

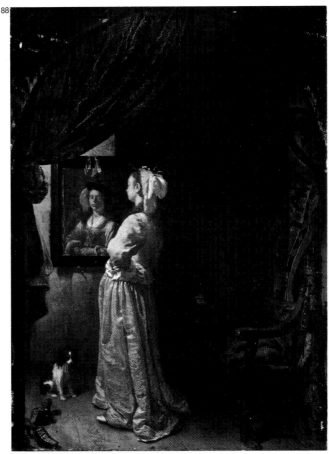

VAN MIERIS THE ELDER Lady at a Mirror

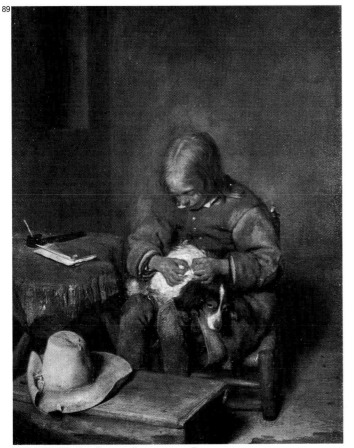

TER BORCH Boy Picking Fleas from a Dog

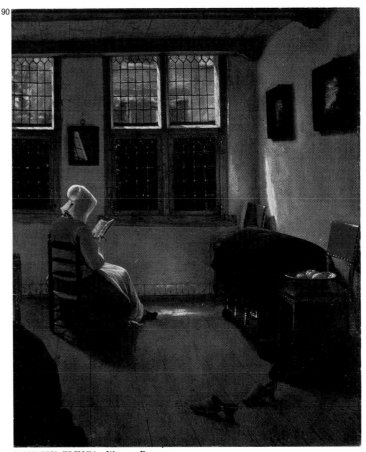

JANSSENS ELINGA Woman Reading

GIOTTO Last Supper

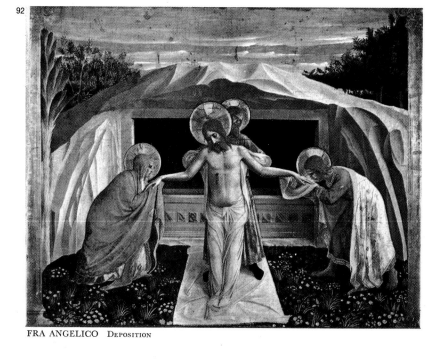

FRA ANGELICO Deposition

FRA ANGELICO Saints Cosmas and Damian before Lisias

ITALIAN MASTERS

91. In the gallery of Italian painters the *Last Supper* by **Giotto** presents a clearly constructed interior which the eye easily scans, guided by the baluster halfway up the picture. The table with its suggestions of still life is surrounded on four sides by the figures of the Apostles and Christ, whose bodies measure out the picture space. The general layout of the painting is by the Master himself, while the execution of the separate parts must be attributed to assistants (often the case in the work of Giotto). This is obvious from a study of the analogous painting in the Scrovegni Chapel in Padua.

92 – 93. Fra Giovanni da Fiesole, called **Fra Angelico**, is the painter of the *Deposition* and *Saints Cosmas and Damian before Lisias*. These are panels of an altarpiece, now dismantled, which he painted for the conventual church of San Marco in Florence. In the *Deposition* the bare mass of the mountain is still Giottesque in character, while the luminosity of the space receding into the distance belongs to the art of the Renaissance. In the other painting, the figures of the saints and their brothers are set out on a flower-covered lawn seen as the Garden of Paradise, according to a system of perspective which confirms Angelico's adherence to the artistic culture of his time.

94. **Masolino** da Panicale, a Tuscan painter of the early 15th century, treats the subject of the *Virgin and Child* in a natural and affectionate manner, a far cry from the severe medieval representations. The luminosity of the golden background, the elegance of the drapery, the Virgin's mantle, and the cushion are all elements which place him, despite his contact with the new art of Masaccio, within the sphere of the painters of the International Gothic.

95. The Florentine Filippo **Lippi** was active at the height of the 15th century. He places his *Virgin and Child* (whose ample forms show the influence of Masaccio) in a background of rugged hills, rivers and flower-strewn mountains.

96. **Piero di Cosimo** was also active in Florence between the end of the 15th century and the beginning of the 16th. Typical of him are his mythological compositions, such as the *Legend of Prometheus* (probably the lid of a dower chest or the decorated back of a bench) which relate to the cultural environment of the court of Lorenzo de' Medici. In the left, Prometheus forms the man who, in the center, receives life from the divine fire; on the right, Prometheus is seen with Minerva, with whom he later flies off.

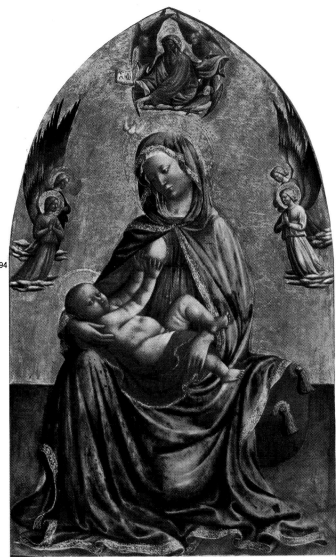

94

MASOLINO Virgin and Child

95

51

FILIPPO LIPPI Virgin and Child

96

PIERO DI COSIMO Legend of Prometheus

GHIRLANDAIO Virgin and Child with Saints

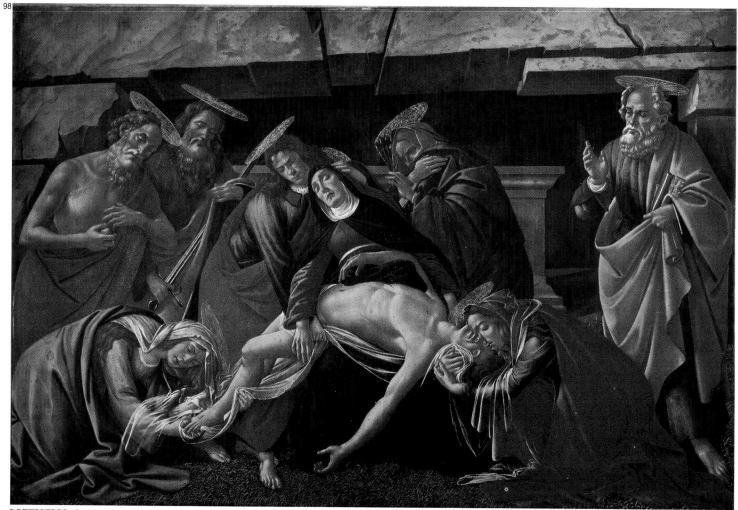

BOTTICELLI Lamentation of Christ

97. Domenico Bigordi, the Florentine artist who was called **Ghirlandaio**, painted the *Virgin and Child with Saints* in a delightful narrative, true to the Renaissance ideal of form and construction. It was the central panel of an altarpiece which his patron, Giovanni Tornabuoni, commissioned him to do for the church of Santa Maria Novella. The outer panels of the work, which was incomplete on the death of the Master, were painted by his pupils.

98. The *Lamentation of Christ* by Sandro **Botticelli** is a late work painted during the period when the voice of Savonarola had already banished the mythological and pagan vision of the great Florentine Master, and the death of Lorenzo the Magnificent had dispersed the group of artists and philosophers attached to his court. The Christian imagery to which, after 1495, Botticelli's output is almost completely dedicated, brought with it a broken, violent, and dramatic treatment which negates the light and pagan beauty of his preceding work.

99. The *Virgin of the Carnation* is a youthful work of **Leonardo** da Vinci, one of the greatest personalities in art and in human genius. He began his painting career in the workshop of Andrea del Verrocchio in the sphere of Florentine culture of the second half of the 15th century. Even in this youthful work the artist already reveals how painting for him is the expression and the culmination of a research which embraced a vast ensemble of disciplines and sciences. The figure of the Virgin is constructed of light values which anticipate the complete fusion of all the diverse elements of the atmosphere – the so called Leonardesque "Sfumato." The loggia in the background extends the limit of the traditional Florentine setting by projecting the observer beyond the foreground into a vast and primeval dimension of nature and landscape which testifies to the new scientific and pictorial awareness of Leonardo.

100. The artists of the later 15th century searched and aspired towards an ideal of harmony and absolute beauty, and Pietro Vannucci, called **Perugino**, was no exception. His version of the ideal at times degenerates into affectation, as in the *Vision of St. Bernard*, whose architectural layout and sweet wide Umbrian landscape in the background breathe the Renaissance.

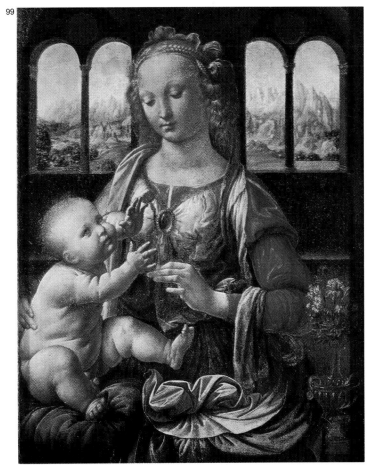

LEONARDO THE VIRGIN OF THE CARNATION

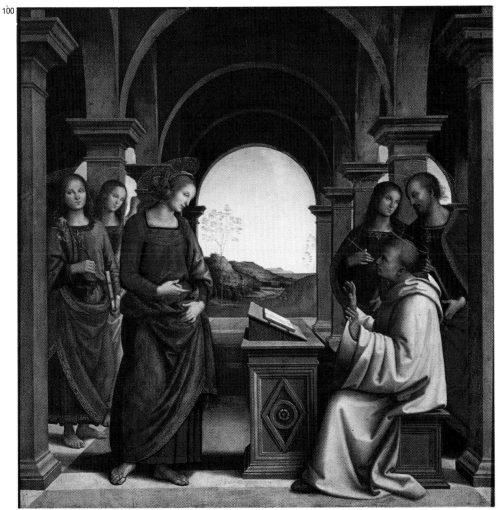

PERUGINO THE VISION OF ST. BERNARD

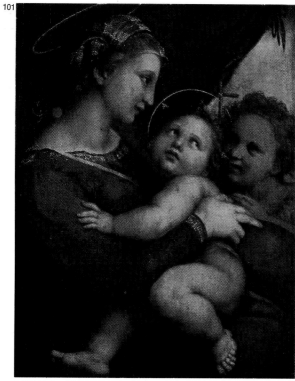

RAPHAEL Madonna della Tenda

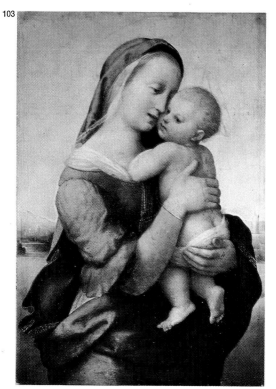

RAPHAEL Tempi Madonna

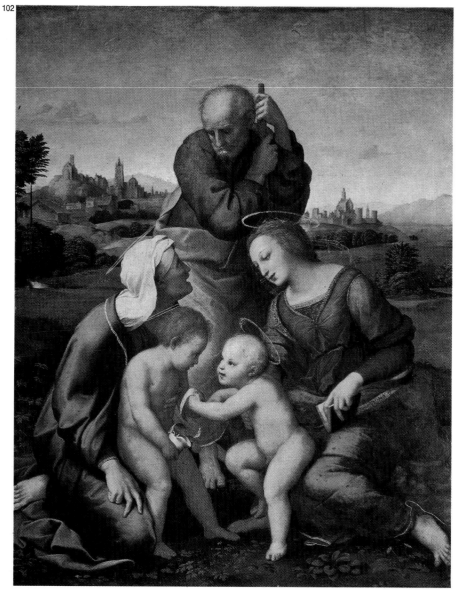

RAPHAEL Canigiani Holy Family

101 – 103. When **Raphael** Sanzio, born in Urbino and trained in the School of Perugino, arrived in Florence at the beginning of the 16th century, he found Leonardo and Michelangelo, the artists who, with himself, would form the mighty Renaissance Triumvirate, already active there. In the *Tempi Madonna* and in the *Canigiani Holy Family*, which take their names from their respective donors, and which mark Raphael's farewell to Florence on his way to Rome, we note Leonardesque elements. The pyramidal composition and the atmospheric quality of the light set an original artistic framework, where landscape and figure are harmoniously fused. In the later *Madonna della tenda*, the more weighty bulk of the Virgin and the striving robust child remind us of a period in the work of Michelangelo.

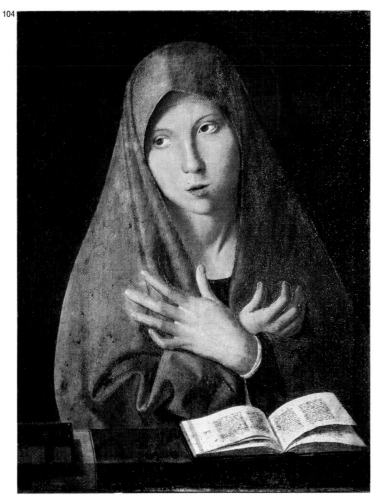

104. The *Virgin of the Annunciation* by **Antonello da Messina**, the first version of a subject he took up again later, confirms his artistic formation in the Neapolitan School and under the influence of Flemish works while in Central Italy. The culture of the Renaissance had been holding sway for some time. A casket in the left foreground and a book on the right are placed on a dangerously inclined plane. They lead our eyes to the very beautiful Virgin whose youthful face and hands vibrate with a deep vitality.

105. By the side of the great masters there existed in Venice a little backwater of culture, unexpected in Italy at the height of the Renaissance, based on Northern European influence represented here by the work of Jacopo **de' Barbari**. He was a rather mysterious painter of Venetian origin who spent a good deal of his time in Germany. He painted compositions which consisted of an amalgam of illusionism and still life, such as the hunting trophy with armor and a folded note, which, together with his signature, shows a staff of Mercury with entwined snakes, a symbol also used by the artist in his many prints.

106. The *Mystic Marriage of St. Catherine* is a youthful work of Lorenzo **Lotto** who, although born in Venice, worked away from this northern capital of the Renaissance in the first half of the 16th century. In this work, which shows Giorgionesque traits, some of the elements which characterize his particularly realistic compositions are to be noted, such as the unexpected ribbon on Saint Catherine's shoulder and the plaited hair around her head.

ANTONELLO DA MESSINA VIRGIN OF THE ANNUNCIATION

DE' BARBARI STILL LIFE

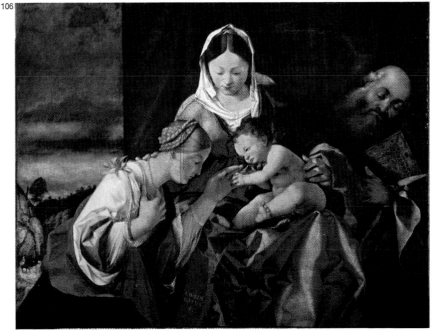

LOTTO THE MYSTIC MARRIAGE OF ST. CATHERINE

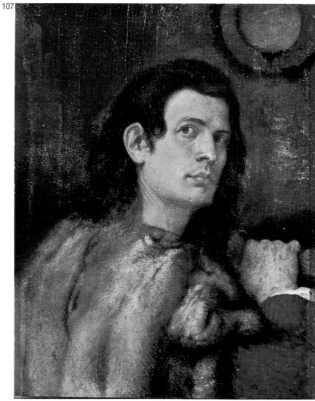

GIORGIONE PORTRAIT OF A YOUNG MAN

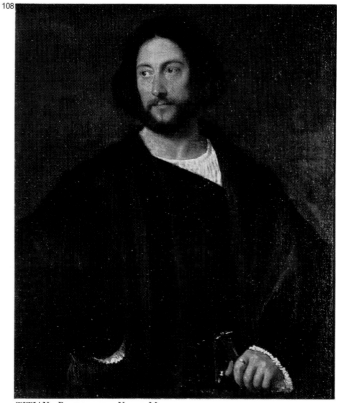

TITIAN PORTRAIT OF A YOUNG MAN

107. Giorgio da Castelfranco, better known as **Giorgione**, who, with Titian, was a pupil of Giovanni Bellini, was a decisive figure in the passage of Venetian painting from the 15th to the 16th century. The shortness of his life, together with the fascination of a personality in which musician, humanist, and painter were combined, lend the few certain facts of his life the aura of a legend. In the *Portrait of a Young Man*, painted with a nobility of style which makes us think that here the hand of Giorgione and that of the youthful Titian have come together, the determining factor is the chromatic resolution of tone values in terms of color enriched by subtle modulation of light and shade.

108 – 110. During his long life **Titian** dominated Venetian painting of the entire 16th century. He painted the *Portrait of a Young Man* and *Emperor Charles V* (who is shown before a spacious background consisting of interior and landscape) during the first half of the century, still within the ambiance of the Renaissance. The *Crowning with Thorns*, on the other hand, belongs to a later period when the calm Renaissance vision is changed to excited criss-crossing diagonals, movement, and broken patches of light which render the dramatic quality of the Mannerist crisis.

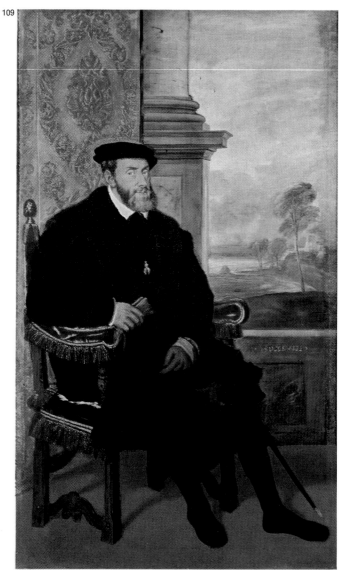

TITIAN PORTRAIT OF CHARLES V

56

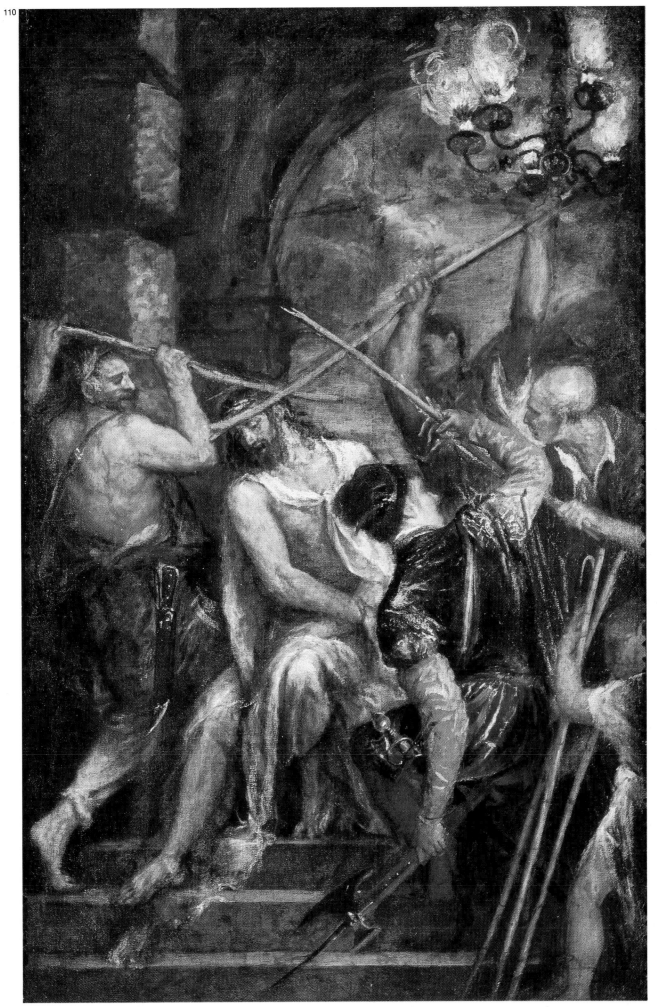

TITIAN Crowning with Thorns

GUARDI Gala Concert

TINTORETTO Christ in the House of Martha and Mary

TIEPOLO Adoration of the Kings

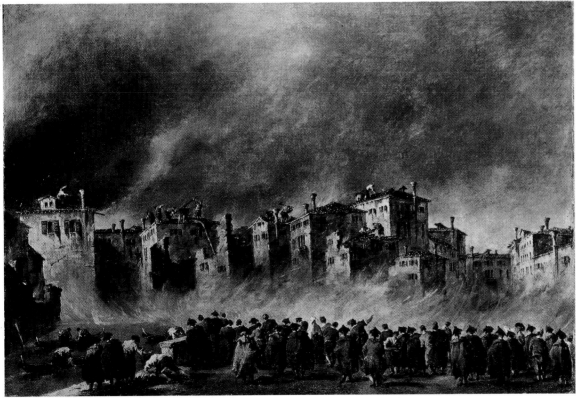

GUARDI Blaze in the San Marcuola Quarter

111 – 112. Francesco **Guardi**, who belonged to the group of painters called "Vedutisti," i.e. painters of views, was active at the height of the 18th century. His vast output consists basically of two subjects: views of the lagoon and episodes taken from Venetian life. The *Gala Concert* is one of five paintings which document the festivities organized by the Venetian Republic on the occasion of the official visit of the Russian Grand Duke Paul Petrovich and his wife in 1782. With rapid brush work the artist has sketched the vivid patches of light which are the silks and brocades, leaving figures and faces as mere patches of color. The *Blaze in the San Marcuola Quarter*, which refers to an actual happening in 1789, shows an unusual rendering of the lagoon, where Guardi treats the dramatic event in a series of broken and excited notes.

113. In *Christ in the House of Martha and Mary* Jacopo Robusti, called **Tintoretto**, the leading painter in Venice at the height of the 16th century, places the religious subject in surroundings full of action, where the contrast of light and shade shows the immediacy of the gestures.

114. Giambattista **Tiepolo**, the Venetian painter, carried the lesson of the great Renaissance Masters, particularly Tintoretto and Veronese, to the great courts of Europe. He painted the *Adoration of the Kings* for the Benedictine church in Schwarzach in 1753 while he was involved in the decoration of the Residenz in Würzburg. The religious theme is portrayed by means of an artistic device of the Master's Grand Style known as "sotto in su," that is, the subject as seen from a low point of view.

115. *Apollo Flaying Marsyas*, painted around 1630 by Guido **Reni**, is the mature version of a subject which he had already painted. This reprise accentuates the robust modelling of the nudes, which are inspired by classical statuary, within a landscape framework of 17th century flavor.

116. Alessandro **Magnasco**, called Lissandrino, worked mostly for the upper middle classes of Genoa (where he was born), Milan, and Florence at the beginning of the 18th century. His *Rocky Cove* was painted in a style consisting of detached strokes of impregnated pigment. He was to mature in the unusual composition called *Fraterie* (that is, painting of monks), which shows a new kind of landscape that was to supersede the naturalism of the 18th century.

RENI Apollo Flaying Marsyas

MAGNASCO Rocky Cove

VELÁZQUEZ Young Spanish Gentleman

60

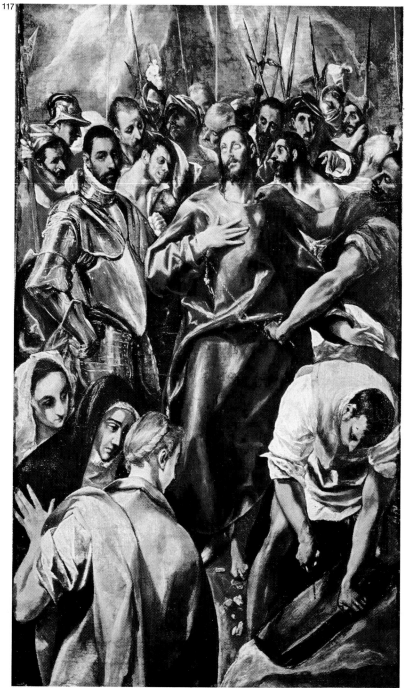

EL GRECO Disrobing of Christ

MURILLO Domestic Toilet

MELÉNDEZ Melons, Pears and Plums

GOYA DON JOSÉ QUERALTO

SPANISH MASTERS

117 – 120. Some highlights of Spanish paintings from the 17th to the 19th century in a panorama of leading names from Greco to Goya. The *Disrobing of Christ*, made around 1610, by Doménikos Theoto-kópoulos, called **El Greco** from his country of origin, is the copy of a famous painting for Toledo Cathedral. It is characterized by the jagged contrasts of light and shade in an intensely dramatic vision. The *Young Spanish Gentleman* was painted by Diego **Velázquez**, the greatest painter in 17th century Spain. This work, unfinished, as can be seen from the hands, shows the Master's extraordinary ability to capture the living humanity of his sitter and his dignity of class and culture. The name of the Sevillian painter, Bartolome Esteban **Murillo**, is linked mainly to popular painting and genre. *Domestic Toilet* is typical of the spontaneous and affectionate style in which he also treated many religious works. An original personality in Spanish painting of the late 18th century was Luis **Meléndez**, the painter of many still lifes of great decorative quality which were mostly painted for the royal residences.

121 – 122. The output of Francisco **Goya** y Lucientes, painter, draftsman, and etcher, has its beginning in Baroque art and reaches beyond late 18th century neo-classicism to grasp at notions of pre-romanticism. This can be seen particularly in the portraits which were painted after 1799, when he became personal painter to Charles IV. To the early years of the 19th century belong those portraying *Don José Queralto*, a doctor in the Spanish Army, and *The Countess of Chinchón*, wife of the dictator Godoy. In both we can trace, beyond the nobility and class pride of the sitters, a thoughtful vein, pre-romantic in spirit.

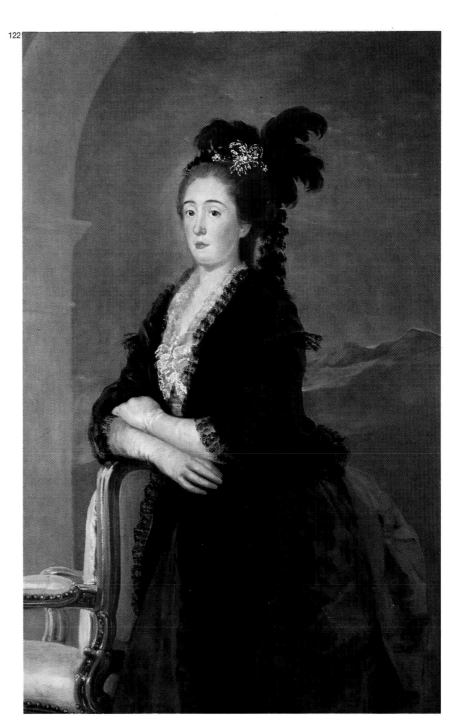

GOYA PORTRAIT OF THE COUNTESS OF CHINCHÓN

MONOGRAMMIST AC Portrait of a Duchess of Jülich

FRENCH MASTERS

123 – 125. French painting of the late 16th century still shows an archaic modelling, as in the *Portrait of a Duchess of Jülich, Cleve and Berg.* Formerly attributed to Antoine Caron, the work is now assigned to the **Monogrammist AC**. On the other hand, the early 17th century is characterized by the presence of a few masters who are attentive to the Italian painting, such as Valentin de Boulogne, called **Le Valentin**. In his *Crowning with Thorns* he seems to go back to a lost work by Caravaggio. Of greater importance was the presence of Nicolas **Poussin** in Roman culture. In the name of a classical ideal, he made Rome his definitive home during his mature years in the middle of the 17th century. *Midas and Bacchus* expresses fully this classicizing doctrine. The nude statuesque figures are set in a landscape that is at once naturalistic and heroic.

LE VALENTIN Crowning with Thorns

POUSSIN Midas and Bacchus

LE LORRAIN Departure of Hagar and Ishmael

126. The direct inspiration of the Roman countryside, rich in ruins and classic memories, compelled Claude Gellée, called **Le Lorrain**, to create compositions consisting of architecture and landscape in which the unifying element is the elegiac quality of the southern light.

127. In the *Bird Cage* painted for Frederick II of Prussia by Nicolas **Lancret**, a pupil of Watteau, can be seen a typically French idea of landscape which is linked to pastoral subjects of archaic grace.

128. To French portrait painting at the beginning of the 18th century belongs the portrait of the *Archbishop Fénélon of Cambrai*, the work of Joseph **Vivien**. The nobility of the features coincides with an expression of mannered elegance.

129. The landscapist Hubert **Robert** painted the *Old Bridge with Washerwomen* in the middle of the 18th century, following an artistic itinerary, secular in tradition, terminating in Rome, where he remained for 20 years. He dedicated himself to the portrayal of architecture and classic ruins with a distinctive pre-romantic and picturesque flavor.

LANCRET The Bird Cage

VIVIEN Archbishop Fénélon of Cambrai

ROBERT Old Bridge with Washerwomen

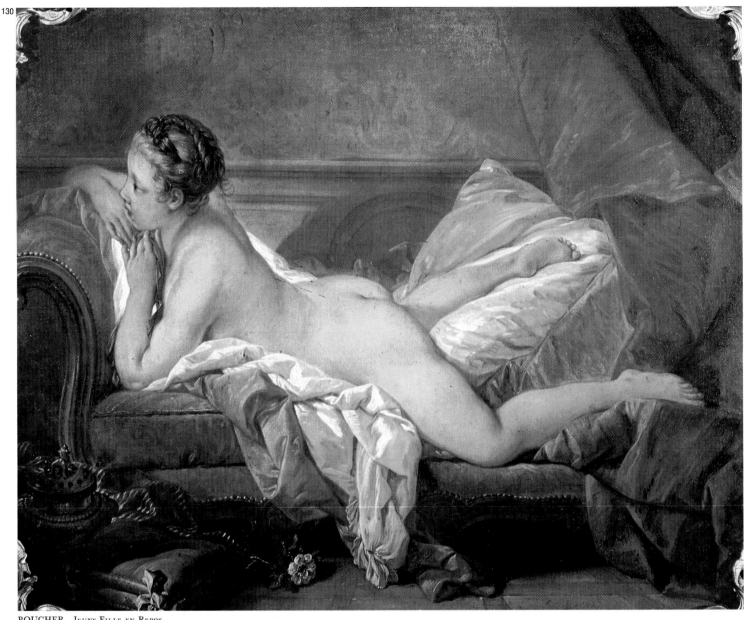

BOUCHER Jeune Fille en Repos

GREUZE Lament of the Watch

130 – 131. François **Boucher**, the painter of gallant subjects, in the *Jeune Fille en Repos* of 1752 realized one of his most celebrated works. As if to synthesize the taste of an epoch, grace, sensuality, wit, and exact details of location, almost in the nature of a chronicle, can be noted. The *Lament of the Watch* was painted 20 years later by Jean-Baptiste **Greuze**. What could be the same young girl has now become the subject of a sentimental and moralistic lecture.

Other Important Paintings
in the Alte Pinakothek

HANS VON AACHEN
Raising of the Young Man of Naim

ALBRECHT ALTDORFER
Birth of the Virgin

ALBRECHT ALTDORFER
Danubian Landscape with the Castle of Wörth

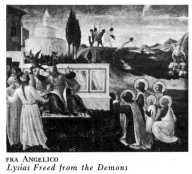

FRA ANGELICO
Lysias Freed from the Demons

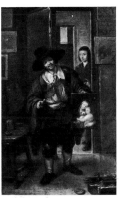

JOSÉ ANTOLÍNEZ
Picture Dealer

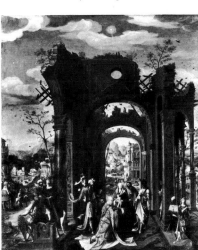

MASTER OF ANTWERP
Adoration of the Kings

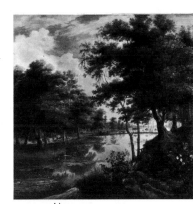

JACQUES D'ARTOIS
Canal in a Wood

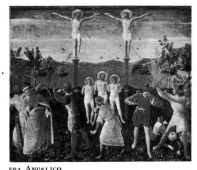

FRA ANGELICO
Crucifixion of Saints Cosmas and Damian

BALTHASAR VAN DER AST
Still Life with Fruit

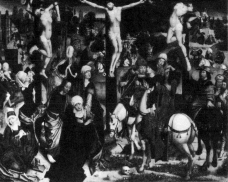

DERICK BAEGERT THE ELDER
Crucifixion

HANS BALDUNG GRIEN
The Palatine Count Philip the Warrior

HANS BALDUNG GRIEN
Nativity

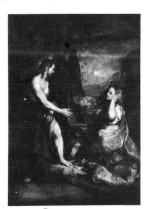

FEDERICO BAROCCI
Christ and Mary Magdalene

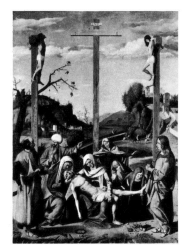

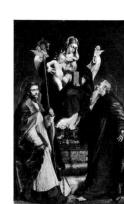

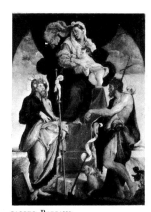

JACOPO BASSANO
*Virgin and Child
with Saints Martin
and Anthony Abbot*

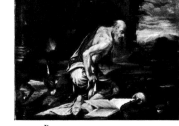

JACOPO BASSANO
Virgin and Child with Saints

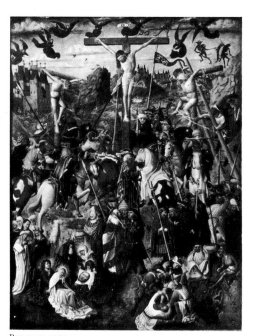

MARCO BASAITI
Lamentation of Christ

66

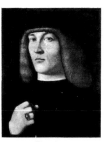

JACOPO BASSANO
St. Jerome in the Cave

BAVARIAN PAINTER
Crucifixion

DOMENICO BECCAFUMI
Holy Family

BARTHEL BEHAM
*The Palatine Count
Ottheinrich*

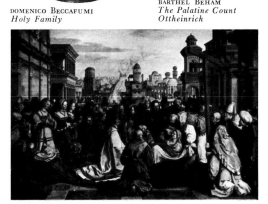

GENTILE BELLINI
(circle of)
Portrait of a Young Man

ABRAHAM VAN BEYEREN
Large Still Life with Lobster

NICOLAES BERCHEM
Italian Landscape at Sunset

BARTHEL BEHAM
The Finding of the True Cross

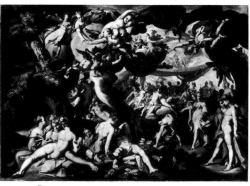

PIETER BOEL
Two Dogs Guarding Game

NICOLAES BERCHEM
Rocky Landscape with Ancient Ruins

ABRAHAM BLOEMAERT
Feast of the Gods

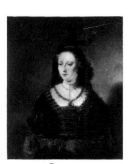

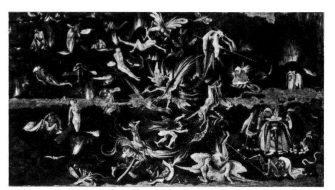

FERDINAND BOL
Portrait of a Young Lady

GERARD TER BORCH
Portrait of a Lady

PARIS BORDONE
Portrait of a Bearded Man

HIERONYMUS BOSCH
Fragment of a Last Judgment

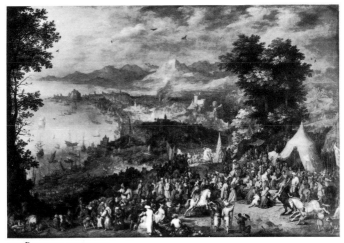

JAN BRUEGHEL THE ELDER
The Temperance of Scipio

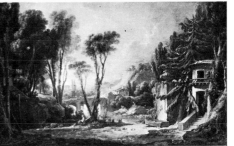

FRANÇOIS BOUCHER
River Landscape

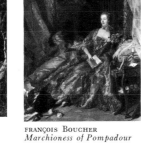

FRANÇOIS BOUCHER
Marchioness of Pompadour

DIERIC BOUTS THE ELDER
St. John the Evangelist

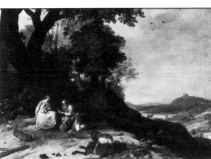

BARTHOLOMEUS BREENBERGH
Rest on the Flight into Egypt

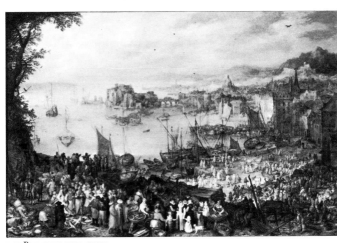

JAN BRUEGHEL THE ELDER
The Great Fish Market

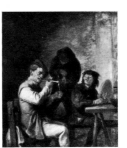

ADRIAEN BROUWER
Taste

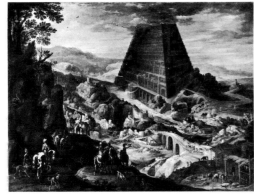

PAUL BRIL
Building of the Tower of Babel

JAN BRUEGHEL THE ELDER
Landscape with Windmill

ADRIAEN BROUWER
Hearing

ADRIAEN BROUWER
Touch

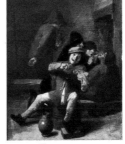

HANS BURGKMAIR
THE ELDER
Martin Schongauer (?)

67

JAN BRUEGHEL THE ELDER
The Burning of Troy

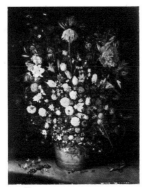

JAN BRUEGHEL THE ELDER
Bunch of Flowers

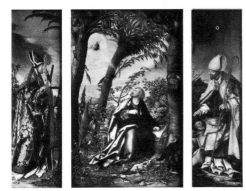

HANS BURGKMAIR THE ELDER
St. John Triptych

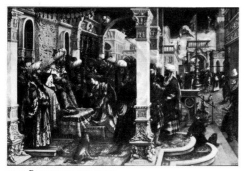

HANS BURGKMAIR THE ELDER
*Esther Intercedes for the Life of the Jews Before
King Ahasuerus*

CANALETTO
Santa Maria della Salute, Venice

CANALETTO
View of Venice

ALONSO CANO
*The Vision of St. Anthony
of Padua*

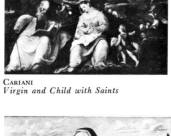

CARIANI
Virgin and Child with Saints

BERNARDO CAVALLINO
Erminia and the Shepherds

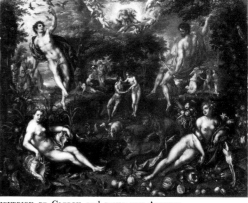

HENDRICK DE CLERCK and DENIS VAN ALSLOOT
Paradise

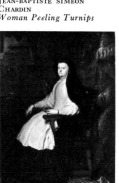

JEAN-BAPTISTE SIMÉON
CHARDIN
Woman Peeling Turnips

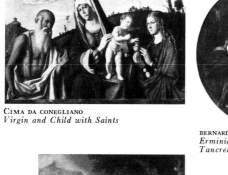

CIMA DA CONEGLIANO
Virgin and Child with Saints

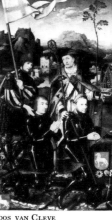

BERNARDO CAVALLINO
*Erminia and the Wounded
Tancredi*

JOOS VAN CLEVE
*St. George and St. Nicasius with the Donors Nicasius and
George Hackeney,* and *St. Christina and St. Gudula with the
Donors' Wives*

CLAUDIO COELLO
Doña Maria Anna of Austria

CLAUDIO COELLO
*St. Peter of Alcantara Walking on
the River Quadiana*

JOOS VAN CLEVE
Portrait of a Lady

LUCAS CRANACH THE ELDER
*Cardinal Albrecht of
Brandenburg Before a Crucifix*

LUCAS CRANACH
THE ELDER
Death of Lucretia

LUCAS CRANACH
THE YOUNGER
Cupid and Venus

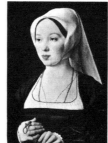

LORENZO DI CREDI
Nativity

AELBERT CUYP
Pasture

CORNELIS VAN DALEM
Landscape with Farmhouse

JACQUES-LOUIS DAVID
*Marchioness of Sorcy
de Thélusson*

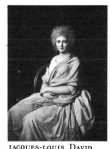

KAREL DUJARDIN
Sick Goat

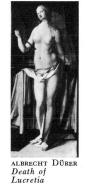

ALBRECHT DÜRER
*Death of
Lucretia*

ALBRECHT DÜRER
*The Virgin of
Sorrows*

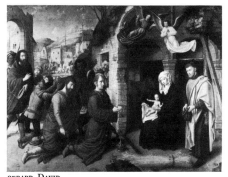

GERARD DAVID
Adoration of the Kings

ALBRECHT DÜRER
Saints Joseph and Joachim and *Simeon and
Lazarus*

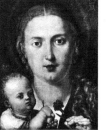

ALBRECHT DÜRER
Virgin of the Carnation

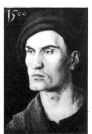

ALBRECHT DÜRER
*Portrait of a Young
Man*

ANTHONIS VAN DYCK
Martyrdom of St. Sebastian 607

ANTHONIS VAN DYCK
Portrait of a Man 407

ANTHONIS VAN DYCK
Portrait of the Sculptor de Nole (?) *and of His Wife
and Daughter* (?)

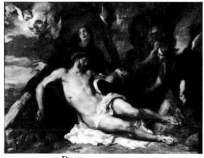

ANTHONIS VAN DYCK
Lamentation of Christ 606

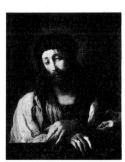

DOMENICO FETTI
"Ecce Homo"

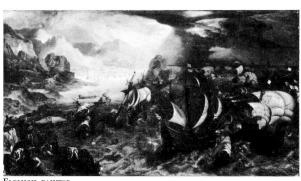

FLEMISH PAINTER
Naval Battle and Sinking Ship

MELCHIOR FESELEN
Julius Caesar Before Alesia

ADAM ELSHEIMER
The Burning of Troy

FLEMISH PAINTER
Family Portrait

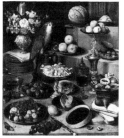

GEORG FLEGEL
Still Life

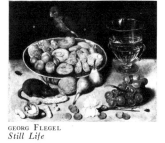

GEORG FLEGEL
Still Life

FRANS FLORIS DE VRIENDT
(attr)
Man with Red Cap

FRANS FLORIS DE VRIENDT
Female Figure

FRANCIA
*Virgin and Child with
Two Angels*

FRANCIA
The Virgin in a Rosery

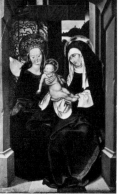

TADDEO GADDI
Death of the Lord of Celano

HANS FRIES
*St. Anne, the Virgin and the
Infant Christ*

HANS FRIES
Raising of the Elect and *Fall of the Damned*

AERT DE GELDER
The Jewish Bride

ORAZIO GENTILESCHI
Two Women with a Mirror

FRANCISCO JOSÉ DE GOYA
Y LUCIENTES
Marchioness of Caballero

LUCA GIORDANO
Cynic Philosopher 493

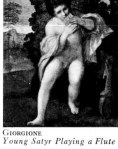

GIORGIONE
Young Satyr Playing a Flute

GIOTTO
Descent into Limbo

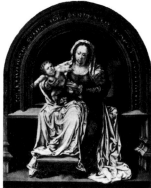

JAN GOSSAERT
Virgin and Child

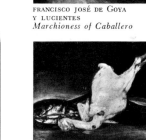

FRANCISCO JOSÉ DE GOYA
Y LUCIENTES
The Plucked Turkey

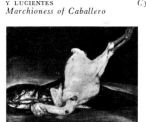

FRANCESCO GUARDI
The Grand Canal Near St. Jeremiah's

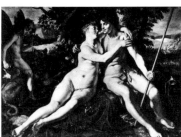

HENDRICK GOLTZIUS
Venus and Adonis

FRANS HALS
*Portrait of Willem
van Heythuyzen*

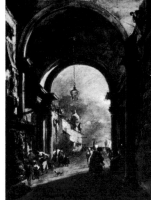

FRANCESCO GUARDI
View Through an Arch

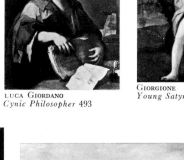

FRANCESCO GUARDI
View of the Rialto

70

JAN DAVIDSZ. DE HEEM
*Flowers with Crucifix and
Skull*

JOSEPH HEINTZ
Satyrs and Nymphs

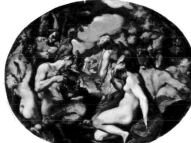

BARTHOLOMEUS VAN DER HELST
Husband and *Wife Portraits*

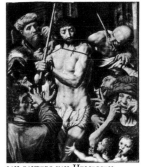

JAN SANDERS VAN HEMESSEN
Christ Scorned

JAN SANDERS VAN HEMESSEN
Isaac Blessing Jacob

MELCHIOR DE HONDECOETER
Birds in a Park

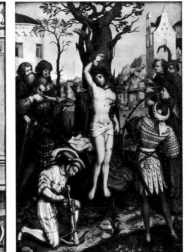

HANS HOLBEIN THE ELDER
St. Sebastian Triptych

MEINDERT HOBBEMA
Landscape

MELCHIOR DE HONDECOETER
Chickens in a Country House Courtyard and
in a Park

DUTCH PAINTER
Flag Bearer

CAREL CORNELISZ. DE HOOCH
Landscape with City Walls

71

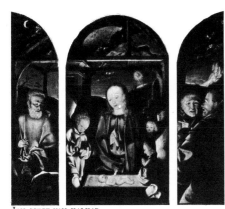

WOLF HUBER
Capture of Christ

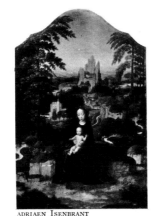

ADRIAEN ISENBRANT
Rest on the Flight into Egypt

ABRAHAM JANSSENS VAN NUYSSEN
Olympus

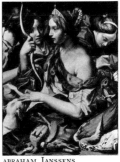

ABRAHAM JANSSENS
VAN NUYSSEN
Diana and the Nymphs

JAN JOEST VAN KALKAR
Adoration of the Christ Child

JACOB JORDAENS
Gay Company

WILLEM KALF
Still Life with Delft Jug

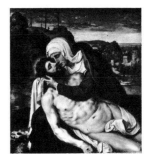

WILLEM KEY
Lamentation of Christ

PHILIPS KONINCK
Landscape

HANS VON KULMBACH
*Margrave Casimir of
Brandenburg*

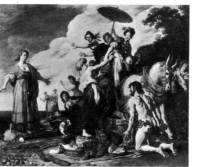

PIETER PIETERSZ. LASTMAN
Ulysses Before Nausicaa

MAURICE QUENTIN
DE LA TOUR
The Abbot Nollet

MAURICE QUENTIN
DE LA TOUR
*Mademoiselle Ferrand
Meditating on Newton*

EUSTACHE LE SUEUR
Christ in the House of Martha

LIBERALE DA VERONA
Lamentation of Christ

JOHANN LISCHKA
Lamentation of Christ

FILIPPO LIPPI
Annunciation

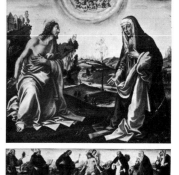

FILIPPINO LIPPI
Intercession of Christ and the Virgin and
*The Dead Christ Upheld by an Angel
and Saints*

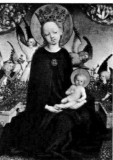

LUCAS VAN LEYDEN
*Virgin and Child with the Magdalene
and a Donor*

STEPHAN LOCHNER
Virgin and Child

LE LORRAIN
Seaport at Dawn

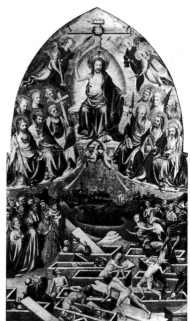

MASTER OF THE LIVELY CHILD
The Last Judgment

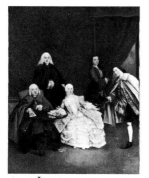

PIETRO LONGHI
The Visit or The Game of Cards

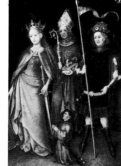

STEPHAN LOCHNER
*Saints Catherine, Hubert,
Quirinus and a Donor*

LE LORRAIN
Hagar and Ishmael in the Desert

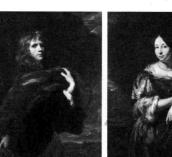

NICOLAES MAES
Portraits of a Young Couple (?)

LE LORRAIN
Idyllic Landscape at Sunset

JAN MANDYN
St. Christopher

72

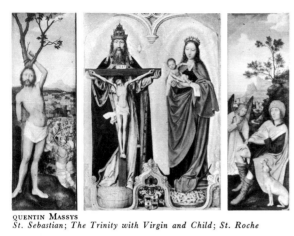

QUENTIN MASSYS
St. Sebastian; The Trinity with Virgin and Child; St. Roche

BARENT VAN DER MEER
Still Life with a Negro

MASTER OF THE PORTRAIT
OF MORNAUER
Duke Sigismund (?)

MASTER OF THE LEGEND OF JOSEPH
Joseph and Potiphar's Wife

73

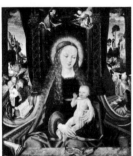

MASTER OF THE AACHEN
ALTARPIECE
*Virgin and Child with Musician
Angels*

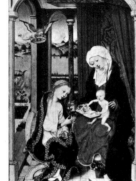

MASTER OF THE ST. BARTHOLOMEW
ALTARPIECE
*St. Anne, the Virgin and the
Infant Christ*

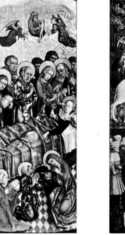

MASTER OF THE REGLER ALTARPIECE AT ERFURT
Presentation, Offering
and *Death of the Virgin*

MASTER OF THE POLLING ALTARPIECE
Episodes in the Finding of the True Cross

MASTER OF THE "ECCE HOMO"
OF OBERALTAICH
"Ecce Homo"

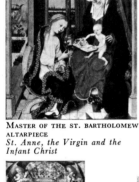

MASTER OF THE
BOOK OF THE HOUSE
Virgin and Child

MASTER OF THE
LICHTENSTEIN CASTLE
Massacre of the Innocents

GABRIEL METSU
Beanfeast

GABRIEL METSU
The Cook

HANS MEMLING
Virgin and Child with Musician Angels and
St. George and Donor

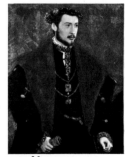

JEAN FRANÇOIS MILLET
Italian Coast Landscape

HANS MUELICH
Albrecht V of Bavaria

PAULUS MOREELSE
The Blonde Shepherdess

MORETTO DA BRESCIA
Portrait of an Ecclesiastic

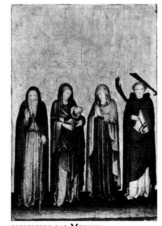

CRISTOFORO DE' MORETTI
Virgin and Child with Saints

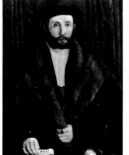
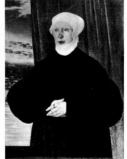

HANS MUELICH
Portraits of the Ligsalz Couple

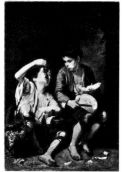

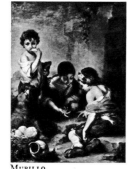

Murillo
*Boys Eating Grapes
and Melon*

Murillo
Boys Playing Dice

Murillo
*St. Thomas of Villanueva
Heals a Cripple*

Jean-Marc Nattier
*Marchioness of Baglion in
the Guise of Flora*

Jean-Marc Nattier
The Alliance of Love and Wine

74

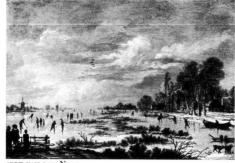

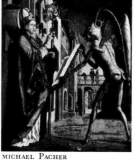

Nardo di Cione
*Saints Maurice,
Augustine, Peter,
Nicholas and Stephen*

Aert van der Neer
Winter Landscape

Eglon van der Neer
Landscape with Tobias and the Angel

Caspar Netscher
Pastoral Scene

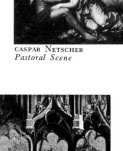

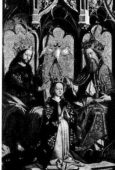

Bernaert van Orley
*Portrait of Jehan
Carondelet*

Adriaen van Ostade
Peasants Fighting

Girolamo del Pacchia
*St. Bernard of Siena
with Two Angels*

Michael Pacher
St. Wolfgang and the Devil

Michael Pacher
Coronation of the Virgin

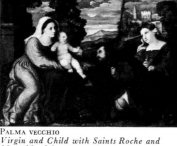

Juan Pantoja de la Cruz
*Albrecht the Pious,
Archduke of Austria*

Palma Vecchio
*Virgin and Child with Saints Roche and
Mary Magdalene*

Michael Pacher
St. Laurence Giving Alms and *His Martyrdom*

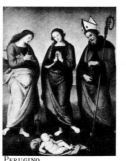

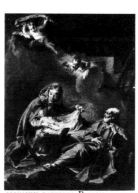

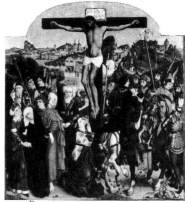

Jean-Baptiste François Pater
Pleasures of Country Life

Perugino
*Virgin with Saints
Worshipping the Christ Child*

Giovanni Battista Pittoni
Nativity

Hans Pleydenwurff
Crucifixion

JAN PORCELLIS THE ELDER
Storm at Sea

PAULUS POTTER
Peasant Family with Animals

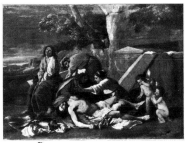
NICOLAS POUSSIN
Lamentation of Christ

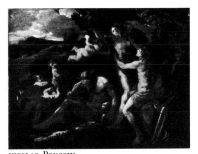
NICOLAS POUSSIN
Apollo and Daphne

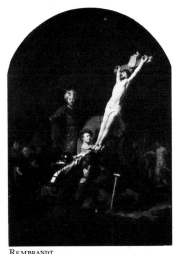
REMBRANDT
Erection of the Cross

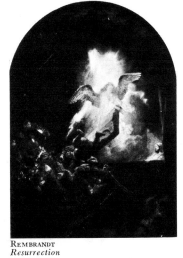
REMBRANDT
Resurrection

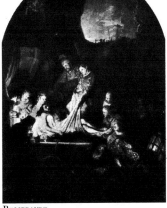
REMBRANDT
Deposition

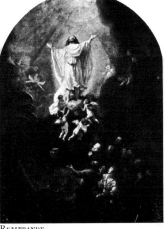
REMBRANDT
Ascension

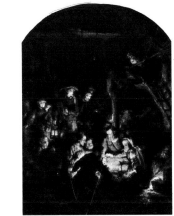
REMBRANDT
Sacrifice of Isaac

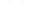
REMBRANDT
Adoration of the Shepherds

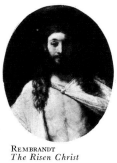
REMBRANDT
The Risen Christ

DOMENICO PULIGO
*Virgin and Child with
Young St. John*

GUIDO RENI
Assumption

JUSEPE DE RIBERA
*St. Peter of Alcantara
in Meditation*

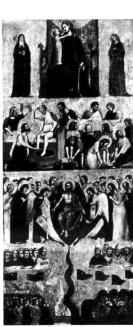
SCHOOL OF RIMINI
*Virgin, Washing of the Feet,
Last Judgment*

JOHANN ROTTENHAMMER
Diana and Actaeon

HUBERT ROBERT
Demolished Houses on the Pont au Change, Paris

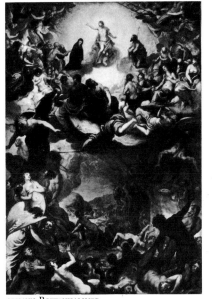
JOHANN ROTTENHAMMER
Last Judgment

JOHANN MICHAEL ROTTMAYR
Saint Benno

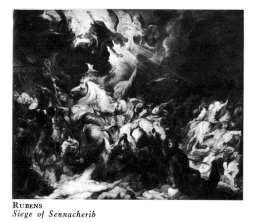

RUBENS
Siege of Sennacherib

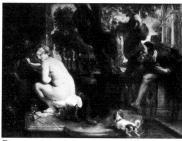

RUBENS
Susanna Bathing

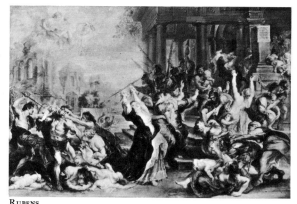

RUBENS
Massacre of the Innocents

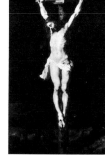

RUBENS
Crucifixion

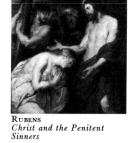

RUBENS
Christ and the Penitent
Sinners

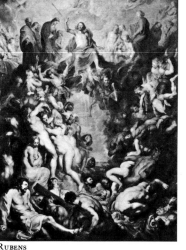

RUBENS
Great Last Judgment

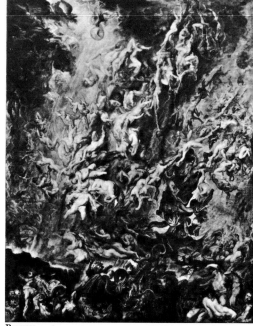

RUBENS
Fall of the Damned

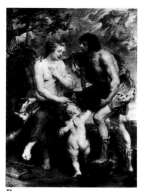

RUBENS
Meleager and Atalanta

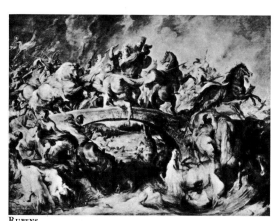

RUBENS
Battle of the Amazons

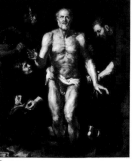

RUBENS
Dying Seneca

RUBENS
Portrait of Dr. Hendrik
van Thulden

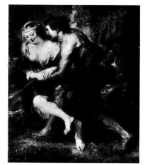

RUBENS
Pastoral Scene

RUBENS
Drunken Silenus

RUBENS
Henry IV at the Battle Near Martin d'Eglise

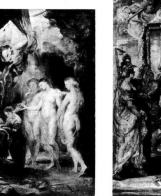

RUBENS
The Education of the Princess
Maria de' Medici

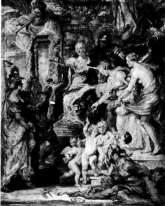

RUBENS
Happiness of the Regency

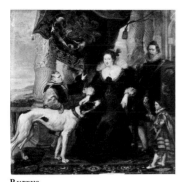

RUBENS
Alathea Talbot, Countess of Shrewsbury

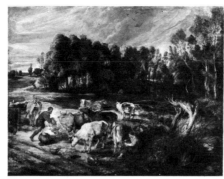

RUBENS
Polder Landscape with Herd of Cows

JACOB VAN RUISDAEL
Sand Dunes with Trees

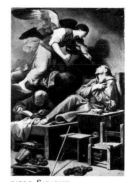

CARLO SARACENI
Vision of St. Francis

JACOB VAN RUISDAEL
Forest Landscape with Threatening Storm

JACOB VAN RUISDAEL
Forest Landscape in the Marshes

SALOMON VAN RUYSDAEL
River Landscape with Ferry

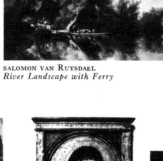

CARLO SARACENI
Death of the Virgin

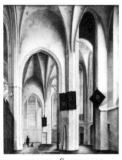

PIETER JANSZ. SAENREDAM
*Interior of the Church of
St. James in Utrecht*

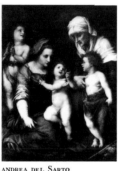

ANDREA DEL SARTO
*Virgin and Child with
Saints John the Baptist,
Elizabeth and Two Angels*

HANS SCHÄUFELEIN
Funeral of the Virgin

SEGNA DI BUONAVENTURA
St. Mary Magdalene

FLORIS VAN SCHOOTEN
Still Life with Cheeses

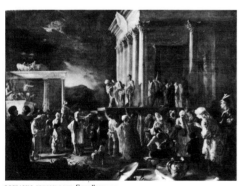

JOHANN HEINRICH SCHÖNFELD
"Ecce Homo"

JAN SIBERECHTS
Grazing Animals and Sleeping Woman

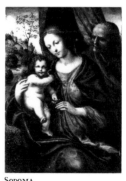

SODOMA
Holy Family

LUCA SIGNORELLI
Virgin and Child

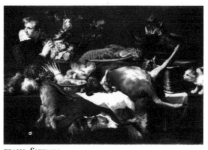

FRANS SNYDERS
Kitchen Table

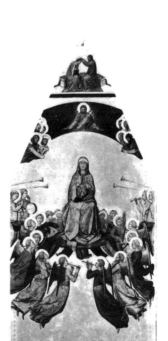

SIENESE MASTER
Assumption

JAN STEEN
Crowned Orator

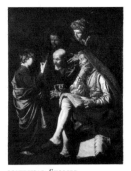

SEBASTIAN STOSSKOPF
Still Life

BERNHARD STRIGEL
*Sleeping Guard with Club
and Sword*

BERNHARD STRIGEL
*Portrait of
Hans Funk*

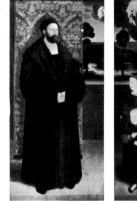

MATTHIAS STOMER
Jesus Among the Doctors

BERNHARD STRIGEL
Konrad Rehlinger the Elder and *His Eight Sons*

LAMBERT SUSTRIS
*Portrait of Veronika
Vöhlin*

BERNARDO STROZZI
The Tribute

MICHAEL SWEERTS
Interior of an Inn

PIERRE SUBLEYRAS
Theodosius Before St. Ambrose and *St. Benedict Brings a Child
Back to Life*

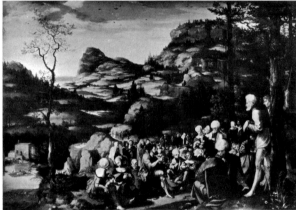

GIOVANNI BATTISTA TIEPOLO
Rinaldo Enchanted by Armida and *The Parting of Rinaldo and Armida*

JAN SWART VAN GRONINGEN
St. John the Baptist Preaching

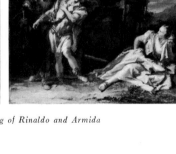

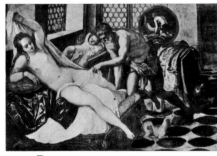

DOMENICO TINTORETTO
Portrait of a Sculptor

JACOPO TINTORETTO
Mars and Venus Surprised by Vulcan

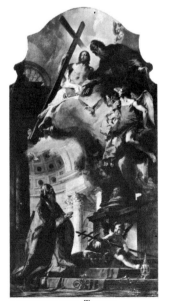

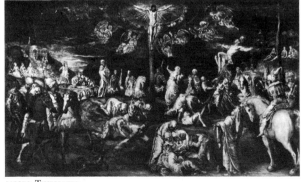

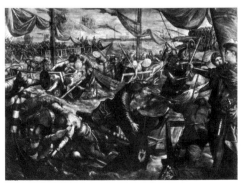

GIOVANNI BATTISTA TIEPOLO
Pope Clement Adoring the Trinity

JACOPO TINTORETTO
Crucifixion

JACOPO TINTORETTO
*Ludovico II Gonzaga Defeats the Venetians
on the Adige Near Legnago*

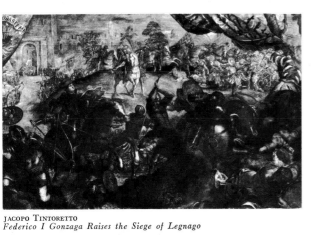

JACOPO TINTORETTO
Federico I Gonzaga Raises the Siege of Legnago

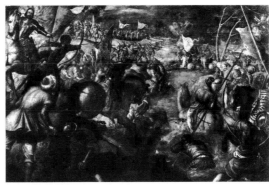

JACOPO TINTORETTO
Francesco II Gonzaga at the Battle of the Taro

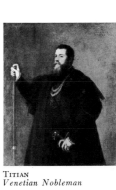

TITIAN
Venetian Nobleman

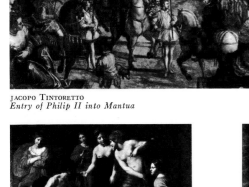

JACOPO TINTORETTO
Entry of Philip II into Mantua

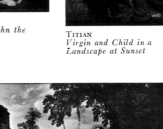

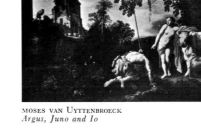

TITIAN
Virgin and Child with St. John the Baptist and Donor

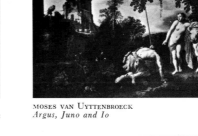

TITIAN
Virgin and Child in a Landscape at Sunset

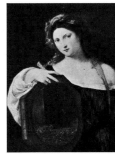

TITIAN
Vanity

ALESSANDRO TURCHI
Hercules and Omphale

UMBRIAN PAINTER
Portrait of a Young Man

MOSES VAN UYTTENBROECK
Argus, Juno and Io

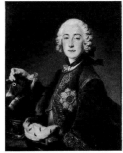

LOUIS TOCQUE
*The Palatine Count
Friedrich Michael of
Zweibrücken-Birkenfeld*

JEAN VALENTIN DE BOULOGNE
Erminia and the Shepherds

JEAN VALENTIN DE BOULOGNE
Crowning with Thorns 477

ESAIAS VAN DE VELDE
Winter Games on Ice

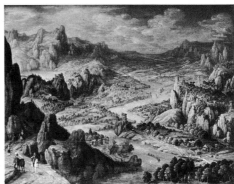

LUCAS VAN VALCKENBORCH
Building of the Tower of Babel

WILLEM VAN DE VELDE THE YOUNGER
Calm Sea

TOBIAS VERHAECHT
Landscape

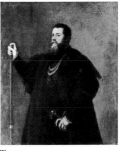

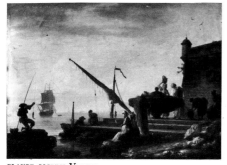

CLAUDE JOSEPH VERNET
Eastern Seaport

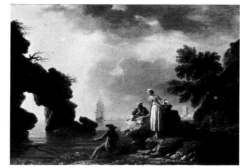

CLAUDE JOSEPH VERNET
Landscape with Bay

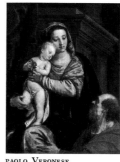

PAOLO VERONESE
Holy Family

PAOLO VERONESE
Portrait of a Venetian Lady

80

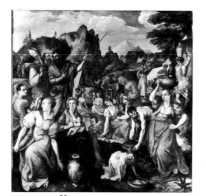

MAERTEN DE VOS
Israelites Gathering Manna

SIMON VOUET
Judith

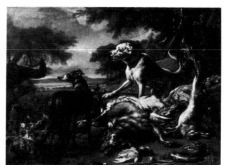

PAOLO VERONESE
Cupid with Two Dogs

JAN WEENIX
Animals, Hunting Gear and Hunter

FRANCISCO DE ZURBARÁN
*St. Francis of Assisi
in Ecstasy*

JAN BAPTIST WEENIX
Sleeping Girl

JAN WEENIX
Still Life with Dead Game and Bensberg Castle in Background

JAN WEENIX
*Still Life with Game
before a Statue of Diana*

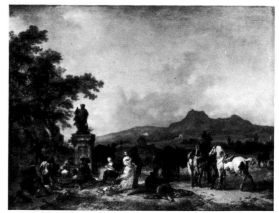

ADRIAEN VAN DER WERFF
Boys Playing Before a Statue of Hercules

PHILIPS WOUWERMANS
Winter Landscape with Ice Skaters

PHILIPS WOUWERMANS
Rest During a Deer Hunt

Description of Schleissheim Castle

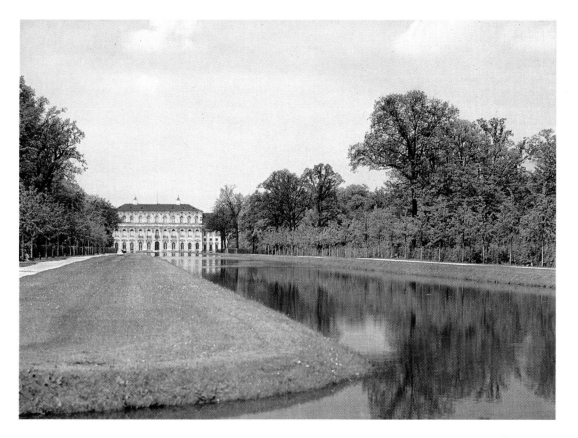

On entering the Schlosspark of Schleissheim one comes face to face with the old castle which was built in 1597 and enlarged in 1626. It was so badly damaged during the last war that the interior is not accessible, even though long and delicate restoration work is being carried out. The new castle, which stands further to the rear of this building, contains part of the collections of the Bavarian princes (see the *History* for the years 1684, 1714, 1719, 1722, 1745, 1775 and 1836). The architects responsible for carrying out the commission of Maximilian Emanuel, an enthusiast for French art, referred to the Louvre and Versailles as their models. The first wing, based on the first plans drawn up by the architect Zuccalli, was almost completed by 1704 when the work was interrupted for fifteen years because of political events.

It was only in 1719 that work was resumed, under the direction of the

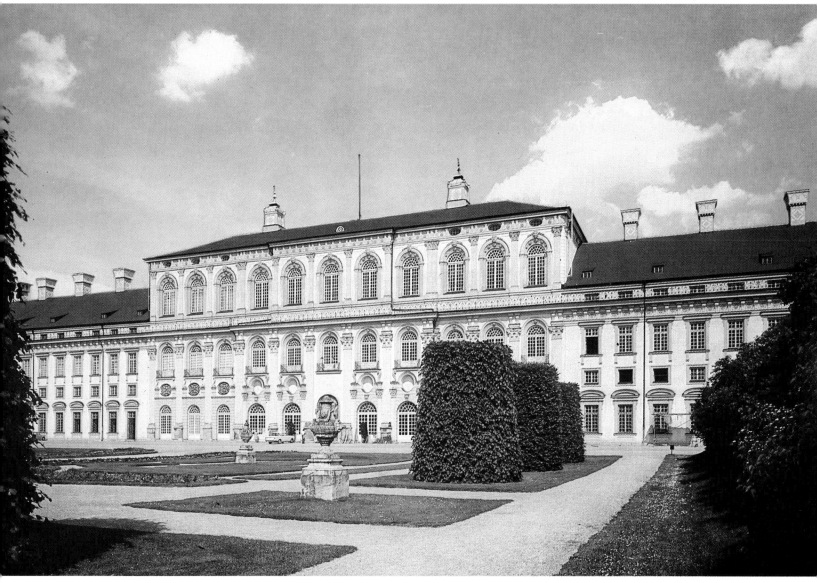

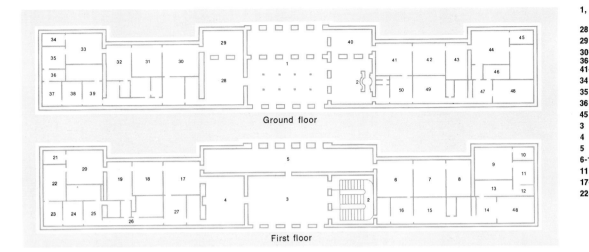

Ground floor

First floor

architect Effner, who had studied in Paris at the expense of Maximilian Emanuel. He set out the existing wing as a building in its own right and altered Zuccalli's project only in the arrangement of the interior and its decoration. The extension displays the grandeur typical of stately Baroque architecture, harmoniously realized in its proportion and in the relation of wall to opening. The plan consists of a long rectangle with slight projections at the ends and in the center in order to enliven the whole and avoid monotony. The central part is raised by a recessed story in such a manner as to create a terrace. The long succession of wide windows which rhythmically break up the façade forms a balanced and elaborate scansion of the surface. It is enriched by a decoration of pediments on the first floor and by Corinthian columns on the upper floors.

During the last war, the bombings of April, 1945, seriously damaged the building to such an extent that reconstruction was necessary. These operations, which lasted from 1959 to 1963, cleaned up the Baroque façade designed by Effner with classicist decorations

during the last century. At the same time, the return to the original color was made possible through the preservation of the original portions and from contemporary evidence.

On entering the castle, one finds the surroundings rich and sumptuous in their overabundant decoration and almost exasperating attention to detail. Nevertheless, there is an apparent, successful harmony and blending when viewed as a whole, thanks to the single-mindedness and co-ordination of the foreign artists and craftsmen who carried out the work under the direction of Effner. They had already been involved at Nymphenburg and were later to be employed in Munich. Jacopo Amigoni was entrusted with the decoration of the ceilings, which render homage to the military glory of Maximilian Emanuel and depict scenes from the Trojan War and mythological and allegorical subjects; these latter seem to bespeak the desire for a more serene existence. In this enterprise, N. G. Stuber, a theatrical scene painter, assisted Amigoni, who was entrusted with the ornamental work, especially of the grisaille. For the plaster work, Maxi-

milian turned to Charles Dubut, Y. B. Zimmermann, and G. Volpini, who carried out the work from sketches made by Effner. The principal wood carver and gilder was the Tyrolean J. A. Pichler, who had studied in Paris. The wrought-iron gates and balcony railings were the work of the court blacksmith, Antoine Motté. To Effner, the leading personality, goes the credit for achieving a co-ordinated and harmonious whole in this task. He attended to many details, including the design of the carved wooden picture frames (see History for the year 1719). His work in this complex makes him the great creator of Bavarian Rococo and author of the decorative style of the court art of Munich during the first quarter of the century. All the apartments of the castle are exquisite jewels of decorative refinement which never degenerate into affectation. The ground floor is connected to the upper floor by a wide staircase which Effner borrowed from Zuccalli's plan. However, he eliminated the other staircase which was to rise in front of the present one. The marble balustrades commissioned by Ludwig I were designed by Leo von Klenze.

Architecturally, the success of the castle can be considered exceptional for that period, in that it attained a clear and functional division of space. To this can be added the majestic and logical linking, over two floors, of the sequence of rooms with the stairway cage and hall of doors, representing one of the most grandiose examples of an interior in the Baroque era. The monumental fluted pilasters, which, projecting from the surface of the wall, rhythmically measure out the space, and the rich and sumptuous plaster-work, whose mass is picked out in shades of white, form a lively contrast to the immense vault fresco by Amigoni and the great canvases by T. Beich on the short stretches of wall. In its galleries the castle houses paintings in accordance with the style of the building and provides a pageant of European Baroque almost unique in its ensemble. At the rear, the castle faces a great park which was planned by Zuccalli and Girard at the time of the second reconstruction. Effner, however, designed the cascade which crosses the park and which was completed only during the last century.

(Here below) View of the Great Gallery. Seventeenth and eighteenth century paintings can be seen hanging on the wall. The ceiling shows a rich grotesque decoration.
(Right) View of the staircase leading to the upper floor. Stucco works were executed on architect Effner's designs.

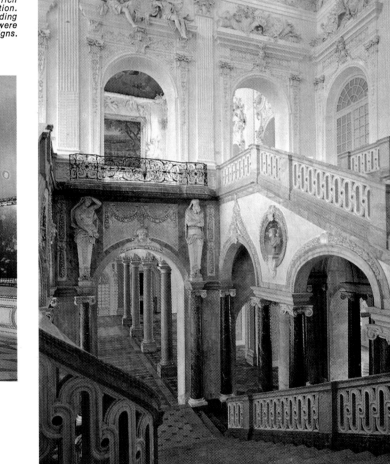

Masterpieces in Schleissheim Castle

132. Joachim **von Sandrart**, an outstanding figure in 17th-century German painting, is remembered chiefly as a chronicler; hence, his paintings and etchings consist of pleasant genre works like the series of the months, executed under a commission of the Elector Maximilian I of Bavaria, to which belongs the representation of *February*, treated in a naturalism at once mischievous and gay.

133 – 134. Adriaen **van der Werff**, a Dutch painter, enjoyed a considerable success in history and portrait painting not only in Rotterdam but also in Düsseldorf where he was in the service of the Elector Johann Wilhelm of Palatinate. The painter is the author of the portraits of the Elector and his wife *Maria Anna Luisa de' Medici*.

VON SANDRART FEBRUARY

VAN DER WERFF PRINCE JOHANN WILHELM, ELECTOR OF PALATINATE

VAN DER WERFF MARIA ANNA LUISA DE' MEDICI

84

VIEW OF THE GALLERY OF THE ARCHDUKE LEOPOLD IN BRUSSELS

TENIERS

135 – 137. David Teniers the Younger, a Flemish painter, lived in Belgium at the height of the 17th century, where he produced many genre paintings. Towards the middle of the century, he became artistic director of the collections of the Archduke Leopold William in Brussels. He showed in many of his paintings the actual works in these collections, thus creating a new kind of subject which links documentation and a crowding of elements in a purely 17th century northern spirit. These works, like the three illustrated, show views of the gallery. Although owing their origin to other motives, they form an interesting illustrated catalogue, which, in later times, constituted a precious testimony to the extent and taste of the collections of the time. This type of subject was very successful and had many imitators. The same Teniers made small drawings of many of the works in the gallery.

VIEW OF THE GALLERY OF THE ARCHDUKE LEOPOLD IN BRUSSELS

VIEW OF THE GALLERY OF THE ARCHDUKE LEOPOLD IN BRUSSELS

138. The *Martyrdom of St. Laurence*, in which the central nude emerges statuesque in treatment, is the work of Peter Paul **Rubens**. The impasto of the color, the diagonal position of the nude, and the excitement of the gestures in the scene show clearly the style of the Master who was the creator of northern Baroque.

139. Rubens' splendid colors survive in *Daedalus and Icarus*, a work attributed to his follower Jan van **Bockhorst**.

140. Anthonis **van Dyck** was a direct heir of Rubens' style. Even though he continues the Master's taste for certain elements of movement and surprise, in the *Portrait of the Painter Eertvelt*, who was faithfully portrayed while actually engrossed in a marine scene, he shows his independence in the unique effect he aimed at in the portrait.

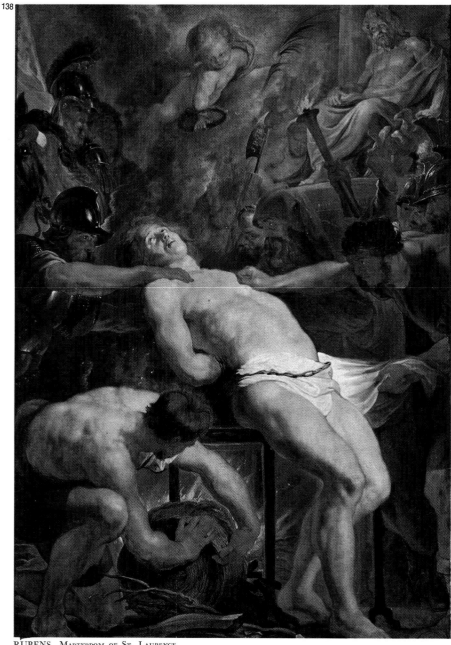

RUBENS Martyrdom of St. Laurence

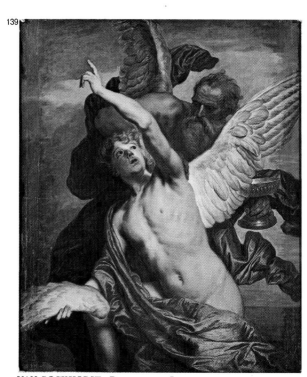

VAN BOCKHORST Daedalus and Icarus

VAN DYCK Portrait of the Painter Eertvelt

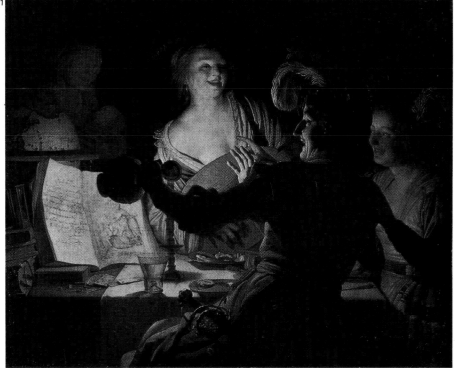

VAN HONTHORST The Prodigal Son

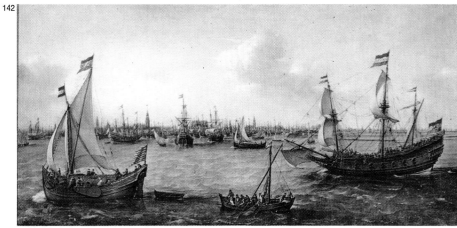

VROOM The Port of Amsterdam

CODDE Portrait of a Child

141 – 144. Some typical aspects of Dutch 17th-century painting are shown in the *Prodigal Son* by Gerrit **van Honthorst** and the *Port of Amsterdam* by Cornelis **Vroom** (who is included in the numbers of those who painted marine scenes, a subject which was amply treated in Holland even to the extent of making exact references to actual events), in the *Portrait of a Child* by Pieter **Codde**, who also painted happy domestic interiors, and finally in the outstanding *Nocturne* by Jacob **van Ruisdael**, where the splendid whites of the winter landscape emerge under the light of the moon.

J. VAN RUISDAEL Village in Winter by Moonlight

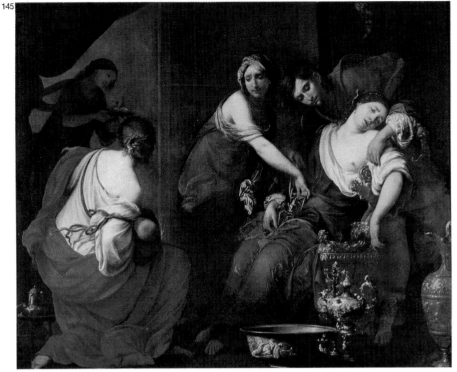

FURINI Birth of Rachel

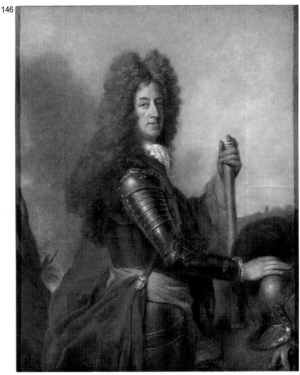

VIVIEN Portrait of the Elector Prince Maximilian Emanuel

145. Francesco **Furini**, a Florentine painter of the early 17th century, reveals in his *Birth of Rachel* the decadence of biblical subjects which had become a pretext for a composition of slow and ambiguous rhythms in which the female figure is characterized by an exaggerated sensuality.

146. Joseph **Vivien**, the French artist whose fame is mainly linked to his work in pastel, shows in official portraits, such as that of the *Prince Elector Maximilian Emanuel*, the impoverishment to which this genre was reduced in the early 18th century. It was often limited to no

more than the description of costume.

147 – 148. The persistence of the crisis in some provincial Italian painting of the 18th century is revealed even in those masters who had contact with the European scene, such as Pietro Antonio **Rotari** of Verona, court painter in Vienna, Dresden, and Petersburg, and painter of the *Sleeping Girl*, which is almost photographic. Because of his skill in constructing compositions which had a certain Arcadian grace, Jacopo **Amigoni**, the Venetian painter of *Venus and Adonis*, was in demand in European courts from Bavaria to Madrid, where he died in 1752.

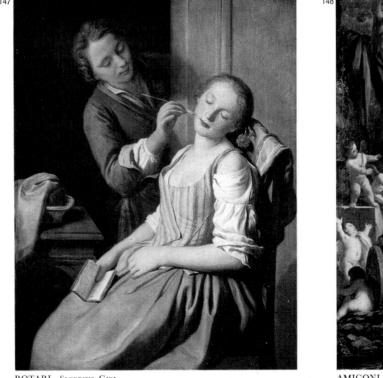

ROTARI Sleeping Girl

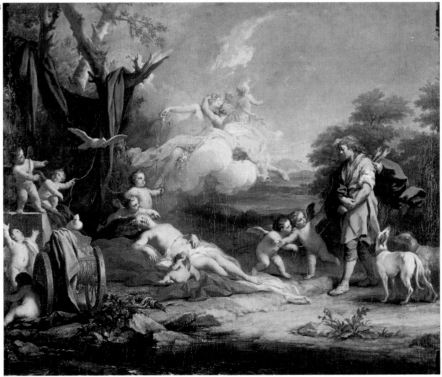

AMIGONI Venus and Adonis

Other Important Paintings
in Schleissheim Castle

JACQUES D'ARTOIS
Hunting with a Falcon

JAN ASSELYN
Landscape with River and Arched Bridge

GIOVACCHINO ASSERETO
St. Francis

POMPEO BATONI
Self-Portrait

NICOLAES BERCHEM
Italian Landscape

CHRISTIAN BERENTZ
Still Life with Books and Vases

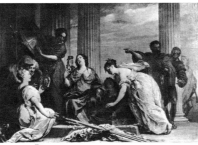

JAN VAN BOCKHORST
Ulysses recognizes Achilles

SÉBASTIEN BOURDON
Roman Furnaces

LUDOVICO CARRACCI
Baptism of Christ

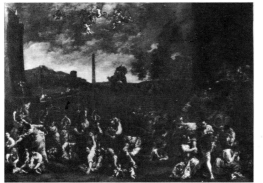

GIUSEPPE MARIA CRESPI
Massacre of the Innocents

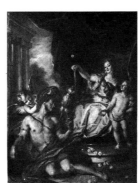

CHARLES COYPEL
Hercules and Omphale

GASPAR DE CRAYER
Virgin Worshiped by Saints

GEORGE DESMARÉES
*Self-Portrait with his
Daughter Maria Antonia*

JACOB DUCK
Smokers in a Tavern

CIRO FERRI
Virgin and Child with St. Martina

FRANCESCO FURINI
Artemisia

FRANCESCO FURINI
St. Sebastian

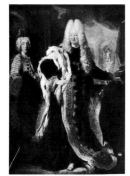

PIERRE GOUDREAUX
*Portrait of the Prince Karl
Philipp, Elector of Palatinate*

JAN VAN GOYEN
Farmhouse with Well

GRECHETTO
Dromedary and Young Moor

JAN HACKAERT
Forest Path with Hunting Party

90

JEAN-BAPTISTE GREUZE
Young Woman

JAN DE HEEM
Composition with Fruit

DUTCH PAINTER
Marine

MELCHIOR DE HONDECOETER
Fighting Cocks

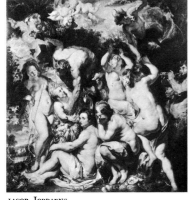

JACOB JORDAENS
Satyrs and Nymphs

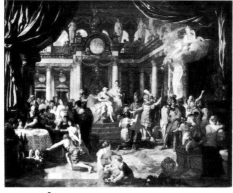

GERARD DE LAIRESSE
Dido and Cupid

NICOLAS DE LARGILLIÈRE
Lady in Ceremonial Dress

FRANÇOIS LEMOINE
Hunting Party

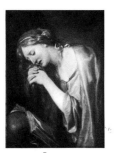

CHARLES LEBRUN
The Magdalene

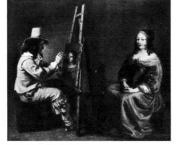

MATHIEU LE NAIN
Artist with Model

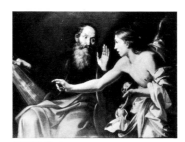

JOHANN LOTH
St. Matthew the Evangelist

JEAN FRANÇOIS MILLET
Classic Landscape

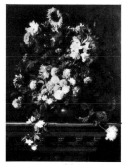

JEAN-BAPTISTE MONNOYER
Still Life with Flowers

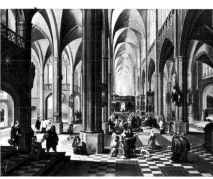

PETER NEEFFS THE ELDER
Interior of Gothic Church

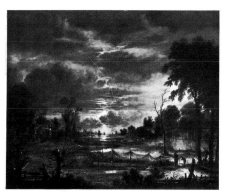

AERT VAN DER NEER
Landscape by Moonlight

EGLON H. VAN DER NEER
Landscape with Pastoral Scene

ISAAK VAN OSTADE
Landscape with Winter Games on Ice

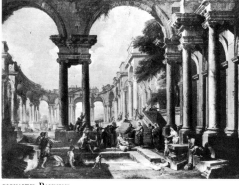

GIOVANNI PANNINI
*Architectural View with Christ Healing
the Blind Man of Bethsaida*

CHRISTOPH PAUDISS
Rest on the Way to Market

BONAVENTURA PEETERS
Marine

ANTONIO PELLEGRINI
Solemn Entrance of Prince Johann Wilhelm, Elector Palatine

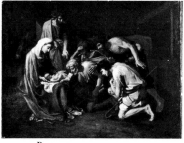

NICOLAS POUSSIN
Adoration of the Shepherds

MATTIA PRETI
The Prodigal Son

CORNELIS POELENBURGH
Rest after Bathing

ANTONIO PELLEGRINI
Wedding Feast

FRANS POST
Brazilian Landscape

PIETRO ROTARI
Weeping Girl

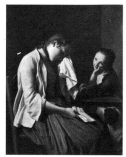

ADAM PYNACKER
Landscape with Tall Trees

SEBASTIANO RICCI
Temptation of St. Anthony

RUBENS (st)
The Apostles Peter and Paul

RUBENS
Reconciliation of Esau and Jacob

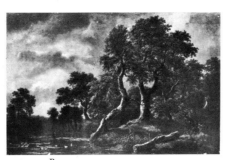

JACOB VAN RUISDAEL
Forest Landscape with Marshes

SALOMON VAN RUYSDAEL
Landscape with Canal

JOACHIM VON SANDRART
July

JOACHIM VON SANDRART
St. Peter's Miraculous Catch

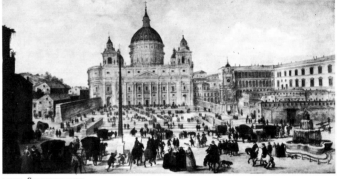

JACOB SWANENBURGH
Architectural View of St. Peter's Square, Before the Building of Bernini's Colonnade

92

JOACHIM VON SANDRART
Jacob's Dream

ANDREA VACCARO
The Scourging of Christ

FRANS SNYDERS
Jesus with the Young St. John

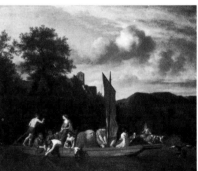

ADRIAEN VAN DE VELDE
The Crossing

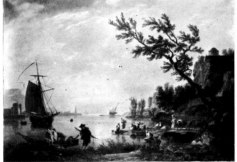

CLAUDE VERNET
Seaport in the Evening Light and *Rocky Coast in a Storm*

VENETIAN PAINTER
*The Venetian
Admiral
Lazaro Mocenigo*

JOSEPH VIVIEN
Self-Portrait

ADRIAEN VAN DER WERFF
Christ on the Cross

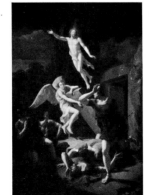

ADRIAEN VAN DER WERFF
Resurrection

ADRIAEN VAN DER WERFF
Pentecost

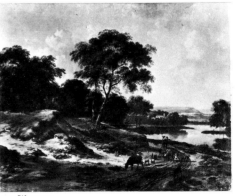

JAN WYNANTS
Landscape with Herd

Catalogue - in German and English - of the Paintings in the Alte Pinakothek and in Schleissheim Castle

List of abbreviations

act	active
ar	arched
attr	attributed
c	circa
centr	central
crt	cartoon
cv	canvas
d	dated, date
dip	diptych
drw	drawing
etc	etcetera
ext	exterior
frm	fragment
frs	fresco
ins	inscribed, inscription
int	interior, internal
l	left
min	miniature
mod	modern
mxt	mixed technique
no	number
obv	obverse
p	page
pn	panel
pp	paper
prec	preceding
pred	predella
ptg	painting
r	right
repl	replica
res	restored
rv	reverse
sg	signed, signature
st	studio
td	tondo
tmp	tempera
trp	triptych
wat	watercolor
wk	work

Measurements are given in inches and in centimeters: first the height, then the width.

The arrow → indicates the number of a color plate; the asterisk * means that the work is reproduced in black and white in the sections "Other important paintings" (pages 65-80 and 89-92).

The bar indicates that the support has been changed. For example: cv/pn = transferred from canvas onto panel.

The dash - refers to a double technique.

When no mention is made of the technique, it is understood that it is oil or tempera; when the support is not indicated, it is paper if it is a watercolor or a pastel, and ivory if it is a miniature.

Alte Pinakothek

AACHEN Hans von
Cologne 1552 – Prague 1615
Die Auferweckung des Jünglings zu Naim *
Raising of the young man of N.
cv 90.6×67.3 (230×171 cm)
sg d 1590
Der Sieg der Wahrheit → no 40
Triumph of Truth
copper 22.0×18.5 (56×47 cm)
sg d 1598

AERTSEN Pieter
Amsterdam (?) 1508 – Amsterdam 1575
Marktszene
Market scene
cv 23.2×48.4 (59×123 cm)
frm from an "Ecce Homo"

Alsloot see under **Clerck**

ALTDORFER Albrecht
Regensburg (?) c 1480 – Regensburg 1538
Drachenkampf des hl. Georg
St. George and the dragon
parchment/pn 11.0×8.7 (28×22 cm) sg d 1510
Geburt Mariae*
Birth of the Virgin
cv 55.5×51.2 (141×130 cm)
false sg
Donaulandschaft mit Schloss Wörth*
Danubian landscape with the Castle of W.
parchment/pn 11.8×8.7 (30×22 cm) sg
Maria mit dem Kind in der Glorie
Virgin and child in glory (rv *Mary Magdalene at the Sepulchre*)
pn 26.0×16.9 (66×43 cm) sg
Susanna im Bade und die Steinigung der Alten → no 26
S. bathing and the stoning of the Elders
pn 29.5×24.0 (75×61 cm) sg d 1526
Sieg Alexanders des Grossen über den Perserkönig Darius in der Schlacht bei Issus im Jahre 333 vor Chr. Geb. (Alexanderschlacht) → no 27
Victory of Alexander the Great
pn 62.2×47.2 (158×120 cm) sg d 1529 ins

AMBERGER Christoph
... c 1505 – Augsburg 1652
Hieronymus Seiler
Felicitas Seiler
Husband and wife portraits
panels 35.4×31.5 (90×80 cm)
d 1537 ins
Christoph Fugger → no 19
pn 38.2×31.5 (97×80 cm) d 1541 ins

**ANGELICO
(Fra Giovanni da Fiesole)**
Vicchio di Mugello c 1400 – Rome 1455
Die hll. Cosmas und Damian mit ihren Brüdern vor dem Prokonsul Lysias → no 93
Lysias wird von den Dämonen befreit*
Die Kreuzigung der hll. Cosmas und Damian *
Grablegung Christi → no 92
St. C. and St. D. and their brothers before the Proconsul Lisias; L. Freed from the demons; Crucifixion of St. C. and D.; Deposition
frm of pred; panels
c 15.0×18.1 (c 38×46 cm)
c 1440

ANTOLÍNEZ José
Madrid 1635 – 1675
Der Bilderverkäufer *
Picture dealer
cv 79.1×49.2 (201×125 cm) sg

ANTONELLO DA MESSINA
Messina c 1430 – 1479
Maria der Verkündigung → no 104
Virgin of the Annunciation
pn 16.5×13.0 (42×33 cm)

**ANTWERPENER MEISTER
(MASTER OF ANTWERP)**
act c 1505
Die Anbetung der Könige
Adoration of the Kings
pn 29.1×25.2 (74×64 cm)
act c 1520
Die Verkündigung
Annunciation
pn 26.0×20.1 (66×51 cm)

ARTOIS Jacques d'
Brussels 1613 – 1686 (?)
Kanal in einem Walde *
Canal in a wood
cv 104.3×95.3 (265×242 cm)
Landschaft mit hohen Bäumen
Landscape with tall trees
cv 94.9×96.5 (241×245)
Die Furt im Walde
Ford in the wood
cv 97.6×94.9 (248×241 cm)

AST Balthasar van der
Middelburg 1593-4 – Delft (?) 1657
Stilleben mit Früchten *
Still life with fruit
pn 14.2×20.5 (36×52 cm) sg

**AUGSBURGER MEISTER
(MASTER OF AUGSBURG)**
act 1510-25
Altar der hll. Narzissus und Matthäus (Universitätsaltar)
Triptych of Saints Narcissus and Matthew (University Altarpiece) (Ext *St. Christopher and St. Marguerite*. Int centr pn *St. Narcissus and St. Matthew*; wings *Virgin and child*, and *St. John the Evangelist*)
panels; centr pn 53.1×42.1 (135×107 cm); wings 53.1×19.7 (135×50 cm) ins

Avont see under
Brueghel der Ältere Jan

**BAEGERT DER ÄLTERE
(THE ELDER) Derick**
... c 1440 – ... c 1515, act Wesel
Passionsaltar *
Altarpiece of the Passion (centr pn *Crucifixion*; r pn *Lamentation of Christ*)
panels; centr pn 52.0×66.1 (132×168 cm); r pn 52.0×31.5 (132×80 cm); l pn in Brussels

BALDUNG Hans (Grien)
Schwäbisch-Gmund 1484-5 – Strasbourg 1545
Markgraf Christoph I. von Baden → no 14
The Margrave Christopher I of B.
pn 18.5×14.2 (47×36 cm) sg d 1517
Pfalzgraf Philipp der Kriegerische *
The Palatine Count Philip the Warrior
pn 16.1×12.2 (41×31 cm) sg d 1517
Geburt Christi *
Nativity
pn 41.3×27.6 (105×70 cm) sg d 1520
Allegorische Frauengestalt 5376, 1423 → nos 12, 13
Allegorical figure
panels c 32.3×13.8 (c 82×35 cm) sg; the first d 1529
Bildnis eines Strassburger Johanniters
Strasbourg knight of Malta
pn 22.4×16.5 (57×42 cm) sg d 1528 ins

BALEN Hendrick van
Antwerp 1573 (?) – 1632
Ein Göttermahl
Feast of the Gods
pn 26.8×41.7 (68×106 cm)
landscape by Jan Brueghel der Ältere

BARBARI Jacopo de'
Venice 1445-50 – Brussels (?) c 1515
Stilleben → no 105
Still life
pn 20.5×16.5 (52×42 cm) sg d 1504

BAROCCI Federico
Urbino 1535 – 1612
Christus und Magdalena *
Christ and Mary Magdalene
cv 102.0×72.8 (259×185 cm)
sg d 1590

BASAITI Marco
act Venice 1500-21
Beweinung Christi *
Lamentation of Christ
pn 48.8×35.8 (124×91 cm)

**BASSANO Jacopo
(J. da Ponte)**
Bassano 1515 – 1592
Maria mit dem Kinde und den hll. Martin und Antonius Abbas *
Virgin and child with Saints Martin and Anthony Abbot
cv 74.8×47.2 (190×120 cm)
c 1540

BAEGERT DER ÄLTERE

Maria mit dem Kinde und den hll. Jacobus maior und Johannes dem Täufer *
Virgin and child with Saints James Major and John the Baptist
cv 75.2×52.8 (191×134 cm)
Der hl. Hieronymus in der Höhle *
St. Jerome in the cave
cv 24 8×32.7 (63×83 cm)

**BAYERISCH
(BAVARIAN PAINTER)**
act c 1440
Kreuzigung Christi *
Crucifixion
pn 66.9×50.4 (170×128 cm)

Bazzi see **SODOMA**

BECCAFUMI Domenico
Montaperti c 1486 – Siena 1551
Die Heilige Familie mit dem kleinen Johannes *
Holy Family with young St. John
pn td 44.5 (113 cm)

Bedoli see
MAZZOLA-BEDOLI

BEHAM Barthel
Nuremberg 1502 – Italy 1540
Kaiserin Helena findet das Heilige Kreuz und lässt es durch Bischof Macarios erproben *
The finding of the True Cross
pn 39.8×59.1 (101×150 cm) d 1530
Herzog Ludwig X. von Bayern
Duke L. X of Bavaria
pn 37.8×28.0 (96×71 cm) sg d 1530
Pfalzgraf Ottheinrich *
Palatine Count O.
pn 16.9×12.6 (43×32 cm) d 1535 ins

Beke see **CLEVE**

**Umkreis von (Circle of)
BELLINI Gentile**
Venice 1429 (?) – 1507
Brustbild eines jungen Mannes *
Portrait of a young man
pn 15.0×12.2 (38×31 cm)

**Umkreis von (Circle of)
BELLINI Giovanni**
Venice c 1430 – 1516
"Salvator mundi"
pn 16.1×13.0 (41×33 cm)

BERCHEM Nicolaes
Haarlem 1620 – Amsterdam 1683
Felsenlandschaft mit antiken Ruinen *
Rocky landscape with ancient ruins
cv 32.7×40.9 (83×104 cm) sg
Italienische Landschaft bei Abendbeleuchtung *
Italian landscape at sunset
pn 16.1×21.3 (41×54 cm) sg

BEYEREN Abraham van
The Hague 1620-1 –
Overschie 1690
Stilleben mit Taschenkrebs
Still life with crab
pn 17.7×24.4 (45×62 cm)
Grosses Stilleben mit Hummer *
Large still life with lobster
cv 49.2×41.3 (125×105 cm) sg
d 1653

Bigordi see **GHIRLANDAIO**

BLOEMAERT Abraham
Dordrecht 1564 – Utrecht 1651
Ein Göttermahl *
Feast of the gods
cv 39.8×57.5 (101×146 cm)

BLOMMENDAEL
Reyer Jacobsz. van
... – Haarlem 1675
Christus und die Apostel am
Ölberg
Christ and the Apostles in the
garden of olives
cv 33.5×42.5 (85×108 cm) sg

BLOOT Pieter de
Rotterdam 1601-2 – 1658
Bauernbelustigung
Peasants playing
pn 13.8×22.8 (35×58 cm) sg
d 1625

BOEL Pieter
Antwerp 1622 – Paris 1674
Erlegtes Wild von zwei Hunden
bewacht *
Two dogs guarding game
cv 77.2×107.1 (196×272 cm)
sg

BOL Ferdinand
Dordrecht 1616 –
Amsterdam 1680
Bildnis eines Mannes → no 84
Portrait of a gentleman
cv 34.3×28.3 (87×72 cm)
Bildnis einer Frau *
Portrait of a young lady
cv 34.3×28.3 (87×72 cm)
sg (?)
Die Vorsteher der Weinhänd-
lergilde → no 85
Rectors of the wine mer-
manchts' guild
cv 76.0×120.1 (193×305 cm)

Bonvicino see
MORETTO DA BRESCIA

BORCH Gerard ter
Zwolle 1617 – Deventer 1681
Ein Knabe floht seinen Hund
→ no 89
Boy picking fleas from a dog
cv 13.4×10.6 (34×27 cm)
Der verweigerte Brief
The rejected letter
cv 22.0×18.1 (56×46 cm)
ins
Bildnis eines Mannes
Bildnis einer Frau *
Husband and wife portraits
canvases c 26.0×19.3
(c 66×49 cm);
the second sg d 1642

BORDONE Paris
Treviso 1500 – Venice 1571
Bildnis eines bärtigen Mannes *
Portrait of a bearded man
cv 30.7×26.0 (78×66 cm) d
1523

BOSCH Hieronymus
's-Hertogenbosch c 1450 – 1516
Bruchstück eines Jüngsten Ge-
richts *
Last Judgment
frm; pn 23.6×44.9 (60×114 cm)

BOTTICELLI (Sandro Filipepi)
Florence 1444-5 – 1510
Die Beweinung Christi → no 98
Lamentation of Christ
pn 54.7×81.5 (139×207 cm)

BOUCHER François
Paris 1703 – 1770
Hirtenlandschaft mit Fluss *
River landscape
cv 26.8×44.1 (68×112 cm) sg
d 1741
Ruhendes Mädchen → no 130
"Jeune fille en repos"
cv 23.2×28.7 (59×73 cm) sg
d 1752

Bildnis der Marquise de Pom-
padour *
Portrait of the Marchioness
of P.
cv 79.1×61.8 (201×157 cm) sg
d 1756

BOURDON Sébastien
Montpellier 1616 – Paris 1671
Befreiung der Andromeda
Rescue of A.
cv 43.7×55.5 (111×141 cm)

BOUTS Aelbrecht
... – Louvain 1549
Die Verkündigung
Annunciation
pn 44.9×42.9 (114×109 cm)

BOUTS DER ÄLTERE
(THE ELDER) Dieric
(Dirk van Haarlem?)
Haarlem (?) ... – Louvain 1475
Gefangennahme Christi → no 46
Auferstehung Christi → no 47
Johannes der Evangelist *
Betrayal of Christ; Resurrec-
tion; St. John the Evangelist
panels from an altarpiece
c 41.3×26.8 (c 105×68 cm);
the third grisaille

BOUTS DER JÜNGERE (?)
(THE YOUNGER) Dieric
... c 1448 – Louvain 1490-1
Flügelalter ("Perle von Bra-
bant") → no 48
Triptych ("Pearl of Brabant")
(Ext *St. Catherine* and *St.*
Barbara grisaille ins. Int centr
pn *Adoration of the Kings*;
wings *St. John the Baptist*
and *St. Christopher with the*
Christ Child)
panels; centr pn 24.4×24.4
(62×62 cm); wings 24.4×26.4
(62×67 cm)

BREENBERGH Bartholomeus
Deventer 1599 –
Amsterdam c 1659
Die Ruhe auf der Flucht nach
Ägypten *
Rest on the Flight into Egypt
pn 21.6×30.7 (55×78 cm) sg d
1634

BREU DER ÄLTERE
(THE ELDER) Jörg
... c 1475-6 – Augsburg 1537
Lucretia, die tugendhafte Gat-
tin des Lucius Tarquinius
Collatinus, erdolcht sich
selbst, nachdem sie durch
Sextus Tarquinius entehrt
worden war → no 20
Death of L.
pn 40.6×58.3 (103×148 cm) sg
d 1528
Der Sieg des P. Cornelius Sci-
pio über Hannibal in der
Schlacht von Zama im Jahre
202 v. Chr.
The Battle of Z.
pn 63.8×47.6 (162×121 cm) sg

BREU DER JÜNGERE
(THE YOUNGER) Jörg
Augsburg c 1510 – 1547
Königin Artemisia erobert Rho-
dos
Queen A. conquers Rhodes
pn 64.6×47.6 (164×121 cm)

BRIL Paul
Antwerp 1554 – Rome 1626
Turmbau zu Babel *
Building of the tower of B.
cv 76.0×102.0 (193×259 cm)
Italienische Gebirgslandschaft
Italian Mountain landscape
copper 10.2×13.4 (26×34 cm)
sg d 1603 or 1605
Hügelige Landschaft
Hilly landscape
copper 3.1×3.9 (8×10 cm) sg
Landschaft mit Ausblick auf ei-
ne Meeresbucht
Landscape with bay
copper 4.7×6.3 (12×16 cm)

BROUWER Adriaen
Oudenaerde 1605-6 –
Antwerp 1638
Dorfbaderstube
Interior of a village barber-
shop
pn 12.2×15.7 (31×40 cm)

Raufende Kartenspieler in einer
Schenke
Brawling card players
pn 13.0×19.3 (33×49 cm) sg
d 1610
Rauchende und trinkende Bauern
in einer Schenke
Peasants (Smoking)
pn 13.8×10.2 (35×26 cm)
Keilerei zwischen fünf Bauern
Five brawling peasants
pn 8.7×11.8 (22×30 cm)
Der Geschmack *
Das Gehör *
Das Gefühl *
Der Geruch *
Taste; Hearing; Touch; Smell
panels; c 9.1×7.9 (c 23×20
cm); the first sg
Zwei raufende Bauern am Fass
→ no 70
Two Quarrelling peasants
pn 5.9×5.5 (15×14 cm)
Schlägerei zwischen zwei
Bauern
Two peasants fighting
pn 11.8×9.8 (30×25 cm)
Kartenspielende Bauern
Peasants playing cards
pn 7.9×13.4 (20×34 cm)
Der eingeschlafene Wirt
Sleeping host
copper 12.2×9.4 (31×:24 cm)
Bauernquartett
Peasant quartet
pn 16.9×22.8 (43×58 cm)
Kartenspielende Bauern in ei-
ner Schenke
Peasants playing cards
pn 13.0×16.9 (33×43 cm)
Eine Trinkstube
Tavern
pn 14.2×10.6 (36×27 cm)
Würfelnde Soldaten in einer
Schenke
Soldiers playing dice
pn 13.8×18.1 (35×46 cm)
Wirt und Wirtin bei der Wein-
probe
Wine tasting
pn 15.4×20.5 (39×52 cm)

BRUEGEL DER ÄLTERE
(THE ELDER) Pieter
Brueghel (?) c 1515 –
Brussels 1569
Das Schlaraffenland → no 53
Land of Cockayne
pn 20.5×30.7 (52×78 cm) sg d
1567
Kopf einer alten Bäuerin
→ no 52
Head of an old peasant wo-
man
pn 8.7×7.1 (22×18 cm)

BRUEGHEL DER ÄLTERE
(THE ELDER) Jan
Brussels 1568 – Antwerp 1625
Landschaft mit dem hl. Hiero-
nymus
Landscape with St. Jerome
copper 10.2×13.8 (26×35 cm)
sg d 159..
Seehafen mit der Predigt Chri-
sti → no 58
Sea port with Christ preach-
ing
pn 30.7×46.9 (78×119 cm) sg
d 1598
Der Kalvarienberg
Calvary
copper 14.2×21.6 (36×55 cm)
sg d 1598
Die Predigt Johannes des Täu-
fers
St. John the Baptist preaching
pn 20.1×23.2 (51×59 cm) sg d
1598
Die Enthaltsamkeit des Scipio *
Temperance of S.
copper 28.3×42.1 (72×107 cm)
sg d 1600 or 1609
Grosser Fischmarkt *
The great fish market
pn 22.8×35.8 (58×91 cm) sg
d 1603
Fischmarkt am Ufer eines Flus-
ses
Fishmarket beside a river
copper 11.4×16.5 (29×42 cm)
sg 1605
Belebte Waldstrasse
Forest road with figures
copper 9.8×14.2 (25×36 cm)
sg d 1605
Landschaft mit Windmühle *
Landscape with windmill
pn 16.1×24.4 (41×62 cm) sg d
1608
Landschaft mit Gepäckzug
Landscape with caravan
copper 8.3×11.8 (21×30 cm)
sg d 1610

Dorfstrasse
Village Street
copper 3.1×5.1 (8×13 cm) sg
d 1610
Windmühle auf weiter Ebene
Erzherzog Albrecht und Isabel-
la vor Schloss Mariemont
Windmill on a wide plain;
The Archduke A. and I. be-
fore the Castle of M.
copper 3.9×5.9 (10×15 cm) sg
d 1611
Rast auf einem Hügel
Rest on a hill
copper 9.8×173.0 (25×33 cm)
sg d 1612
Die überschwemmte Landstras-
se
Flooded Street
copper 9.8×13.0 (25×33 cm)
sg d 1614
Landungsplatz
Landing
copper 10.2×14.6 (26×37 cm)
sg d 1615
Belebte Landstrasse
Street with figures
copper 10.6×14.6 (27×37 cm)
sg d 1619
Waldlandschaft mit dem hl. Hu-
bertus
Forest with St. Hubert
copper 19.7×28.3 (50×72 cm)
sg d 1621
Wirtshaus an der Uferstrasse
Tavern
copper td 8.3 (21 cm) sg d 16..
Sodom und Gomorrha
Das brennende Troja *
S. and G.; The burning Troy
copper 10.2×13.8 (26×35 cm);
the first sg
Blumenstrauss *
Bunch of flowers
pn 49.2×37.8 (125×96 cm)
Landschaft mit Dorfschenke
Landscape with Village tavern
copper 12.6×17.3 (32×44 cm)
Landschaft
Landscape
pn td 7.1 (18 cm)
Jonas entsteigt dem Walfisch
→ no 57
Jonah leaving the whale
pn 15.0×22.0 (38×56 cm)
Landschaft mit der Ruhe auf
der Flucht
Landscape with rest on the
flight into Egypt
pn td 8.3 (21 cm)
figures possibly by Pieter van
Avont (Malines 1600 - Deurne
1652)
Die Ernte
Harvest
copper td 4.7 (12 cm)
Römischer Karneval
Roman carnival
copper td 4.7 (12 cm)
Die Heilige Familie
Holy Family
pn 36.6×28.3 (93×72 cm)
in collaboration with Pieter
van Avont
Die Weissagung des Propheten
Jesaias
Prophecy of Isaias
copper 15.7×19.7 (40×50 cm)
ins c 1600
figures by Hendrick van Ba-
len
Die Versuchung des hl. Anto-
nius
Temptation of St. Anthony
copper td 5.1 (13 cm) attr
see also Balen, Momper, Ru-
bens

BRUGGHEN Hendrick ter
Deventer 1588 – Utrecht 1629
Der Landsknecht
Knight
cv 28.0×23.6 (71×60 cm) sg
d 1627

BRUYN DER ÄLTERE
(THE ELDER) Bartholomäus
Lower Rhineland 1493 –
Cologne 1555
Kreuzigungsaltar
Triptych of the Crucifixion
(Ext *St. Henry, Emperor* and
St. Helena grisaille. Int centr
pn *Crucifixion with the Vir-*
gin, Saints and three donors;
wings *Holy bishop and donor*
and *St. Agnes and donor*)
panels; centr pn 37.8×28.7
(96×73 cm); ext of the wings
37.4 and 38.2×12.6 (95 and
97×32 cm)
detached panels

Kreuzigung Christi
Christ carrying the Cross
pn 29.5×22.8 (75×58 cm)
Bildnis eines unbekannten Man-
nes
Portrait of an unknown man
pn 19.7×13.8 (50×35 cm)

BURGKMAIR DER ÄLTERE
(THE ELDER) Hans
Augsburg 1473 – 1531
Martin Schongauer (?) *
pn 11.8×8.7 (30×22 cm) ins
Johannesaltar * → no 16
St. John Triptych (Ext St.
John the Baptist and St. John
the Evangelist. Int centr pn
St. J. the E. at Patmos; wings
St. Erasmus and St. Martin
and the beggar)
panels; centr pn 60.2×49.2
(153×125 cm);
wings c 57.5×17.7 (c 146×45
cm); sg d 1518
ext of the wings detached
Kreuzigungsaltar → no 17
Triptych of the Crucifixion
(Ext St. Sigismund and St.
George. Int centr pn Crucifi-
xion with Virgin, St. John and
Mary Magdalene; wings The
good Thief and St. Lazarus
and the bad Thief and St.
Martha)
ar panels; centr pn 70.5×45.7
(179×116 cm);
wings c 70.9×21.3 (c 180×54
cm);
ext of the wings detached
Königin Esther setzt sich bei
ihrem Gemahl, König Ahas-
ver, für die Rettung des jüdi-
schen Volkes in ihrem Kö-
nigreich ein *
E. intercedes for the life of
the Jews before King Aha-
suerus
pn 40.6×61.4 (103×156 cm)
sg d 1528

Busi see **CARIANI**

Caliari see **VERONESE**

CANALETTO
(Giovanni Antonio Canal)
Venice 1697 – 1768
Piazzetta und Bacino di S. Mar-
co in Venedig *
View of Venice
cv 27.2×37.0 (69×94 cm)
Santa Maria della Salute und
die Riva degli Schiavoni in
Venedig *
S. M. della S., Venice
cv 27.6×36.2 (70×92 cm)

CANDID (Pieter de Witte)
Bruges c 1548 – Munich 1628
Die Tochter des Jephta
J.'s daughter
cv 42.9×33.1 (109×84 cm)
Herzogin Magdalena von Bayern
→ no 55
M. Duchess of Bavaria
pn 38.2×28.0 (97×71 cm)

CANO Alonso
Granada 1601 – 1667
Die Vision des hl. Antonius von
Padua *
Vision of St. Anthony of P.
cv 63.4×43.7 (161×111 cm)

CARIANI (Giovanni Busi)
Venice (?) 1485-90 – c 1547
Maria mit dem Kinde, dem Jo-
hannesknaben und dem hl.
Antonius Abbas in einer Land-
schaft *
Virgin and child with saints
cv 44.6×78.3 (164×199 cm)

CAVALLINO Bernardo
Naples 1616 – 1656
Erminia unter den Hirten *
Erminia und der verwundete
Tancred *
E. and the shepherds; E. and
the wounded Tancred
canvases/panels tondos 19.7
and 20.5 (50 and 52 cm)

CHAMPAIGNE Philippe de
Brussels 1602 – Paris 1674
Der Feldherr Vicomte de Tu-
renne
Portrait of the Viscount of T.
pn 31.1×25.2 (79×64 cm)

CHARDIN
Jean-Baptiste Siméon
Paris 1699 – 1779
Die Rübenputzerin *
Woman peeling turnips
cv 18.1×14.6 (46×37 cm) sg

CIMA DA CONEGLIANO
Giovanni Battista
Conegliano c 1459 – 1517-8
Maria mit dem Kinde und den
hl. Hieronymus und Magda-
lena *
Virgin and Child with saints
pn 31.5×48.4 (80×123 cm) sg

CLAESZ. Pieter
*Burgsteinfurt 1597-98 –
Haarlem 1661*
Stilleben mit Zinnkanne
Still life with pewter jug
pn 22.0×33.9 (56×86 cm)

CLERCK Hendrick de
Brussels c 1570 – 1629
Adam und Eve
A. and Eve
ar copper 5.1×3.1 (13×8 cm)
Das Paradies *
Paradise
copper 20.5×25.2 (52×64 cm)
sg (de Clerck and van Als-
loot)
in collaboration with Denis
van Alsloot
(... c 1570 [?] – ... c 1626 Brus-
sels)

CLEVE Joos van
(J. van der Beke, J. van Cleef)
... c 1480 – Antwerp 1540-41
Flügelaltar ** → no 43
*Triptych (Ext St. Christopher
and St. Anne and St. Sebas-
tian and St. Roche grisaille.
Int centr pn Death of the Vir-
gin; wings St. George and
St. Nicasius with the donors
Nicasius and George Hacke-
ney, and St. Christina and
St. Gudula with the donors'
wives)*
panels; centr pn 52.0×60.6
(132×154 cm); wings 52.0×28.7
and 29.1 (132×73 and 74 cm)
Bildnis einer Frau *
Portrait of a lady
pn 21.3×15.4 (54×39 cm)

COELLO Claudio
Madrid 1642 – 1693
Doña Maria Anna von Öster-
reich *
D. M. A. of Austria
cv 71.7×52.0 (182×132 cm)
Der hl. Petrus von Alcantara
wandelt über den Fluss Qua-
diana *
*St. Peter of A. walking on the
river Q.*
cv 90.6×78.3 (230×199 cm)

COYPEL Charles Antoine
Paris 1694 – 1752
Herkules und Omphale
Hercules and O.
cv 70.9×52.4 (180×133) sg d
1731

**CRANACH DER ÄLTERE
(THE ELDER) Lucas**
Kronach 1472 – Weimar 1553
Christus am Kreuz, die beiden
Schächer sowie Maria und
Johannes → no 36
Crucifixion
pn 54.3×39.0 (138×99) d 1503
Adam und E.
A. and E.
pn 18.5×13.8 (47×35 cm)
Maria mit dem Kind, dem sie
eine Traube reicht → no 35
Virgin and Child with grapes
pn 23.6×16.5 (60×42 cm)
(lower l hand corner winged
dragon as emblem)
Hl. Anna Selbdritt auf einer
Rasenbank
*St. Anne with the Virgin and
the Infant Christ*
pn 24.0×15.7 (61×40 cm)
Christus am Kreuz zwischen
den beiden Schächern
*Christ crucified between two
thieves*
pn 20.5×11.8 (52×30 cm)
winged dragon below
Hans (?) Melber → no 33
pn 23.6×15.4 (60×39 cm) d
1526
upper l winged dragon

Kardinal Albrecht von Branden-
burg in Anbetung vor dem
Gekreuzigten *
*Cardinal A. of B. before a
crucifix*
pn 62.2×44.1 (158×112 cm)
Johannes Geiler von Kaysers-
berg (?) → no 34
pn 11.8×9.1 (30×23 cm) mu-
tilated
Das Goldene Zeitalter →
The Golden age
cv/pn 28.7×41.3 (73×105 cm)
Selbstmord der Lucretia *
Death of L.
pn 76.4×29.5 (194×75 cm)
winged dragon below

**CRANACH DER JÜNGERE
(THE YOUNGER) Lucas**
Wittenberg 1515 – Weimar 1586
Venus und Amor *
Cupid and V.
pn 77.2×35.0 (169×89 cm)
Bildnis einer Dame → no 38
Portrait of a lady
pn 34.3×27.2 (87×69 cm)
lower r winged dragon

CREDI Lorenzo di
Florence 1459 (?) – 1537
Die Geburt Christi *
Nativity
pn td 38.6 (98 cm)

CUYP Aelbert
Dordrecht 1620 – 1691
Flachlandschaft
Landscape
pn 11.4×17.3 (29×44 cm)
Der Weideplatz *
Pasture
cv 38.2×68.9 (97×175) sg

CUYP Benjamin Gerritsz.
Dordrecht 1612 – 1652
Der Pferdeknecht
Groom
pn 13.8×16.9 (35×43 cm)

Da Ponte see BASSANO

DALEM Cornelis van
... 1530-5 – ... act 1556 Antwerp
Landschaft mit Gehöft *
Landscape with farmhouse
pn 40.6×50.0 (103×127 cm) sg
d 1564

DAVID Gerard
Oudewater 1460 – Brussels 1523
Maria mit dem Kind
Abschied Christi von Maria
*Virgin and child; Christ's
farewell to the Virgin*
ar panels 3.9×2.7 (10×7 cm)
detached panels of a diptych
Anbetung der Könige *
Adoration of the Kings
pn 48.4×65.4 (123×166 cm)

DAVID Jacques-Louis
Paris 1748 – Brussels 1825
Die Marquise de Sorcy de Thé-
lusson *
The Marchioness of S. of T.
cv 50.4×38.2 (128×97 cm) sg
d 1790

DERUET Claude
Nancy 1588 – 1662
Raub der Sabinerinnen
Rape of the Sabine women
cv 45.3×73.2 (115×186 cm)

Desiderio (Monsù) see NOME

**DOMENICHINO
(Domenico Zampieri)**
Bologna 1581 – Naples 1641
Der hl. Matthäus und der Engel
St. Matthew and the Angel
copper 11.0×8.3 (28×21 cm)

DOU Gerrit
Leyden 1613 – Naples 1675
Das Tischgebet der Spinnerin
The Spinner's prayer
pn 11.0×11.0 (28×28 cm) sg

DUJARDIN Karel
*Amsterdam (?) c 1622 –
Venice 1678*
Die kranke Ziege *
Sick goat
cv 33.1×28.7 (84×73 cm) sg

DÜRER Albrecht
Nuremberg 1471 – 1528
Maria als Schmerzensmutter *
Virgin of sorrows
pn 42.9×16.9 (109×43 cm)
part of the Seven Dolours of
Dresden series
Oswolt Krel → no 21
O. K. (wings *Woodsman* with
coat of arms of O. K. and
Woodsman with coat of arms
of Agata von Esendorf)
panels; centr pn 19.3×15.4
(49×39 cm); wings 19.3×6.3
(c 49×16 cm); d 1499
Selbstbildnis → no 22
Self-portrait
pn 26.4×19.3 (67×49 cm) sg
d 1500 ins
Bildnis eines jungen Mannes *
Portrait of a young man
pn 11.0×8.3 (28×21 cm) d
1500 mutilated
Beweinung Christi (Glimmsche
Beweinung) → no 38
*Lamentation of Christ (Glimm
Lamentation)*
pn 59.4×47.6 (151×121 cm)
Paumgartneraltar → no 24
*Paumgartner Triptych (Ext
Virgin of the Annunciation
grisaille. Int centr pn Nativity
with donors; wings St. Geor-
ge [Stephen Paumgartner?]
and St. Eustace [Lukas Paum-
gartner?])*
panels; centr pn 61.0×49.6
(155×126 cm); wings 61.8×24.0
(157×61 cm) sg
ext of r pn is missing
Innenseiten des Flügelpaars
vom sog. Jabach'schen Al-
tar **
*Inside of the wings of Jabach
Altarpiece (l St. Joseph and
St. Joachim; r St. Simeon and
St. Lazarus)*
ar panels 37.8×21.3 and
38.2×21.6 (96×54 and 97×55
cm) sg ins
the outsides of wings in Co-
logne
Muttergottes mit der Nelke *
Virgin of the carnation
parchment/pn 15.4×11.4
(39×29 cm) sg d 1516
Selbstmord der Lucretia *
Death of L.
pn 66.1×29.5 (168×75 cm) sg
d 1518
Die Vier Apostel → no 25
*Four Apostles (l St. John the
Evangelist and Peter; r St.
Mark the Evangelist and Paul)*
panels 84.6×29.9 (21.5×76 cm)
sg d 1526

DYCK Anthonis van
*Antwerp 1599 –
Blackfriars (London) 1641*
Beweinung Christi 404
Lamentation of Christ
cv 79.9×61.4 (203×156 cm)
Beweinung Christi 606 *
pn 42.9×58.7 (109×149 cm)
Susanna im Bade
S. Bathing
cv 76.4×56.3 (194×143 cm)
Martyrium des hl. Sebastian
607 *
Martyrdom of St. Sebastian
cv 78.3×59.1 (199×150 cm)
Martyrium des hl. Sebastian
371
Martyrdom of St. Sebastian
cv 89.8×63.8 (228×162 cm)
Maria mit dem Kind und dem
Johannesknaben
Virgin and child with St. John
pn 59.4×44.9 (151×114 cm)
Ruhe auf der Flucht → no 69
Rest on the flight into Egypt
cv 52.8×44.9 (134×114 cm)
Jugendliches Selbstbildnis
→ no 67
Self-portrait as a young man
cv 31.9×27.2 (81×69 cm)
Der Bildhauer Georg Petel
The sculptor G. P.
cv 28.7×22.4 (73×57 cm)
Sebastian Leerse, Kaufmann in
Antwerpen (?)
Die zweite Gemahlin des Se-
bastian Leerse
*portraits of the Antwerp mer-
chant S. L. and of his second
wife*
canvases c 80.7×47.6
(c 205×121 cm)
Herzog Wolfgang Wilhelm von
Pfalz-Neuburg
Duke W. W. of P.-N.
cv 81.1×52.0 (206×132 cm)

Der Bildhauer Colyn de Nole
(?) *
Die Gemahlin des Colyn de
Nole mit ihrer Tochter (?) *
*portraits of the sculptor C.
d. N. (?) and of his wife and
daughter*
panels 48.4×35.4 (123×90 cm)
Bildnis eines Mannes 407 *
Portrait of a man
cv 77.2×46.5 (196×118 cm)
Bildnis eines Mannes 995
Bildnis einer Dame
*portraits of a gentleman and
a lady*
canvases 83.1×53.9 and
82.7×53.5 (211×137 cm and
210×136 cm)
Der Maler Jan de Wael und sei-
ne Frau Gertrud de Jode
*The painter J. d. W. and his
wife G. d. J.*
cv 49.6×55.1 (126×140 cm)
Der Kupferstecher Karel van
Mallery
The engraver K. v. M.
cv 41.7×35.0 (106×89 cm)
Der Organist Heinrich Liberti
The organist H. L.
cv 42.5×34.6 (108×88 cm)
Der Schlachtenmaler P. Snayers
The painter of battles, P. S.
pn 11.0×8.3 (28×21 cm)
Die Gambenspielerin → no 68
*Lady playing a viola de gam-
ba*
cv 44.9×37.8 (114×96 cm)
Sauhatz
Boar hunt
cv 80.7×120.1 (205×305 cm)
school

EECKHOUT Gerbrand van den
Amsterdam 1621 – 1674
Alexander und die Frauen des
Darius
A. and D.' family
cv 81.5×94.1 (207×239 cm)

ELSHEIMER Adam
Frankfurt 1578 – Rome 1610
Die Flucht nach Ägypten → no
39
Flight into Egypt
copper 12.2×16.1 (31×41 cm)
sg d 1609
Der Brand von Troja *
Burning of Troy
copper 14.2×19.7 (36×50 cm)
Die Predigt Johannes des Täu-
fers
*St. John the Baptist preach-
ing*
copper 15.7×21.6 (40×55 cm)

ENGELBRECHTSZ. Cornelis
Leyden 1468 – 1533
Beweinung Christi
Lamentation of Christ
pn 45.3×48.8 (115×124 cm)
Die hll. Konstantin und Helena
*St. Constantine and St. He-
lena*
pn 34.3×22.0 (87×56 cm)

FABRITIUS Carel
*Midden-Beemster 1622 –
Delft 1654*
Selbstbildnis (?) → no 86
Self-portrait (?)
cv 24.4×20.1 (62×51 cm) sg
mutilated attr

**FERRARESISCH
(PAINTER OF FERRARA)**
act 1480
Thronende Madonna mit vier
Heiligen
*Virgin enthroned with four
saints*
pn 16.9×17.3 (43×44 cm)

**FERRARESISCHER MEISTER
(MASTER OF FERRARA)**
act 1480-90
Familienbildnis
Family of Uberto de' Sacrati
cv 44.1×35.4 (112×90 cm) ins

FESELEN Melchior
... c 1495 – Ingolstadt 1538
Cloelia und andere als Geiseln
gehaltene Römerinnen wer-
den vom Etrusker König Por-
senna während seiner Bela-
gerung Roms wegen des von
ihnen bewiesenen Mutes frei-
gelassen
P. frees the Roman ladies
pn 40.6×66.1 (103×168 cm) sg
d 1529

Der Bildhauer Colyn de Nole

Belagerung der Stadt Alesia
durch Julius Caesar und der
Kampf gegen Vercingetorix *
J. C. before A.
pn/cv 63.8×47.6 (162×121 cm)
sg d 1533

FETTI Domenico
Rome 1589 – Venice 1624
"Ecce Homo" *
pn 31.9×25.2 (81×64 cm) ins

**FLÄMISCH
(FLEMISH PAINTER)**
act c 1556
Seeschlacht und Schiffbruch *
Naval battle and sinking ship
pn 30.7×58.7 (78×149 cm) d
1556

act c 1630
Familienbild *
Family portrait
cv 87.4×116.9 (222×297 cm)

FLEGEL Georg
Olmütz 1566 – Frankfurt 1638
Grosses Schauessen *
Still life
pn 30.7×26.4 (78×67 cm) sg
Stilleben *
Still life
pn 8.7×11.0 (22×28 cm)

Flinck see under Rembrandt

FLORIS DE VRIENDT Frans
Antwerp c 1516 – 1570
Weibliche Halbfigur *
Female figure
pn 29.5×19.7 (75×50 cm)
mutilated
Die Heilige Familie
Holy Family
pn 37.8×35.4 (96×90 cm) sg
Mann mit roter Mütze *
Man with red cap
pn 14.2×10.2 (36×26 cm) attr

**FRANCIA
(Francesco Raibolini)**
Bologna 1460 – 1517
Madonna im Rosenhag *
The Virgin in a rosery
pn 68.5×52.0 (174×132 cm) sg
Maria mit dem Kinde und zwei
Engeln *
*Virgin and Child with two an-
gels*
pn 25.2×19.3 (64×49 cm)

FRANCKEN II Frans
Antwerp 1581 – 1642
Gastmahl im Hause des Bürger-
meisters Rockox → no 56
*Banquet in the house of bur-
gomaster R.*
pn 24.4×37.8 (62×96 cm) sg

**FRANZÖSISCH
(FRENCH PAINTER)**
act 1520-30
Mann mit schwarzem Barett
Man with black cap
pn 13.8×10.6 (35×27 cm)

FRIES Hans
*Fribourg i. Üchtland c 1465 –
c 1518 Bern*
Teile eines Altars oder ver-
schieder Altarwerke ***
Wings from one or more altar-
pieces
*(Raising of the elect; Fall of
the damned; Vision of St.
Bernard; Stigmata of St.
Francis; Martyrdom of St. Se-
bastian; St. Anne, the Virgin
and the Infant Christ)*
panels, the first two
c 49.2×10.6 (c 125×27 cm);
the others c 25.2×14.6
(c 64×37 cm); the third sg d
1501; the sixth ins
reverses of the last four were
originally painted or had re-
lief decorations

**FRUEAUF DER ÄLTERE
(THE ELDER) Rueland**
... 1440-5 (?) – Passau 1507
Christus als Schmerzensmann
→ no 30
Christ crowned with thorns
pn 71.7×45.7 (182×116 cm)

FYT Jan
Antwerp 1611 – 1661
Rehe, von Hunden verfolgt
Deer fleeing from hounds
cv 76.8×120.9 (195×307 cm)
sg

Bärenjagd
Bear hunt
cv 76.8×121.2 (195×308 cm)
sg
Sauhatz
Boar hunt
cv 76.8×120.1 (195×305 cm)
sg

GADDI Taddeo
act 1334-66 Florence
Teile der Türen eines Sakristeischrankes aus S. Croce in Florenz, mit den originalen Vierpassrahmen *
Panels from a wardrobe from Florence (Death of the Lord of Celano and Trial by fire of St. Francis)
panels c 13.8×12.2 (c 35×31 cm)

GELDER Aert de
Dordrecht 1645 – 1727
Esther lässt sich schmücken (Die Judenbraut) *
Toilet of E. (The Jewish bride)
cv 54.7×64.2 (139×163 cm) sg d 1684

Gellée see **LORRAIN**

GENTILESCHI Orazio
Pisa c 1565 – London 1647
Zwei Frauen mit einem Spiegel *
Two women with a mirror
cv 52.4×60.6 (133×154 cm)

GHIRLANDAIO (Domenico di Tommaso Bigordi)
Florence 1449 – 1494
Maria mit dem Kinde und den hll. Dominikus, Michael, Johannes dem Täufer und Johannes dem Evangelisten → no 97
Virgin and child with Saints
centr pn from an altarpiece
87.0×78.0 (221×198 cm)

GIORDANO Luca (L. Fa Presto)
Naples 1632 – 1705
Kreuzabnahme des hl. Andreas
St. Andrew taken down from the cross
cv 101.6×77.6 (258×197 cm) sg ("Josepe de Ribera Español") d 1644 (false sg and d)
Ein cynischer Philosoph 492, 493 *
Cynic philosopher
canvases 51.6×40.6 (131×103 cm)

GIORGIONE (Giorgio da Castelfranco)
Castelfranco c 1477 – Venice 1510
Bildnis eines jungen Mannes → no 107
Portrait of a young man
pn 27.2×20.9 (69×53 cm)
Junger flötenspielender Satyr *
Young satyr playing a flute
pn 7.5×6.3 (19×16 cm)

GIOTTO DI BONDONE
Vicchio di Mugello c 1267 – Florence 1337
Das Letzte Abendmahl → no 91
Christus am Kreuz
Christus in der Vorhölle *
Last Supper; Crucifixion; Descent into Limbo
panels of pred c 17.7×16.9 (c 45×43)

GIOVANNI DI PAOLO DI GRAZIA
Siena c 1403 – 1482
Die Geburt Johannes des Täufers
Johannes vor Herodes
Birth of John the Baptist; J. t. B. before Herod
panels from an altarpiece 28.7×15.0 and 29.9×13.0 (78×38 cm and 76×33 cm)

GOES Hugo van der
Gand (?) ... – Roodekloster 1482
Maria mit dem Kind und Engel mit den Leidenswerkzeugen → no 50
Virgin and child with angel and instruments of the Passion
cv 21.6×17.3 (55×44 cm)

GOLTZIUS Hendrick
Mühlbrecht 1558 – Haarlem 1616-7
Venus und Adonis *
V. and A.
cv 44.9×75.2 (114×191 cm) sg d 1614

GOSSAERT Jan (Mabuse)
Duurstede or Maubeuge c 1480 – Antwerp c 1534
Maria mit dem Kind *
Virgin and Child
ar pn 11.8×9.4 (30×24 cm) sg d 1527
Danae → no 49
pn 44.5×37.4 (113×95 cm) sg d 1527

Gothard-Neithardt see **GRÜNEWALD**

GOYA Y LUCIENTES Francisco José de
Fuendetodos 1746 – Bordeaux 1828
Bildnis der Doña Maria Teresa de Vallabriga, Condesa de Chinchón → no 122
D. M. T., Countess of C.
cv 59.4×38.6 (151×98 cm)
Don José Queralto als spanischer Armeearzt → no 121
D.J.Q., doctor in the Spanish Army
cv 40.2×29.9 (102×76 cm) 1802 ins
Gerupfte Pute *
Still life with plucked turkey
cv 17.7×24.4 (45×62 cm) sg
Marquesa de Caballero *
Marchioness of C.
cv 41.3×33.1 (15×84 cm) sg d 1807

GOYEN Jan van
Leyden 1596 – The Hague 1656
Landschaft mit Bauernhof
Landscape with farmhouse
pn 16.1×26.0 (41×66 cm) sg d 1629
Dorf am Fluss
Village on river bank
pn 15.4×23.6 (39×60 cm) sg d 1636
Landschaft mit Motiv aus Leiden
Landscape with Leyden architecture
pn 15.7×23.2 (40×59 cm) sg d 1643
Der Marketenderzug
Quartermaster's Convoy
pn 4.4×7.1 (11×18 cm) sg d 1646
Der Pferdewagen auf der Brücke → no 77
Coach and horses on a bridge
pn 14.6×26.0 (37×66 cm) sg d 1648

GRECO El (Doménikos Theotokópoulos)
Candia 1541 – Toledo 1614
Die Entkleidung Christi → no 117
Disrobing of Christ
cv 65.0×39.0 (165×99 cm)
Die hl. Veronika mit dem Schweisstuch Christi
Veronica with the holy veil
cv 40.6×31.1 (103×79 cm) st

GREUZE Jean-Baptiste
Tournus 1725 – Paris 1805
Die Klagen der Uhr → no 131
Lament of the watch
cv 31.1×24.0 (79×61 cm)

Grien see **BALDUNG**

GRÜNEWALD (Matthis Gothardt-Neithardt)
... c 1475 – Halle a.d. Saale 1528
Verspottung Christi → no 8
Christ scorned
pn 42.9×28.7 (109×73 cm)
Die hll. Erasmus und Mauritius → no 9
St. E. and St. Maurice
pn 89.0×69.3 (226×176 cm)

GUARDI Francesco
Venice 1712 – 1793
Der Canal Grande bei S. Geremia *
Grand Canal near St. Jeremiah's
cv 28.0×47.2 (71×120 cm)

Blick auf den Rialto und den Palazzo dei Camerlenghi *
View of the R.
cv 28.3×47.2 (72×120 cm) sg
Der Uhrturm am Markusplatz
Tower of St. Mark's
cv 17.3×27.6 (44×70 cm)
Blick auf Santa Maria della Salute und die Dogana
View of S. M. d. S.
cv 16.9×23.2 (43×59 cm)
Tordurchblick *
View through an arch
cv 23.6×16.9 (60×43 cm)
Venezianisches Galakonzert → no 111
Gala concert in Venice
cv 26.8×35.8 (68×91 cm)
Der Brand im Quartier von S. Marcuola, 1789 → no 112
Blaze in the S. M. quarter
cv 16.5×24.4 (42×62 cm)

HALS Frans
Antwerp (?) 1580-1 – Haarlem 1666
Bildnis eines Mannes (Willem Croes?) → no 72
Portrait of a man
pn 18.5×13.4 (47×34 cm) sg
Bildnis des Willem van Heythuyzen *
Portrait of W. v. H.
cv 80.7×53.1 (205×135 cm)

HEEM Jan Davidsz. de
Utrecht 1606 – Antwerp 1683-4
Blumenstrauss mit Kruzifix und Totenkopf *
Flowers with Crucifix and skull
cv 40.6×33.5 (103×85 cm) sg
in collaboration with Nicolaes van Veerendael (Antwerp 1640-1691)

HEINTZ Joseph
Basel 1564 – Prague 1609
Satyr und Nymphen *
Satyrs and nymphs
copper, oval 9.4×12.6 (24×32 cm) sg d 1599
Amor schnitzt den Bogen
Cupid drawing his bow
pn 54.7×26.8 (139×68 cm)
copy from Parmigianino (Parma 1503 – Casalmaggiore 1540)
see also under Rubens

HEISS Johann
Memmingen 1640 – Augsburg 1704
Christus bei Maria und Martha
Christ in the house of M. and Mary
cv 35.4×26.4 (90×67 cm)

HELST Bartholomeus van der
Haarlem 1613 – Amsterdam 1670
Bildnis eines Mannes in schwarzem Atlasrock *
Bildnis einer Frau in schwarzer Atlasrobe *
Husband and wife portraits (?)
canvases c 43.7×34.6 (c 111×88 cm)
the first sg d 1649

HEMESSEN Jan Sanders van
Hemessen c 1504 – Haarlem 1555
Die Berufung des Matthäus
Vocation of the Apostle Matthew
pn 46.9×60.6 (119×154 cm) sg d 1536 ins
a strip has been added at the top and another at r
Die Vespottung Christi *
Christ scorned
pn 48.4×40.2 (123×102 cm) sg d 1544
Isaak segnet Jacob *
Isaac blessing J.
pn 46.5×59.1 (118×150 cm)

HEY Jean
act 1500, France
Karl II. von Bourbon, Kardinalbischof von Lyon
Charles II of B., cardinal bishop of L.
pn 13.4×9.8 (34×25 cm)

HEYDEN Jan van der
Gorinchem 1637 – Amsterdam 1712
Ein Platz in Köln
Square in Cologne
pn 19.3×23.2 (49×59 cm) sg
Das Alte Palais in Brüssel
The Old Palace in Brussels
pn 20.1×24.8 (51×63 cm) sg

HOBBEMA Meindert
Amsterdam 1638 – 1709
Landschaft *
Landscape
pn 20.5×25.6 (52×65 cm) sg

HOLBEIN DER ÄLTERE (THE ELDER) Hans
Augsburg c 1465 – ... 1524
Flügel des Kaisheimer Altares → no 11
Panels of the Kaisheim altarpiece (Ext upper l Christ in the Garden of Olives and Capture of C.; below Crowning with thorns and "Ecce Homo." Ext upper r Christ before Pilate and Scourging; below Christ carrying the Cross and Resurrection. Int upper l Presentation of the Virgin and Annunciation; below Circumcision and Adoration of the Kings. Ext upper l Visitation and Nativity; below Presentation of Jesus and Death of the Virgin)
panels; ext panels detached l panels c 55.9×33.1 (c 142×84 cm), r panels c 70.5×32.3 (c 179×82 cm); int l panels c 70.5×32.3 (c 179×82 cm); int r panels c 55.5×33.5 (c 141× 85 cm); sg d 1502
Sebastiansaltar *
St. Sebastian Triptych (Ext Angel of the Annunciation and Virgin of the Annunciation grisaille. Int centr pn Martyrdom of St. Sebastian; wings St. Barbara and St. Elizabeth with three beggars)
panels; centr pn 60.2×42.1 (153×107 cm); wings 59.1×57.9 (150×147 cm) 1516

HOLBEIN DER JÜNGERE (THE YOUNGER) Hans
Augsburg 1497-8 – London 1543
Derich Born → no 18
pn td 3.9 (10 cm) d 1530 ins

HOLLÄNDISCH (DUTCH PAINTER)
act 1590
Der Fahnenträger *
Flag bearer
pn 41.3×34.3 (105×87 cm) d 1590 ins

HONDECOETER Melchior de
Utrecht 1636 – Amsterdam 1695
Der Hühnerhof
Poultry-yard
cv 36.2×43.7 (92×111 cm) sg
Geflügel im Hofe eines Landhauses *
Geflügel in einem Park *
Chickens in a country house courtyard; Chickens in a park
canvases 152.8×74.0 and 82.3 (388×188 cm and 209 cm)
Vogelpark *
Birds in a park
cv 133.5×206.3 (339×524 cm)

HONTHORST Gerrit van
Utrecht 1590 – 1656
Fröhliche Gesellschaft ("Der verlorene Sohn") → no 74
Gay Company ("Prodigal son")
cv 51.2×77.2 (130×196 cm) sg d 1622

HOOCH Carel Cornelisz. de
... – Utrecht 1638
Landschaft mit Haus
Landscape with house
pn 3.5×6.3 (9×16 cm) sg
Landschaft mit Stadtmauer *
Landscape with city walls
pn 3.5×6.3 (9×16 cm) sg

HUBER Wolf
Feldkirch (?) c 1485 – Passau 1553
Teile eines Flügelaltars *
Panels of an altarpiece (upper l Christ in the garden of Olives; upper r Capture of C.)
panels c 24.0×26.4 (c 61×67 cm)
on rv traces of reliefs

HUYSUM Jan van
Amsterdam 1682 – 1749
Früchte, Blumen und Insekten
Fruit, flowers and insects
cv 15.7×13.0 (40×33 cm) sg

Korb mit Blumen
Basket of flowers
pn 15.4×12.6 (39×32 cm) **sg**

ISENBRANT Adriaen
... – Bruges 1551
Ruhe auf der Flucht *
Rest on the flight into Egypt
ar pn 19.3×13.4 (49×34 cm)
Darbringung Christi im Tempel
Presentation of Jesus in the Temple
pn 18.9×19.3 (48×49 cm)
Maria mit dem Kind und sechs weiblichen Heiligen
Virgin and child and six saints
pn 24.4×23.6 (62×60 cm)

JAN JOEST (J. J. van Kalkar or van Haarlem)
... – Haarlem 1519
Anbetung des Christkindes *
Adoration of the Christ child
trp; ar centr pn 18.1×10.6 (46×27 cm); side panels 18.1×5.1 (46×13 cm)
Bildnis eines Mannes
Bildnis einer Frau
Husband and wife portraits (?)
panels 13.8×9.4 (35×24 cm)

JANSSENS ELINGA Pieter
Bruges 1623 – Amsterdam c 1682
Die lesende Frau → no 90
Woman reading
cv 29.5×24.8 (75×63 cm)

JANSSENS VAN NUYSSEN Abraham
Antwerp 1575 – 1632
Diana mit ihren Nymphen *
D. and the nymphs
pn 48.0×37.0 (122×94 cm)
Der Olymp *
The Olympus
cv 81.5×94.5 (207×240 cm)

JORDAENS Jacob
Antwerp 1593 – 1678
Der Satyr beim Bauern → no 71
S. with peasants
cv/pn 76.4×79.9 (194×203 cm)
Wie die Alten singen, so zwitschern die Jungen *
Gay company
cv 89.8×126.4 (228×321 cm) sg d 1646

KALF Willem
Rotterdam 1619 – Amsterdam 1693
Ein Kramladen
Country Shop
copper 7.1×5.5 (18×14 cm)
Stilleben mit Delfter Kanne *
Still life with Delft jug
pn 17.7×13.8 (45×35 cm) sg d 1653

KEY Adriaen Tomasz.
Antwerp (?) c 1544 – Antwerp c 1589
Bildnis eines braunbärtigen Mannes
Portrait of a man with a black beard
pn 16.9×14.6 (47×37 cm) sg d 1576 ins; mutilated

KEY Willem
Breda c 1520 – Antwerp 1568
Die Beweinung Christi *
Lamentation of Christ
pn 44.1×40.6 (112×103 cm)
Der hl. Hieronymus
St. Jerome
pn 57.9×41.7 (147×106 cm)

KNÜPFER Nicolaus
Leipzig (?) 1603 – Utrecht 1655
Die Jagd nach dem Glück
Fortune hunting
copper 11.8×16.5 (30×42 cm)

KÖLNISCH (PAINTER OF COLOGNE)
act c 1380
Linker Flügel eines Altärchens
Left hand wing of a small altarpiece (Int Annunciation; ext Virgin)
pn 13.0×7.9 (33×20 cm)
frm of *Adoration of Kings*; other parts in Cologne; centr pn missing

96

act c 1440
Thronende Muttergottes mit Kind und musizierenden Engeln
Virgin enthroned with child and musician angels
pn td 33.5 (85 cm)

act c 1500
Legende der hll. Eremiten Antonius und Paulus → no 10
Legend of the Saint hermits Anthony and Paul
pn 42.5×74.4 (108×189 cm)

KONINCK Philips
Amsterdam 1619 – 1688
Flachlandschaft *
Landscape
cv 52.4×65.4 (133×166)

KONRAD VON SOEST
Dortmund (?) c 1370 – ... c 1425
Hl. Paulus
St. Paul (rv *St. Rinaldo*)
pn 20.9×7.5 (53×19 cm)

KULMBACH Hans von (H. Suess)
Kulmbach (?) c 1480 – Nuremberg 1521
Markgraf Casimir von Brandenburg *
Margrave C. of B.
pn 16.9×12.2 (43×31 cm) sg d 1511 ins

KUPETZKY Johann
Bösing 1667 – Nuremberg 1740
Bildnis einer jungen Frau
Portrait of a young woman
cv 29.5×24.0 (75×61 cm)

LAER Pieter van
Haarlem 1599 – ... c 1642
Die Flagellanten → no 76
Flagellants
cv/pn 21.3×32.3 (54×82 cm)

LANCRET Nicolas
Paris 1690 – 1745
Der Vogelkäfig → no 127
Bird cage
cv 17.3×18.9 (44×48 cm)

LASTMAN Pieter Pietersz.
Amsterdam 1583 – 1633
Odysseus vor Nausikaa *
· *Ulysses before Nausicaa*
pn 35.8×46.1 (91×117 cm) sg d 1619

LA TOUR Maurice Quentin de
St. Quentin 1704 – 1788
Bildnis des Abbé Nollet *
Portrait of the Abbot N.
pastel 25.6×21.3 (65×54 cm)
Mademoiselle Ferrand meditiert über Newton *
M. F. meditating on N.
pastel 28.7×23.6 (73×60 cm)

LECLERC Jean
Nancy 1587-8 – 1633
Der verlorene Sohn
Prodigal son
cv 53.9×66.9 (137×170 cm)

LEONARDO DA VINCI
Vinci 1452 – Cloux 1519
Maria mit dem Kinde → no 99
Virgin and child (Madonna of the carnation)
pn 24.4×18.5 (62×47 cm)

LE SUEUR Eustache
Paris 1617 – 1655
Christus im Hause der Martha *
Christ in the house of M.
cv 64.2×50.8 (163×129 cm)

LEYDEN Lucas Huighensz. van
Leyden 1494 – 1533
Maria mit dem Kinde, der hl. Magdalena und einem Stifter *
Verkündigung Mariae *
Virgin and Child with the Magdalene and a donor; Annunciation
panels of a dip 19.7×26.8 and 16.5×11.4 (50×68 cm and 42×29 cm); the first sg d 1522

LIBERALE DA VERONA (L. di Jacopo della Biava)
Verona 1455 – 1526-9
Die Beweinung Christi *
Lamentation of Christ
pn 52.4×34.6 (133×88 cm)

LIPPI Filippino
Prato 1457 (?) – Florence 1504
Die Fürbitte Christi und Mariae *
Christus als Schmerzensmann von einem Engel gehalten *
Intercession of Christ and the Virgin; The Dead Christ upheld by an angel and saints
panels 61.4×57.9 and 11.8×59.1 (156×147 cm and 30×150 cm)

LIPPI Fra Filippo
Florence 1406 – Spoleto 1469
Die Verkündigung Mariae *
Annunciation
pn 79.9×72.8 (203×185 cm) 1443
Maria mit dem Kinde → no 95
Virgin and child
pn 29.9×21.3 (76×54 cm)

LISCHKA Johann
Breslau ... – Leubus 1712
Beweinung Christi *
Lamentation of Christ
pn 34.6×28.7 (88×73 cm)

LISS Johann
Oldenburg 1593-4 – Venice 1629
Tod· der Kleopatra
Death of Cleopatra
cv 38.2×33.5 (97×85 cm)

Lissandrino see MAGNASCO

LOCHNER Stephan
Meersburg c 1410 – Cologne 1451
Maria mit dem Kind vor einer Rasenbank *
Virgin and Child
pn 14.6×11.0 (37×28 cm)
Anbetung des Christkindes → no 2
Adoration of Christ Child (rv *Crucifixion with Virgin and St. John*)
pn 14.2×9.1 (36×23 cm)
Aussenseiten der Flügel des Weltgerichtsaltars * → no 1
Exterior of the wings of the altarpiece of the Last Judgment (at l *St. Anthony hermit, St. Cornelius Pope, The Magdalene and a donor*; at r *St. Catherine, St. Hubert, St. Quirinus and a donor*)
panels 47.2×31.5 (120×80 cm) centr pn in Cologne, Wallraf-Richartz-Museum; int of the wings in Frankfurt, Städelsches Kunstinstitut

LONGHI Pietro (P. Falca)
Venice 1702 – 1785
Der Besuch oder Das Kartenspiel *
The visit or The game of cards
cv 24.4×19.7 (62×50 cm)

LORENZO DI PIETRO (Il Vecchietta)
Siena c 1412 – 1480
Das Eselswunder des hl. Antonius
The miracle of the ass by St. Anthony
pn 12.6×26.0 (32×66 cm)

LORRAIN Claude Le (C. Gellée)
Chamagne 1600 – Rome 1682
Die Verstossung der Hagar → no 126
Hagar und Ismael in der Wüste *
Repudiation of H.; H. and Ishmael in the desert
canvases 41.7×55.1 and 54.7 (106×140 and 139 cm) the first sg d 1668
Seehafen beim Aufgang der Sonne *
Seaport at dawn
cv 28.7×38.2 (73×97 cm) sg d 1674
Idyllische Landschaft bei untergehender Sonne *
Idyllic landscape at sunset
cv 28.7×38.2 (73×97 cm) sg d 1676

LOTTO Lorenzo
Venice 1480 – Loreto 1556
Die mystische Vermählung der hl. Katharina → no 106
The mystic marriage of St. Catherine
cv 28.0×35.8 (71×91 cm)

Lucas of Leyden see
LEYDEN

Mabuse see **GOSSAERT**

MAES Nicolaes
Dordrecht 1634 – Amsterdam 1693
Bildnis eines jungen Mannes *
Bildnis einer jungen Frau *
Portraits of a young couple (?)
canvases c 45.3×35.8 (c 115×91 cm)

MAESTRO DEL BAMBINO VISPO (MASTER OF THE LIVELY CHILD)
first half of the Fifteenth Century, Florence
Das Jüngste Gericht *
The Last Judgment
pn 35.0×20.9 (89×53 cm)

MAGNASCO Alessandro (Lissandrino)
Genoa 1667 – 1749
Felsige Meeresbucht mit Mönchen und Schiffen → no 116
Rocky cove with monks and boat men
cv 45.7×68.5 (116×174 cm)

MAIR Hans (M. von Landshut)
Freising (?) c 1450 – ...
Drachenkampf des hl. Georg.
St. George and the dragon
cv 17.3×13.8 (44×35 cm)

MALER Hans
act c 1500-29 Germany
Wolfgang Ronner
pn 18.9×15.4 (48×39 cm) d 1529 ins

MANDYN Jan
Haarlem c 1500 – Antwerp 1560
Der hl. Christophorus *
St. Christopher
pn 55.9×70.5 (142×179 cm)

Umkreis von (Circle of) MANTEGNA Andrea
Isola di Carturo 1431 (?) – Mantua 1506
Mucius Scaevola
cv 16.1×13.4 (41×34 cm)

MASOLINO DA PANICALE (Tommaso di Cristoforo Fini)
Panicale 1383 – Florence (?) 1447
Maria mit dem Kinde → no 94
Virgin and Child
pn 37.4×22.4 (95×57 cm)

MASSYS Quentin
Louvain 1465-6 – Antwerp 1530
Flügelaltar *
Triptych (Ext *St. Luke the Evangelist* with coat of arms of Lucas Rehm, and *St. Anne, the Virgin and the Infant Christ* with coat of arms of his wife Anna Ehen, grisaille. Int centr pn *Trinity with Virgin and Child*; wings *St. Sebastian and St. Roche*)
panels; centr pn 35.4×24.8 (90×63 cm); wings 35.4×11.0 (90×28 cm)

Master see **MEISTER**

MAULBERTSCH Franz Anton
Langenargen 1724 – Vienna 1796
Allegorische Darstellung
Allegory
cv 18.5×12.6 (47×32 cm)

MAZZOLA-BEDOLI Girolamo
Parma 1500 – 1569
Maria mit dem Kinde und dem hl. Bruno
Virgin and Child and St. B.
pn 10.6×8.3 (27×21 cm)

MAZZOLINI Ludovico
Ferrara c 1480 – 1528-30
Die Heilige Familie in einer Landschaft
Holy Family in a landscape
cv 24.8×19.3 (63×49 cm)

MEER Barent van der
Haarlem 1659 – ... c 1690-1702
Stilleben mit Mohr und Prachtgeschirr *
Still life with a Negro
cv 59.1×46.1 (150×117 cm) sg

MEISTER DES AACHENER ALTARES (MASTER OF THE AACHEN ALTARPIECE)
act 1480-1520 Cologne
Hans von Melem
ar pn 21.3×13.4 (54×34 cm) sg
Maria mit Kind und musizierenden Engeln *
Virgin and Child with musician angels
pn 21.3×18.5 (54×47 cm) ins

MEISTER DES BARTHOLOMÄUSALTARES (MASTER OF THE ST. BARTHOLOMEW ALTARPIECE)
act 1450 – c 1510 Cologne
Anbetung des Christkindes durch die hll. Drei Könige
Adoration of the Kings
pn 33.9×26.0 (86×66 cm) ins
Anna Selbdritt *
St. Anne, the Virgin and the Infant Christ
pn 16.9×11.8 (43×30 cm)
Bildnis eines Mannes
Portrait of a man
pn 13.8×9.8 (35×25 cm) d 1492
Bartholomäusaltar → no 4
St. Bartholomew Triptych (centr pn *St. Agnes, St. Bartholomew and St. Cecilia*; wings *St. John the Evangelist and St. Margaret and St. James and St. Christina*)
panels; centr pn 50.8×63.4 (129×161 cm); wings 50.8×29.1 (129×74 cm); ins

MEISTER DER BENEDIKTBEURER MADONNA (MASTER OF THE VIRGIN OF B.)
first half of the Fifteenth Century, Southern Germany
Muttergottes mit Kind
Virgin and child
cv/pn 17.3×13.4 (44×34 cm)

MEISTER DES ERFURTER REGLERALTARES (MASTER OF THE REGLER ALTARPIECE AT ERFURT)
second half of the Fifteenth Century, Germany
Zwei Flügel eines Altares *
Two wings of an altarpiece (Int at l *Presentation and offering of the Virgin in the Temple*; ext *V. of the Annunciation*. Int at r *Death of the V.*; ext *Angel of the Annunciation*)
panels 62.6×22.8 and 63.0×23.2 (159×58 cm and 160×59 cm)

MEISTER DES HAUSBUCHS (MASTER OF THE BOOK OF THE HOUSE)
second half of the Fifteenth Century, Central Rhineland
Maria mit Kind, von Engeln gekrönt *
Virgin and child crowned by angels
pn 15.4×9.8 (39×25 cm)

MEISTER DER JOSEPHSFOLGE (Josephslegende) (MASTER OF THE LEGEND OF JOSEPH)
act 1500 Brussels
Joseph und Potiphars Weib *
J. and Potiphar's wife
pn td 61.8 (157 cm)

MEISTER DES MARIENLEBENS (MASTER OF THE LIFE OF THE VIRGIN)
act c 1463-80 Cologne
Tafeln mit Szenen aus dem Marienleben:
Begegnung von Joachim und Anna an der goldenen Pforte
Geburt Mariae → no 6
Tempelgang Mariae
Vermählung Mariae
Verkündigung an Maria
Mariae Heimsuchung
Mariae Himmelfahrt
Stories from the life of the Virgin:
Meeting at the Golden Gate (rv [upper half] *Crucifixion*); *Birth*; *Presentation in the Temple*; *Marriage* (rv [upper half] *Coronation*); *Annuncia-*

tion (rv [lower half] *Crucifixion*); *Visitation* (rv in the National Gallery, London); *Assumption* (rv [lower half] *Coronation*)
panels c 33.5×41.7 (c 85×106 cm)
the second, third and sixth/ canvases
Marienkrönung
Coronation of the Virgin
pn 39.8×52.4 (101×133 cm)
Bildnis eines Baumeisters → no 5
Portrait of a master builder
pn 15.0×12.2 (38×31 cm)

MEISTER DES MORNAUER-BILDNISSES (MASTER OF THE PORTRAIT OF M.)
act 1465-80 Bressanone
Herzog Sigismund von Österreich, Graf von Tirol (?) *
Duke S. of Austria, Count of Tyrol (?)
pn 17.3×11.8 (44×33 cm)

MEISTER DER MÜNCHNER MARIENTAFELN (MASTER OF THE MARY PANELS)
act 1450 Munich
Halbfigur eines Propheten *
A Prophet
pn 10.2×8.7 (26×22 cm) mutilated; on rv false ins

MEISTER DES OBERALTAICHER SCHMERZENSMANNES (MASTER OF THE OBERALTAICH "ECCE HOMO")
act c 1510-20 Lower Bavaria
Christus als Schmerzensmann (Oberaltaicher Schmerzensmann) *
"Ecce Homo"
pn 53.5×36.6 (136×93 cm) ins

MEISTER DER POLLINGER TAFELN (MASTER OF THE POLLING ALTARPIECE)
act 1439-44 Kremsmünster and Polling
Linker Flügel eines Marienaltares aus dem Augustinerchorherrnkloster in Polling
Left hand wing of the altarpiece of the Virgin from the cloister of the chapter house of the Augustinian Convent of P. (Ext top *Annunciation*; below *Adoration of the Kings*; int originally in relief with three figures)
panels 50.8×33.9 (129×86 cm); the first d 1444 ins
r wing in Nuremberg, Germanisches Nationalmuseum
Innenseiten der Flügel des Kreuzaltars aus dem Augustinerchorherrnkloster in Polling *
Interiors of the wings of the altarpiece of the Cross from the cloister of the chapter house of the Augustinian Convent of P. (upper l *Duke Tassilon hunting accompanied by three grooms*; below *T. and a bishop with escort on the road to Calvary*. Upper r *A deer causes part of the Cross to appear from the earth*; below *The Cross is unearthed and consecrated by the bishop in the presence of T. and his followers*)
panels 86.2×34.3 (219×87 cm) ins ext wings in Munich, Bayerisches Nationalmuseum

MEISTER VON SCHLOSS LICHTENSTEIN (MASTER OF THE L. CASTLE)
act c 1425-50 Austria and Swabia (?)
Bethlehemitischer Kindermord *
Massacre of the innocents
cv/pn 39.8×19.7 (101×50 cm) part of a cycle of '*Stories*' of Christ and the Virgin scattered in various museums

MEISTER DER HEILIGEN SIPPE (MASTER OF THE SACRED KIN)
act 1480-1520 Cologne
Beschneidungsaltar
Triptych of the Circumcision (Ext *Saints Bartholomew, John the Baptist* and *Saints Barba-*

ra(?), Christina and the Magdalene. Int centr pn *Circumcision;* wings *Saints Jerome, Peter and Joseph* and *Saints Columba, Ursula and Agnes)* trp; panels, centr pn 40.2× 77.2 (102×196 cm), wings 39.4×35.4 (100×90 cm) in int wing a strip (3.9×10 cm) has been added in recent times at the top

MEISTER DER TEGERNSEER TABULA MAGNA (MASTER OF THE T. M. OF TEGERNSEE)
act 1440-60 Tegernsee
Kalvarienberg → no 28
Calvary
pn 73.2×115.7 (186×294 cm)

MEISTER DER HEILIGEN VERONIKA (MASTER OF ST. VERONICA)
act 1400-20 Cologne
Hl. Veronika mit dem Schweisstuch → no 3
St. Veronica with the veil
pn 30.7×18.9 (78×48 cm) ins

MELÉNDEZ DE RIVERA DURAZO Luis Eugenio
Naples 1716 – Madrid 1780
Melonen, Birnen und Pflaumen → no 120
Melons, pears and plums
cv 19.7×14.6 (50×37 cm) sg

MEMLING Hans
Seligenstadt 1433 – Bruges 1494
Johannes der Täufer → no 44
St. John the Baptist
pn 12.2×9.4 (31×24 cm)
Die sieben Freuden Mariae → no 45
Seven joys of the Virgin
pn 31.9×74.4 (71×189)
Klappaltärchen *
Portable altarpiece (wing Virgin and child with musician angels; r wing St. George and donor; rv of wing St. Anne, the Virgin and the Infant Christ)
dip; panels 16.9×12.2 (43×31 cm) rv detached

METSU Gabriel
Leyden 1629 –Amsterdam 1667
Das Bohnenfest *
Beanfeast
cv 31.9×38.6 (81×98 cm)
sg c 1650-55
Die Köchin *
The cook
pn 11.4×9.4 (29×24 cm)
sg c 1665

MIERIS DER ÄLTERE (THE ELDER) Frans van
Leyden 1635 – 1681
Der schlafende Offizier im Gasthaus
Officer asleep in a tavern
pn 16.1×13.0 (41×33 cm)
sg c 1660
Selbstbildnis
Bildnis der Frau des Künstlers
Self-portrait; Portrait of artist's wife
oval panels c 4.3×3.1 (c 11×8 cm) sg d 1662
Dame vor dem Spiegel → no 88
Lady at a mirror
pn 16.9×12.2 (43×31 cm)
originally ar
Der Reitstiefel
Large boot
ar pn 9.1×10.6 (23×27 cm)
sg d 1666
addition to lower part

MILLET Jean François (Francisque M.)
Antwerp 1642 – Paris 1679
Italienische Küstenlandschaft *
Italian coast landscape
cv 42.1×46.9 (107×119 cm)

MOMPER DER JÜNGERE (THE YOUNGER) Joos de
Antwerp 1564 – 1635
Landschaft mit weiter Fernsicht
Landscape with wide distant view
pn 28.3×40.9 (72×104 cm)
probably in collaboration with Jan Brueghel the Elder
Der Hinterhalt
Ambush
pn 28.7×40.9 (73×104 cm)

MONOGRAMMIST AC
act 1577 France or Germany
Bildnis einer Herzogin von Jülich, Cleve und Berg → no 123
Portrait of a Duchess of J., C. and B.
pn 16.9×13.4 (43×34 cm)
sg d 1577

MOR VAN DASHORST Anthonis
Utrecht 1517-19 – Antwerp (?) 1576-7
Der hl. Sebastian
St. S.
pn 31.5×27.2 (80×69 cm)

MOREELSE Paulus
Utrecht 1571 – 1638
Die blonde Schäferin *
B. shepherdess
cv 29.9×24.8 (76×63 cm)
sg d 1624

MORETTI Cristoforo de'
act 1452-85, Lombardy and Piedmont
Maria mit dem Kind und der hl. Anna zwischen den hll. Antonius Abbas und Petrus Martyr *
Virgin and Child with saints wing of a dip; pn 16.1×11.8 (41×30) original frame other wing in Prague, Národní Galerie

MORETTO DA BRESCIA (Alessandro Bonvicino)
Brescia 1498 – 1554
Bildnis eines Geistlichen *
Portrait of an ecclesiastic
cv 39.8×30.7 (101×78 cm)

MUELICH or MIELICH Hans
Munich 1516 – 1573
Andreas Ligsalz *
Die Gattin des Andreas Ligsalz, geb. Ridler *
Husband and wife portraits
panels c 31.9×24.0 (c 81×61 cm) on reverses coats of arms of sitters
Herzog Albrecht V. von Bayern*
p 8
A. V of Bavaria
pn 34.3×26.8 (87×68 cm)
sg d 1545 ins

MURILLO Bartolomé Esteban
Seville 1618 – 1682
Trauben- und Melonenesser *
Boys eating grapes and melon
cv 57.5×40.6 (146×103 cm)
Häusliche Toilette → no 119
Domestic toilet
cv 57.9×44.5 (147×113 cm)
Buben beim Würfelspiel *
Boys playing dice
cv 57.5×42.5 (146×108)
Die Pastetenesser
Boys eating pastries
cv 48.4×40.2 (123×102 cm)
Die kleine Obsthändlerin
Little fruit seller
cv 58.3×44.5 (148×113 cm)
Der hl. Thomas von Villanueva heilt einen Lahmen *
St. T. of V. heals a cripple
cv 87.0×58.3 (221×148 cm)

NARDO DI CIONE
Florence (?) 1343 – ... c 1365
Die hll. Mauritius, Augustinus, Petrus, Nikolaus und Stephanus *
Die hll. Antonius, Ambrosius, Johannes der Täufer, Paulus und Katharina
Saints Maurice, Augustine, Peter, Nicholas and Stephen; Saints Anthony, Ambrose, John the Baptist, Paul and Catherine
panels c 55.9×27.6 (c 142×70 cm)

NATTIER Jean-Marc
Paris 1685 – 1766
Galante Szene («Les Amants ou l'Alliance de l'Amour et du Vin») *
Lovers or The Alliance of Love and Wine
cv 22.8×29.1 (58×74 cm)
sg d 1744
Bildnis der Marquise de Baglion als Flora *
Portrait of Marchioness of B. in the guise of F.
cv 53.9×41.7 (137×106 cm)
sg d 1746

NEER Aert van der
Amsterdam 1603-4 – 1677
Winterlandschaft *
Winter landscape
pn 9.1×13.4 (23×34 cm) sg

NEER Eglon Hendrick van der
Amsterdam 1634 – Düsseldorf 1703
Landschaft mit Tobias und dem Engel *
Landscape with T. and the Angel
copper 4.3×5.5 (11×14 cm) sg

NETSCHER Caspar
Prague or Heidelberg 1635-6 – The Hague 1684
Musikalische Unterhaltung
Musical entertainment
cv 19.7×18.1 (50×46 cm)
sg d 1665
Schäferszene *
Pastoral scene
cv 20.9×17.7 (53×45 cm)
sg d 1681

NIEDERRHEINISCH (PAINTER OF THE LOWER RHINELAND)
act 1430-40
Der hl. Hieronymus mit den beiden Frauen Paula und Eustochium (Julia)
St. Jerome with Saints P. and E. (J.)
pn 10.2×12.2 (26×31 cm)

NOME François de (Monsù Desiderio)
Metz c 1593 – ...
David im Tempel
D. in the Temple
cv 31.1×39.8 (79×101 cm)

OBERRHEINISCH (PAINTER OF THE UPPER RHINELAND)
act c 1460
Drachenkampf des hl. Georg
St. George and the dragon
pn 18.5×15.4 (47×39 cm)

Orbetto see **TURCHI**

ORLEY Bernaert van
... 1488 – ... 1541, act Brussels
Jehan Carondelet *
pn 20.9×14.6 (53×37 cm)
Predigt des hl. Ambrosius
St. Ambrose preaching
pn 37.4×25.2 (95×64 cm)

OSTADE Adriaen van
Haarlem 1610 – 1684
Männer und Weiber in einer Bauernstube
Ausgelassene Bauern in einer Schenke → no 75
Men and women in a peasant interior; Rowdy peasants
panels 11.4×14.2 (29×36 cm) sg
Raufende Bauern *
Lustige Bauerngesellschaft
Peasants fighting; Gay company of peasants
panels 17.7×14.6 and 15.0 (45×37 cm and 38 cm)
sg d 1656 and 16..

PACCHIA Girolamo del
Siena 1477 – France (?) c 1533
Maria· mit dem Kinde und vier Engeln
Der hl. Bernhardin von Siena mit zwei Engeln *
Virgin and child with four angels; St. Bernard of Siena with two angels
ar panels 24.0×16.9 (61×43 cm) 1512
decorations for a coffin

PACHER Michael
Pacherhof (?) c 1435 – Salzburg 1498
Krönung Mariae *
Coronation of the Virgin
pn 56.7×36.2 (144×92 cm) mutilated
on rv plant forms decoration
Tafeln vom Laurentiusaltar aus der Pfarrkirche zum hl. Laurentius in St. Lorenzen bei Bruneck **
Panels of the St. Laurence altarpiece from the parochial church of St. Laurence near B. (From int wing [?] Annun-

ciation; ext *St. L. giving alms;* from int wing [?] *Death of the Virgin,* ext *Martyrdom of St. L.)*
frm; panels c 39.8×38.6 (c 101×98 cm)
Kirchenväteraltar aus dem Augustinerchorherrnstift * → no 32
Altarpiece of the Fathers of the Church from the Augustinian Convent at Novacella near Bressanone (Ext wing: above St. Wolfgang cures a sick man, below Dispute of St. W.; r wing: above St. W. at prayer, below St. W. and the devil. Int centr panel St. Augustine and St. Gregory; wings St. Jerome and St. Ambrose)
panels; centr panels 83.5×39.4 (212×100 cm); wings 85.0×35.8 (216×91 cm);
detached panels 40.6×35.8 (103×91 cm)

PALMA VECCHIO (THE ELDER) (Jacopo d'Antonio Negretti)
Serina 1480 – Venice 1528
Maria mit dem Kinde und den hll. Rochus und Magdalena *
Virgin and Child with Saints Roche and Mary Magdalene
pn 26.4×36.2 (67×92 cm)

PANTOJA DE LA CRUZ Juan
Valladolid 1553 – Madrid 1608
Albrecht der Fromme, Erzherzog von Österreich *
A. the Pious, Archduke of Austria
cv 48.8×38.2 (124×97 cm)
sg d 1600

Parmigianino see under **Heintz** and **Rubens**

Pasture see **WEYDEN**

PATER Jean-Baptiste François
Valenciennes 1695 – Paris 1736
Die Freuden des Landlebens *
Pleasures of country life
cv 21.3×26.0 (54×66 cm)

PAUDISS Christoph
Lower Saxony 1618 – Freising 1667
Hl. Hieronymus
St. Jerome
metal 21.6×18.1 (55×46 cm)
sg d 1664

PEETERS Clara
Antwerp c 1589 – ...
Stilleben
Still life
pn 36.6×48.4 (93×123 cm)
sg (?) attr

PENCZ Georg
Nuremberg 1500 – Leipzig 1550
Judith
pn 33.9×28.3 (86×72 cm)
sg d 1531

PERUGINO (Pietro di Cristoforo Vannucci)
Città della Pieve 1445 – ... 1523
Die Vision des hl. Bernhard → no 100
Vision of St. Bernard
pn 67.7×66.9 (172×170 cm)
Maria, Johannes der Evangelist und der hl. Nikolaus beten das Christkind an *
Virgin with Saints John the Evangelist and Nicholas worshiping the Christ Child
pn 79.9×61.8 (203×157 cm)

PIERO DI COSIMO
Florence 1462 – 1521
Darstellung aus Prometheussage → no 96
Legend of Prometheus
pn 26.0×46.5 (66×118 cm)

PITTONI Giovanni Battista
Venice 1687 – 1767
Die Geburt Christi *
Nativity
cv 28.7×22.0 (73×56 cm)
Der hl. Eustachius verweigert den Götzendienst
St. Eustache's refusal to worship idols
cv 12.6×25.2 (32×64 cm)

PLEYDENWURFF Hans
Bamberg (?) 1420 – Nuremberg 1472
Zwei Flügelpaare des sog. Hofer Altares
Two pairs of wings of the "Court Altarpiece"
(Ext l wing *Michael the Archangel* [rv *Christ in the Garden of Olives*]; ext r wing *The Apostles Bartholomew and James* [rv *Resurrection*]; int l wing *Crucifixion* [rv *Annunciation*]; int r wing *Deposition* [rv *Nativity*])
panels; ext wings 69.7×44.1 (177×112 cm);
int wings c 70.1×44.9 (c 178×114 cm); ins
Kreuzigung Christi *
Crucifixion (on rv *St. Anne, the Virgin and the Infant Christ*)
ar pn 75.6×71.3 (192×181 cm)
mutilated; ins

POELENBURGH Cornelis
Utrecht 1586 (?) – 1667
Die Wasserfälle von Tivoli
Italienische Landschaft
Tivoli falls; Italian landscape
copper 9.4×13.0 (24×33 cm);
the first sg originally oval
Bildnis eines Mädchens → no 73
Portrait of a little girl
pn 8.3×6.7 (21×17 cm) sg

POLACK Jan
Poland ... – Munich 1519
Zwei Tafeln von Weihenstephaner Hochaltar
Two panels from the high altar of Weihenstephan (ext lower l wing [?] Christ in the Garden of Olives [on rv Death of St. Corbinian]; ext upper r wing Christ nailed to the Cross [on rv St. Benedict discusses the rule with representatives of the Church])
panels 57.9×50.8 (147×129 cm)
other parts at Freising and at Munich, Bayerische Staatsgemäldesammlungen (storerooms)

Ponte see **BASSANO**

PORCELLIS DER ÄLTERE (THE ELDER) Jan
Gand c 1584 – Soeterwoude 1632
Stürmische See *
Storm at sea
pn 7.1×9.4 (18×24 cm) sg d 1629

POST Frans
Leyden c 1612 – 1680
Brasilianische Landschaft mit Ameisenbär
Brasilian landscape with ant eater
pn 20.9×27.2 (53×69 cm) sg d 1649

POTTER Paulus
Enkhuizen 1625 – Amsterdam 1654
Bauernfamilie mit Vieh *
Peasant family with animals
pn 14.6×11.4 (37×29 cm) sg d 1646

POURBUS DER JÜNGERE (THE YOUNGER) Frans
Antwerp 1569 – Paris 1622
Bildnis eines Mannes
Portrait of a man
pn 27.2×21.3 (69×54 cm) sg d 1614

POUSSIN Nicolas
Villers 1594 – Rome 1665
Die Beweinung Christi *
Lamentation of Christ
cv 40.2×58.3 (102×148 cm)
Midas und Bacchus → no 125
M. and B.
cv 38.6×52.8 (98×134 cm)
Apollo und Daphne *
D. and A.
cv 39.0×53.1 (99×135 cm)

PULIGO Domenico
Florence 1492 – 1527
Maria mit dem Kinde und dem Johannesknaben *
Virgin and Child with the young St. John
pn 51.2×37.0 (130×94 cm)

PYNAS Jacob
Haarlem c 1585 – ...
Nebukadnezar erhält die Königswürde zurück
Nebuchadnezzar restored to regal dignity
pn 28.7×48.0 (73×122 cm) sg d 1616

Raibolini see **FRANCIA**

RAPHAEL (Raffaello Sanzio)
Urbino 1483 – Rome 1520
Die Heilige Familie aus dem Hause Canigiani → no 102
C. Holy Family
pn 51.6×42.1 (131×107 cm) sg
Die Madonna Tempi → no 103
T. M. (Virgin and child)
pn 29.5×16.1 (75×41 cm)
Die Madonna della Tenda → no 101
M. d. T. (Virgin and child with the young St. John)
pn 25.6×20.1 (65×51 cm)

REFINGER Ludwig
... 1510-5 – Munich 1549
Susannas Unschuld wird durch das Einschreiten des Knaben Daniel bewiesen, worauf die beiden verleumderischen Alten gesteinigt werden
Innocence of Susanna and stoning of the Elders
pn 39.8×59.1 (101×150 cm) d 1537 ins mutilated

REICHLICH Marx
... 1460 – Salzburg(?) c 1520
Altar der hll. Jacobus und Stephanus
Altarpiece of St. James and Stephen (centr panels St. J. and St. S.; upper l wing St. J. baptizing Joshua and Death of St. J.; below Body of St. J. presented to Queen Lupa of Spain: upper r wing Dispute of St. S.; below Stoning of St. S.)
panels c 42.9×30.7 (c 109× 78 cm) (the last one 48.8×30.7 [124×78 cm])
ext wings in Munich, Bayerische Staatsgemäldesammlungen (storerooms)
Die vier Flügeltafeln des Marienaltares → no 29
Four wings from the altarpiece of the Virgin with stories from the life of the Virgin (Ext upper l wing Birth of the Virgin; below Marriage of the Virgin upper r wing Presentation of the Virgin in the Temple; below Visitation)
upper panels c 33.5×31.1 and 31.9 (c. 85×79 cm and 81 cm) mutilated
lower panels c 39.4×31.9 (c 100×81 cm); upper r wing sg d 1502 or 1511
int of wings with gold ground; originally with reliefs. now at Innsbruck, Ferdinandeum

REMBRANDT HARMENSZ. VAN RIJN
Leyden 1606 – Amsterdam 1669
Selbstbildnis → no 80
Self-portrait
pn 5.9×4.7 (15×12 cm) sg d 1629
additions at top and at l
Brustbild eines Mannes in orientalischer Tracht → no 81
Portrait of a man in Oriental costume
oval cv 33.9×25.2 (86×64 cm) sg d 1633
Die Heilige Familie → no 82
Holy Family
cv 72.0×48.4 (183×123) sg d 163...
originally ar
Die Kreuzaufrichtung *
Die Kreuzabnahme → no 83
Die Himmelfahrt Christi *
Die Grablegung Christi *
Die Auferstehung Christi *
Erection of the Cross; Deposition; Ascension; Burial; Resurrection
ar canvases c 36.2×27.6 (c 92 ×70 cm); the second false sg; the third and the fifth sg d 1636
Opferung Isaaks *
Sacrifice of Isaac
cv 76.8×52.0 (195×132 cm) sg d 1636 ins probably in colla-

boration with Govaert Flinck (Cleves 1615 – Amsterdam 1660)
Die Anbetung der Hirten *
Adoration of the shepherds
ar cv 38.2×28.0 (97×71 cm) sg d 1646
Der auferstandene Christus *
Risen Christ
oval cv 30.7×24.8 (78×63 cm) sg d 1661

RENI Guido
Bologna 1575 – 1642
Die Himmelfahrt Mariae *
Assumption
silk 116.1×81.9 (295×208 cm)
Apoll schindet Marsyas → no 115
Apollo flaying M.
cv 88.2×66.9 (224×170 cm)

RIBERA Jusepe de (Lo Spagnoletto)
Játiva 1591 – Naples 1652
Der hl. Bartholomäus
St. Bartholomew
cv 29.9×25.2 (76×64 cm)
Der hl. Petrus von Alcantara in Meditation *
St. Peter of A. meditating
cv 29.1×22.8 (74×58 cm)

RIMINI Schule von (School of)
first half of the Fourteenth Century
Flügel eines Altärchens mit je drei übereinander liegenden Darstellungen *
Wings of altarpiece with three pictures on each (Virgin enthroned with two saints. Washing of the feet, Last Judgment, Crucifixion, Scourging and Carrying of the Cross. St. Francis receives the Stigmata)
panels 25.2×11.8 and 24.8× 11.0 (64×30 cm and 63×28 cm)

ROBERT Hubert
Paris 1733 – 1808
Wäscherinnen unter einem Brückenbogen → no 129
Old bridge with washerwomen
cv 9.4×13.0 (24×33 cm)
Der Abbruch der Häuser auf dem Pont au Change in Paris, 1788 *
Demolished houses on the P. a. C., P. 1788
cv 31.5×61.0 (80×155 cm)

Robusti see **TINTORETTO**

ROTTENHAMMER Johann
Munich 1564 – Augsburg 1625
Das Jüngste Gericht *
Last Judgment
copper 26.8×18.1 (68×46 cm) sg d 1598
Diana und Aktäon *
D. and Actaeon
copper 13.8×18.9 (35×48 cm) sg d 1602
Die Geburt Christi
Nativity
copper 12.2×14.6 (31×37 cm)

ROTTMAYR Johann Michael
Laufen 1654 – Vienna 1730
Hl. Benno *
St. B.
cv 46.1×35.4 (117×90 cm) sg d 1692

ROYMERSWAELE Marinus van
Reymerswael c 1490 – ... c 1567
Ein Steuereinnehmer mit seiner Frau
Tax collector and his wife
pn 26.4×40.6 (67×103 cm) d 1538
Ein Notar → no 51
A notary
pn 40.6×47.2 (103×120 cm) sg d 1541

RUBENS Peter Paul
Siegen 1577 – Antwerp 1640
Der Engelsturz
Fallen angels
cv 176.4×114.6 (448×291 cm)
Die Niederlage Sanheribs *
Siege of Sennacherib
pn 38.6×48.4 (98×123 cm)
Susanna im Bade *
S. bathing
pn 31.1×42.9 (79×109 cm)

Der Bethlehemitische Kindermord *
Massacre of the innocents
pn 78.3×118.9 (199×302 cm)
Die Madonna im Blumenkranz → no 65
Virgin in a garland of flowers
pn 72.8×82.7 (185×210 cm) garland by Jan Brueghel the Elder
Christus am Kreuz *
Crucifixion
pn 57.1×37.8 (145×96)
Grablegung Christi
Burial of Christ
pn 33.1×26.0 (84×66 cm)
Christus und die reuigen Sünder *
Christ and the penitent sinners (The Magdalene, the good thief, King David and Peter)
pn 57.9×51.2 (147×130 cm)
Das grosse Jüngste Gericht *
Great Last Judgment
cv 240.4×181.0 (610×460 cm) 1615-6
Das kleine Jüngste Gericht
Small Last Judgment (on rv Landscape sketch)
pn 72.0×46.9 (183×119 cm)
Der Höllensturz der Verdammten *
Fall of the damned
pn 113.4×88.6 (288×225 cm)
Das apokalyptische Weib
Woman of the Apocalypse
cv 218.9×145.3 (556×369 cm)
Der hl. Christophorus
St. Christopher
pn 30.3×26.8 (77×68 cm)
Der hl. Franz von Paula heilt die Pestkranken
St. Francis of P. heals the plague-stricken
pn 25.2×19.3 (64×49 cm)
Die Krönung des Tugendhelden
Crowning of the virtues
pn 87.0×78.7 (221×200 cm)
Krieg und Frieden
War and peace
cv 91.3×133.9 (232×340 cm)
Der Raub der Töchter des Leukippos → no 62
Rape of the daughters of Leucippus
cv 87.4×82.3 (222×209 cm)
Meleager und Atalanta *
M. and A.
cv 77.6×56.3 (197×143 cm)
Schäferszene *
Pastoral scene
pn 63.8×52.8 (162×134 cm)
Zwei Satyrn
Two satyrs
pn 22.0×19.7 (56×50 cm)
Der Früchtekranz
Children with a garland of fruit
cv 47.2×79.9 (120×203 cm) fruit by Franz Snyders
Amor schnitzt den Bogen
Cupid drawing his bow
cv 55.9×42.5 (142×108 cm) sg d 1614
free copy from Parmigianino
Der trunkene Silen *
Drunken Silenus
pn 83.5×83.9 (212×213 cm)
Die Amazonenschlacht *
Battle of the Amazons
pn 47.6×65.0 (121×165 cm)
Die Aussöhnung der Römer und Sabiner
Romans and Sabines reconciled
cv 100.0×133.3 (254×341 cm)
Der sterbende Seneca *
Dying S.
pn 72.4×61.0 (184×155 cm)
Heinrich IV. in der Schlacht bei Martin d'Eglise *
Henry IV at the battle near M. d'E.
cv 133.9×107.5 (340×273 cm)

SKETCHES FOR THE MARIA DE' MEDICI CYCLE
Die Erziehung der Prinzessin *
Education of the Princess
pn 19.3×15.4 (49×39 cm)
Heinrich IV. empfängt das Bildnis der Prinzessin
Presentation of the Princess' portrait to Henry IV
pn 18.9×14.2 (48×36 cm)
Die Vermählung der Prinzessin
Marriage of the princess
pn 24.0×19.7 (61×50 cm)
Empfang der neuvermählten Königin im Hafen von Marseille → no 66
Reception of the Princess at Marseilles
pn 25.2×19.7 (64×50 cm)

Die Krönung der Königin
Crowning of the Queen
pn 21.3×34.6 (54×88 cm)
Die Übergabe der Regentschaft
Conferring the Regency
pn 18.5×13.8 (47×35 cm)
Die Vergötterung Heinrichs IV.
Apotheosis of Henry IV
pn 21.3×36.2 (54×92 cm)
Die Unterdrückung des Bürgerkrieges
Repression of the Civil War
pn 25.2×19.7 (64×50 cm)
Die glückliche Regierung der Königin *
Happiness of the Regency
pn 25.2×19.7 (64×50 cm)
Familien-Verbindung zwischen Frankreich und Spanien
Family ties between Spain and France
pn 29.5×18.9 (75×48 cm)
Die Blüte Frankreichs unter der Regentschaft der Königin
Prosperity of France under the Regency
pn 21.3×36.2 (54×92 cm)
Die Volljährigkeit Ludwigs XIII.
Coming of age of Louis XIII
pn 25.6×19.7 (65×50 cm)
Die Gefangennahme der Königin
Arrest of the Queen
pn 24.4×19.7 (62×50 cm)
Die Flucht der Königin
Flight of the Queen
pn 24.8×19.7 (63×50 cm)
Aussöhnung der Königin mit ihrem Sohn
Reconciliation of the Queen and her son
pn 25.2×19.7 (64×50 cm)
Zusammenkunft der Königin mit ihrem Sohn
Meeting of the Queen with her son
pn 25.2×19.3 (64×49 cm)

Rubens und Isabella Brant, des Künstlers erste Frau, in der Geissblattlaube → no 59
R. and I. B. in the Honeysuckle Bower
cv/pn 70.1×53.5 (178×136 cm)
Ein General des Franziskaner-Ordens
Father general of the Franciscan order
cv 41.3×31.1 (105×79 cm)
Bildnis des Lizentiaten Hendrik van Thulden *
Portrait of Dr. H. v. T.
pn 47.6×40.9 (121×104 cm)
Junger Mann mit schwarzem Barett
Young man with a black cap
pn 17.3×13.8 (44×35 cm)
Alte Frau
Portrait of an old lady
pn 19.3×13.0 (49×33 cm)
Alathea Talbot, Gräfin von Shrewsbury, mit ihren Reisebegleitern *
A. T., Countess of Shrewsbury
pn 104.3×105.1 (265×267 cm)
Don Ferdinand von Spanien in Kardinalskleidung
Don Ferdinando of Spain in the robes of a cardinal
cv 46.5×33.1 (118×84 cm)
Hélène Fourment, die zweite Frau des Künstlers, im Hochzeitsgewand → no 60
H. F. in her wedding dress
pn 64.2×53.5 (163×136 cm)
Hélène Fourment, einen Handschuh anziehend
H. F. putting on a glove
pn 37.8×26.8 (96×68 cm)
Rubens und seine zweite Frau im Garten → no 64
R. and Hélène Fourment in their garden
pn 38.6×51.6 (98×131 cm)
Hélène Fourment mit ihrem erstgeborenen Sohn Frans → no 61
H. F. with her firstborn F.
pn 57.1×40.2 (145×102 cm)
Jan Brant, Schwiegervater des Künstlers
J. B., the painter's father-in-law
cv 42.5×37.4 (108×95 cm)
Polderlandschaft mit einer Kuhherde *
Polder landscape with herd of cows
pn 31.9×41.7 (81×106 cm)
Landschaft mit Regenbogen → no 63
Landscape with rainbow
pn 37.0×48.4 (94×123 cm)

Nilpferdjagd
Hippopotamus hunt
cv 97.2×126.4 (247×321 cm)
Löwenjagd
Lion hunt
cv 98.0×147.6 (249×375 cm)

RUISDAEL Jacob Isaacksz. van
Haarlem 1628-9 – Amsterdam 1682
Sandhügel mit Bäumen bewachsen *
Sand dunes with trees
pn 27.6×36.2 (70×92 cm) sg d 1607
Waldlandschaft mit aufsteigendem Gewitter *
Forest landscape with threatening storm
cv 21.6×26.8 (55×68 cm) sg
Waldlandschaft mit sumpfigem Gewässer *
Forest landscape in the marshes
cv 23.6×28.7 (60×73 cm) sg c 1660
Flachlandschaft mit einem Kirchdorf → no 79
Wide landscape with village church
cv 23.2×28.7 (59×73 cm) sg
Eichen an einem Giessbach *
Torrent with oak trees
cv/pn 28.3×35.4 (72×90 cm) sg

RUYSCH Rachel
Amsterdam 1664 – 1750
Blumenstrauss
Bunch of flowers
cv 29.5×23.6 (75×60 cm) sg d 1715

RUYSDAEL Salomon van
Naarden c 1600 – Haarlem 1670
Flusslandschaft mit Fähre *
River landscape with ferry
pn 25.6×37.0 (65×94 cm) sg d 16..
Der Wachtturm an der Landstrasse → no 78
Watch tower on the main road
pn 26.0 31.9 (66×81 cm)

SAENREDAM Pieter Jansz.
Assendelft 1597 – Haarlem 1665
Das Innere der St.-Jacobs-Kirche in Utrecht *
Interior of the church of St. James in U.
pn 21.6×16.9 (55×43 cm) sg d 1642 ins

SALVIATI Cecchino del (Francesco Rossi)
Florence 1510 – Rome 1563
"Caritas"
pn 56.3×40.2 (143×102 cm)

SALZBURGISCH (PAINTER OF SALZBURG)
act 1450-60
Maria mit Kind
Virgin and child
pn 18.9×14.2 (48×36 cm) (including original frame)

SANDRART Joachim von
Frankfurt 1606 – Nuremberg 1688
Bildnis einer Frau
Portrait of a woman
cv 26.4×20.9 (67×53 cm)

SARACENI Carlo
Venice 1580-5 – 1620
Die Vision des hl. Franziskus *
V. of St. Francis
cv 95.7×65.7 (243×167 cm) sg
Der Tod Mariae *
Death of the Virgin
copper 17.7×11.0 (45×28 cm)

SARTO Andrea del (A. d'Agnolo di Francesco)
Florence 1486 – 1530
Maria mit dem Kinde, Johannes dem Täufer, Elisabeth und zwei Engeln *
Virgin and Child with Saints John the Baptist, Elizabeth and two angels
pn 53.9×40.9 (137×104 cm)

SAVERY Roeland
Coutrai c 1576 – Utrecht 1639
Eberjagd → no 54
Boar hunt
pn 9.8×13.8 (25×35 cm) sg d 1609

99

SCHÄUFELEIN Hans
... 1480-5 – Nördlingen 1539
Vier Tafeln vom sog. Christgartner Altar *
Four panels from the Christgarten Altarpiece (Death of the Virgin; Coronation of the V.; Angel bearing the palm of victory of the V.; Funeral of the V.)
panels c 50.0×39.4 (c 127×100 cm) ins
reverses in Munich, Bayerische Staatsgemäldesammlungen (storerooms)

SCHAFFNER Martin
... 1477-8 – Ulm 1547
Wolfgang I., Graf von Oettingen
W. I, Duke of O.
pn 18.1×11.4 (46×29 cm)
sg d 1508 ins
Zwei Flügelpaare vom Hochaltar der Kirche des ehemaligen Augustiner-Chorherren-Stifts in Wettenhausen
Two pairs of wings from the altarpiece of the main altar of the old Augustinian convent in W. (Ext wings: ext Christ's farewell to the Virgin; int Annunciation and Death of the V. Int wings: ext Presentation in the Temple and Descent of the Holy Ghost)
ar panels 118.1×62.2 (300×158 cm) sg d 1523 and 1524
int of internal wings originally relief with *Adoration of the Kings*, now in Munich, Bayerisches Nationalmuseum
Eitel Hans Besserer
pn 16.5×11.8 (42×30 cm)
ins 1529

SCHÖNFELD Johann Heinrich
Biberach 1609 – Augsburg 1682-3
"Ecce Homo" *
cv 59.4×81.1 (151×206 cm)

SCHÖPFER DER ÄLTERE (THE ELDER) Hans
... 1505 – Munich 1566
Appius Claudius fällt ein ungerechtes Urteil über Verginia, die dann zur Wahrung ihrer Unschuld von ihrem Vater Verginius erdolcht wird
Death of Virginia
pn 37.4×66.1 (95×168 cm)
sg d 1535 (false sg and d)

SCHONGAUER Martin
Kolmar 1430-5 – Breisach 1491
Heilige Familie → no 7
Holy Family
pn 10.2×6.7 (26×17 cm)

SCHOOTEN Floris van
act 1612-55 Haarlem
Stilleben mit Käselaiben *
Still life with cheeses
pn 20.5×32.3 (52×82 cm)

SEGNA DI BUONAVENTURA
act 1299-1331 Siena
Die hl. Magdalena *
St. Mary Magdalene
pn 17.3×11.4 (44×29 cm) ins

SELLAER Vincent
act c 1538 Malines
Christus segnet die Kinder
Christ blesses little children
pn 32.7×50.0 (83×127 cm)
sg d 1538 mutilated

SIBERECHTS Jan
Antwerp 1627 – London 1703 (?)
Viehweide mit schlafender Frau *
Grazing animals and sleeping woman
cv 42.1×33.1 (107×84 cm)

SIENESISCHER MEISTER (SIENESE MASTER)
act c 1340
Die Himmelfahrt Mariae *
Assumption
ar pn 27.2×11.8 (69×30 cm)

SIGNORELLI Luca
Cortona 1445-50 – 1523
Maria mit dem Kinde *
Virgin and Child
pn td 33.9 (86 cm) (including gold frame)

SNYDERS Frans
Antwerp 1579 – 1657
Küchenstück *
Kitchen table
cv (135×201 cm) sg
Eine Löwin schlägt ein Wildschwein
Lioness attacking boar
cv 53.1×94.1 (164×239 cm)
Zwei junge Löwen verfolgen einem Rehbock
Two young lions following a deer
cv 65.0×94.5 (165×240 cm)
see also Rubens

SODOMA (Giovanni Antonio Bazzi)
Vercelli 1477 – Siena 1549
Die Heilige Familie *
Holy Family
pn 28.0×20.1 (71×51 cm)

Soest see **KONRAD VON S.**

SOREAU Jan
act 1620-38 Hanau
Stilleben
Still life
pn 14.6×20.1 (37×51 cm)

Spagnuolo see **CRESPI**

SPRANGER Bartholomäus
Antwerp 1546 – Prague 1611
Die Beweinung Christi
Lamentation of Christ
copper 5.9×4.7 (15×12 cm)
Angelica und Medoro
A. and Medorus
cv 42.1×31.1 (107×79 cm)

STEEN Jan
Leyden 1625-6 – 1679
Schlägerei zwischen Kartenspielern in einer Schenke
Brawling card players in a tavern
cv 26.8×31.5 (68×80 cm)
sg d 1664 ins
Die Liebeskranke → no 87
Lovesick woman
cv 24.0×20.5 (61×52 cm)
sg ins
Der gekrönte Redner *
Crowned orator
cv 27.2×25.6 (69×64 cm)
sg ins

STOMER Matthias
Low Countries c 1600 – Sicily(?) c 1650
Ceres, von Abbas verhöhnt
C. scorned by A.
cv 68.9×87.0 (175×221 cm)
Der zwölfjährige Jesus unter den Schriftgelehrten *
Jesus among the doctors
cv 79.5×58.3 (202×148 cm)

STOSSKOPF Sebastian
Strasbourg 1597 – Idstein 1657
Stilleben *
Still life
cv 20.9×27.2 (53×69 cm)

STREECK Juriaen van
Amsterdam 1632 – 1687
Stilleben mit Mohr und Porzellangefässen
Still life
cv 56.3×47.2 (143×120 cm)
damaged

STRIGEL Bernhard
Memmingen 1460-1 – 1528
Rückkehr Davids mit dem Haupt des Goliath
David returning with the head of G.
pn 30.3×17.7 (77×45 cm)
Hieronymus Haller
pn 18.5×12.6 (47×32 cm)
ins 1503
Devotionsdiptychon des Hans Funk *
Devotional diptych of H. F. (l wing Virgin and child; r wing Hans Funk)
panels 24.4×15.0 and 24.0×14.6 (62×38 cm and 61×37 cm) ins
Sibylla von Freyberg, geborene Gossenbrot → no 15
Portrait of S. v. F. G.
pn 24.0×14.2 (61×36 cm)
on rv coat of arms of the two families
Konrad Rehlinger der Ältere und seine acht Kinder **
K. R. the Elder and his eight sons
dip; panels 82.3×39.8 and 38.6 (209×101 cm and 98 cm)
d 1517; the second ins

SNYDERS — (continued)

Tafeln vom Sarg eines Heiligen Grabes *
Three mortuary panels (Sleeping guard with club and sword; with sword and halbert [?]; with crossbow)
panels 18.9×18.1 (48×46 cm)
fourth pn at York (Yorkshire), City Art Gallery

STROBEL Bartholomäus
act 1600 Breslau
Das Gastmahl des Herodes
Herod's feast
cv 37.4×28.7 (95×73 cm)

STROZZI Bernardo (Il Cappuccino or Il Prete Genovese)
Genoa 1581 – Venice 1644
Der Zinsgroschen *
The tribute
cv 62.6×48.4 (159×123 cm)

SUBLEYRAS Pierre
Saint-Gilles-du-Gard 1699 – Rome 1749
Kaiser Theodosius vor dem hl. Ambrosius *
Der hl. Benedikt erweckt ein totes Kind *
T. before St. Ambrose; St. Benedict brings a child back to life
cv and crt/cv 15.7×10.2 (40×26 cm); the first sg

SÜDNIEDERLÄNDISCH (PAINTER OF THE SOUTHERN LOW COUNTRIES)
act c 1530
Landschaft mit dem hl. Hubertus
Landscape with St. Hubert
pn 22.8×33.1 (57×84 cm)

Suess see **KULMBACH**

SUSTRIS Friedrich
Italy (?) c 1540 – Munich 1599
Triumph des Marius über Jugurtha
Darius weist die Ratschläge des Charidemus zurück
Triumph of M.; D. rejects C.'s counsel
canvases 40.9×63.0 (104×160 and 106×159 cm)

SUSTRIS Lambert
Amsterdam 1515-20 – Padua (?) c 1568
Hans Christoph (I.) Vöhlin von Frickenhausen
Veronika Vöhlin *
Husband and wife portraits
canvases 46.5×88.6 and 45.7×88.2 (118×225 cm and 116×224 cm) d 1552 ins

SWART VAN GRONINGEN Jan
Groningen c 1500 – Antwerp (?) c 1553
Die Predigt Johannes des Täufers *
St. John the Baptist preaching
pn 29.1×44.1 (74×112 cm)
1528-30

SWEERTS Michael
Brussels 1624 – Goa (India) 1664
Eine Wirtsstube *
Interior of an inn
cv 39.4×37.8 (100×96 cm)

TENIERS DER JÜNGERE (THE YOUNGER) David
Antwerp 1610 – Brussels 1690
Flämische Dorfkneipe
Flemish village tavern
pn 11.0×14.6 (28×37 cm) sg

Terborch see **BORCH**

Terbrugghen see **BRUGGHEN**

Theotokópoulos see **GRECO**

TIEPOLO Giovanni Battista
Venice 1696 – Madrid 1770
Die Verehrung der Heiligen Dreifaltigkeit durch Papst Clemens *
Pope Clement adoring the Trinity
altarpiece; cv 176.4×100.8 (448×256 cm) 1735
Die Anbetung der Könige → no 114
Adoration of the Kings
cv 160.6×82.7 (408×210 cm)
sg d 1753

Rinaldo im Zauberbann Armidas *
Rinaldos Trennung von Armida *
R. enchanted by Armida; Parting of R. and A.
canvases 41.3 and 41.7×55.9 (105 and 106×142 cm)
sg 1751-3

TINTORETTO Domenico (D. Robusti)
Venice 1559 – 1637
Bildnis eines Bildhauers *
Portrait of a sculptor
cv 29.1×24.8 (74×63 cm) res

TINTORETTO Jacopo (J. Robusti)
Venice 1518 – 1594
Vulkan überrascht Venus und Mars *
M. and V. surprised by Vulcan
cv 53.1×78.0 (135×198 cm)
Die Kreuzigung Christi *
Crucifixion
cv 60.2×97.2 (153×247 cm)
Bildnis eines Edelmannes mit einer Skulptur der Lucretia
Portrait of a gentleman with a bust of L.
cv 44.5×35.0 (113×89 cm)
Christus bei Maria und Martha → no 113
Christ in the house of M. and Mary
cv 78.7×52.0 (200×132 cm) sg

CYCLE OF PANTINGS FOR THE GONZAGA FAMILY
Die Erhebung des Giovanni Francesco Gonzaga zum Markgrafen von Mantua durch Kaiser Sigismund (1433)
King S. (1433) names G. F. G. as Margrave of M.
cv 107.1×170.1 (272×432 cm) 1579
Ludovico II. Gonzaga besiegt die Venezianer an der Etsch bei Legnano (1439) *
L. II G. defeats the Venetians on the Adige near L.
cv 107.5×151.6 (273×385 cm) 1579
Federico I Gonzaga entsetzt die Stadt Legnago (1478) *
F. I G. raises the siege of Legnano
cv 103.1×165.8 (262×421 cm) 1579
Francesco II. Gonzaga kämpft in der Schlacht am Taro gegen Karl VIII. von Frankreich (1495) *
F. II G. at the battle of the Taro
cv 105.9×166.1 (269×422 cm) 1579
Federico II. Gonzaga nimmt Parma ein (1521) *
F. II G. conquers P.
cv 83.5×111.4 (212×283 cm) 1579-80
Federico II. Gonzaga nimmt Mailand ein (1521) *
F. II G. conquers Milan
cv 80.3×131.1 (204×333 cm) 1579-80
Federico II. Gonzaga verteidigt Pavia (1522) *
F. II G. defends P.
cv 82.7×108:7 (210×276 cm) 1579-80
Der Einzug Philipps II. in Mantua (1549) *
Entry of Philip II into M.
cv 83.5×129.9 (212×330 cm) 1579-80

TIZIANO VECELLIO
Pieve di Cadore (?) 1488-90 – Venice 1576
Die Eitelkeit des Irdischen *
Vanity
cv 38.2×31.9 (97×81 cm)
Bildnis eines jungen Mannes → no 108
Portrait of a young man
cv/pn 35.0×29.1 (89×74 cm)
Maria mit dem Kind, Johannes dem Täufer und einem Stifter*
Virgin and Child with St. John the Baptist and donor
cv 29.5×36.2 (75×92 cm)
Venezianischer Nobile *
Venetian nobleman (Marshall of the Knights of the Order of Santiago)
cv 54.7×46.1 (139×117 cm)
sg ins
Bildnis Kaiser Karls V. → no 109
Portrait of Charles V
cv 79.9×48.0 (203×122 cm)
sg d 1548

Maria mit dem Kinde in einer Abendlandschaft *
Virgin and Child in a landscape at sunset
cv 68.1×52.4 (173×133 cm) sg
Die Dornenkrönung → no 110
Crowning with Thorns
cv 110.2×71.7 (280×182 cm)

TOCQUE Louis
Paris 1696 – 1772
Pfalzgraf Friedrich Michael von Zweibrücken-Birkenfeld *
The Palatine Count F. M. v. Z.-B.
cv 35.0×29.5 (89×75 cm) sg

TURCHI Alessandro (L'Orbetto)
Verona 1588-90 – Rome 1648
Herkules und Omphale *
Der rasende Herkules *
Hercules and O.; Madness of H.
canvases c 65.4×92.9 (c 166×236 cm)

UMBRISCH (UMBRIAN PAINTER)
act 1505
Bildnis eines jungen Mannes *
Portrait of a young man
pn 20.9×16.1 (53×41 cm) false sg (Raffaello)

UNBEKANNTER MEISTER (ANONYMOUS)
act beginning Seventeenth Century
Marine
cv 29.1×42.1 (74×107 cm)

UYTTENBROECK Moses van
The Hague 1584-90 – 1648
Argus, Juno and Jo *
A., J. and Io
pn 20.1×35.0 (51×89 cm)
sg d 1625
Schäferszene
Pastoral scene
pn 12.6 19.3 (32×49 cm) attr

VADDER Lodewyck de
Brussels 1605 – 1655
Landschaft mit Hohlweg
Landscape with road
pn 12.6×20.1 (32×51 cm)

VALCKENBORCH Frederick van
Antwerp c 1570 – Nuremberg 1623
Karneval
Carnival
cv 20.5×34.6 (52×88 cm)

VALCKENBORCH Lucas van
Louvain (?) c 1530 – Frankfurt 1597
Der Babylonische Turmbau *
Building of the Tower of Babel
pn 8.3×11.4 (21×29 cm)
sg d 1568

VALENTIN DE BOULOGNE Jean (Le V.)
Coulommiers 1594 – Rome 1632
Dornenkrönung und Verspottung Christi 188 → no 124
Crowning with Thorns and Christ scorned
cv 50.4×37.4 (128×95 cm)
Dornenkrönung Christi 477 *
Crowning with thorns
cv 68.1×96.5 (173×245 cm)
Herminia bei den Hirten *
Erminia and the shepherds
cv 52.8×72.8 (134×185 cm)

VASARI Giorgio
Arezzo 1511 – Florence 1574
Heilige Familie
Holy Family
pn 53.5×40.2 (136×102 cm)

Veerendael see under **Heem**

VELÁZQUEZ Diego Rodríguez de Silva y
Seville 1599 – Madrid 1660
Junger spanischer Edelmann → no 118
Young Spanish gentleman
cv 35.0×27.2 (89×69 cm)

VELDE Adriaen van de
Amsterdam 1636 – 1672
Hirt mit Rinderherde
Herder
cv 38.2×51.6 (97×131 cm)
sg d 1660

VELDE Esaias van de
Amsterdam c 1591 – The Hague 1630
Eisbelustigung auf dem Wallgraben *
Winter games on ice
pn 11.4×19.7 (29×50 cm)
sg d 1618

VELDE DER JÜNGERE (THE YOUNGER) Willem van de
Leyden 1633 – London 1707
Ruhige See *
Calm sea
cv 20.1×22.0 (51×56 cm)
c 1655

VERHAECHT Tobias
Antwerp 1561 – 1631
Landschaft *
Landscape
pn 19.3×26.4 (94×67 cm)
sg d 1612

VERMEYEN Jan Cornelisz.
Beverwijk c 1500 – Brussels 1559
Bildnis eines Mannes
Portrait of a man
pn 30.3×22.8 (77×58 cm) mutilated

VERNET Claude Joseph
Avignon 1714 – Paris 1789
Eine Meersbucht *
Landscape with bay
cv 18.1×26.8 (46×68 cm)
sg d 1760
Orientalischer Seehafen *
Eastern seaport
copper 11.8×16.9 (30×43 cm)
sg

VERONESE Paolo (P. Caliari)
Verona 1528 – Venice 1588
Die Heilige Familie *
Holy Family
cv 42.9×32.7 (109×83 cm)
Bildnis einer venezianischen Dame *
Portrait of a Venetian lady
cv 46.1×39.8 (117×101 cm)
Amor mit zwei Hunden *
Cupid with two dogs
cv 39.4×52.8 (100×134 cm)

VIVIEN Joseph
Lyons 1657 – Bonn 1734
Erzbischof Fénélon von Cambrai → no 128
Archbishop F. of C.
cv 31.5×24.8 (80×63 cm)

VOS Maerten de
Antwerp 1532 – 1603
Die Israeliten sammeln das Manna *
Israelites gathering M.
pn 60.6×62.2 (154×158 cm)

VOUET Simon
Paris 1590 – 1649
Judith *
cv 37.8×28.3 (96×72 cm)

VRANCX Sebastian
Antwerp 1573 – 1647
Wallfahrer bei einer Stadt
Pilgrim before a city
pn 22.0×46.9 (56×119 cm)
sg d 1622

WEENIX Jan
Amsterdam 1642 (?) – 1719
Schlafendes Mädchen
Jägerbursche mit totem Wild
Sleeping girl; Hunter with dead game
panels c 17.7×13.8 (c 45×35 cm) sg d 1665
Tiere, Jagdgerät und Jäger *
Jäger mit Hunden und totem Geiter
Animals, hunting gear and hunter; Hunter with dogs and dead game
canvases 70.9 and 71.7×98.4 (180 and 182×250 cm) sg d 1702
Der Jagdzyklus:
Jagdstilleben vor einer Landschaft mit Schloss Bensberg*
Schweinsjagd
Jagdstilleben vor einer Dianastatue *
Hunting cycle: Still life with dead game and B. castle in background; Boar hunt; Still life with game before a statue of Diana

canvases 135.4×220.9, 135.8×83.9 and 80.7 (344×561 cm, 345×213 cm and 205 cm); the first sg d 1712
other paintings of the cycle in Munich, Bayerische Staatsgemäldesammlungen (storerooms)

WEENIX Jan Baptist
Amsterdam 1621 – Huys ter Mey (Utrecht) c 1660
Stilleben mit totem Geflügel, Henkelkrug und Glas
Still life with birds, jug and glass vase
cv 26.0×21.6 (66×55 cm)
c 1650
Schlafendes Mädchen *
Sleeping girl
cv 26.0 21.3 (66×54 cm)
sg d 1656 ins

WERFF Adriaen van der
Kralingen-Ambacht 1659 – Rotterdam 1722
Spielende Kinder vor einer Herkulesgruppe *
Boys playing before a statue of Hercules
ar pn 18.5×13.8 (47×35 cm)
sg d 1687
Grablegung Christi
Burial of Christ
ar pn 32.3×21.3 (82×54 cm)
sg d 1703

WERTINGER Hans
Landshut 1465-70 – 1533
Herzog Wilhelm IV. von Bayern * (p 8)
Maria Jacobäa von Baden Herzogin von Bayern → no 31
Portraits of Duke W. of Bavaria and of his wife
ar panels 26.8 and 27.2×17.7 (68 and 69×45 cm)
on rv of the first coats of arms of the sitters

WEYDEN Rogier van der (R. de la Pasture)
Tournai c 1399 – Brussels 1464
Der Dreikönigsaltar → no 42
Triptych of the Kings (Centr pn *Adoration of the Kings;* wings *Annunciation* and *Presentation in the Temple*)
panels: centr pn 54.3×60.2 (138×153 cm); wings 54.7×27.6 (139×70 cm)
Der hl. Lukas zeichnet die Madonna → no 41
St. Luke painting the Virgin
pn 54.3×43.3 (138×110 cm)

Witte see **CANDID**

WOENSAM VON WORMS Anton
... c 1500 – Cologne 1540-1
Zwei Flügel eines Altares
A pair of altarpiece wings (Ext *Martyrdom of the Theban Legion.* Int l wing *Saints Anne and Gregory the Great;* r wing *Saints Stephen and Maurice*)
panels 53.5×40.9 (136×104 cm); l wing sg d 1520

WOUWERMANS Philips
Haarlem 1619 – 1668
Dünenlandschaft
Landscape with dunes
pn 9.8×8.7 (25×22 cm) sg
Winterlandschaft mit Eisbahn *
Winter landscape with ice skaters
pn 18.5×24.8 (47×63 cm)
sg c 1655
Rast auf der Hirschjagd *
Rest during a deer hunt
pn 18.9×25.2 (48×64 cm) sg

WTEWAEL Joachim Anthonisz.
Utrecht c 1566 – 1638
Die Vermählung von Peleus und Thetis
Marriage of P. and T.
copper 6.3×8.3 (16×21 cm)

Zampieri see **DOMENICHINO**

ZURBARÁN Francisco de
Fuente de Cantos 1598 – Madrid 1664
Der hl. Franziskus von Assisi in Ekstase *
St. Francis of A. in Ecstasy
cv 25.6×20.9 (65×53 cm)

Schleissheim

ALBRECHT Balthasar Augustin
Berg bei Starnberg 1687 – Munich 1765
Selbstbildnis
Self-portrait
cv 63.8×48.0 (162×122 cm)
sg d 1761
Bildnis des Bildhauers Johann Straub
Portrait of the sculptor J. S.
cv 63.8×46.1 (162×117 cm) sg d 1763

AMIGONI Jacopo
Venice 1675 – Madrid 1752
Venus und Adonis → no 148
V. and A.
cv 55.9×68.1 (142×173 cm)

ARTOIS Jacques d'
Brussels 1613 – 1686 (?)
Hirschjagd
Falkenbeize *
Deer hunt and *Hunting with a falcon*
canvases 53.1×81.1 (135×206 cm)

ASSELYN Jan
Dieppe 1610 – Amsterdam 1652
Landschaft mit Fluss und Bogenbrücke *
Landscape with river and arched bridge
pn 24.0×29.9 (61×76 cm) sg

ASSERETO Giovacchino
Genoa 1600 – 1649
Hl. Franziskus *
St. Francis
cv 55.9×39.4 (142×100 cm)

BADALOCCHIO Sisto
Parma 1585 – Ordogno 1647
Gethsemane
Garden of G.
slate 17.7×12.2 (45×31 cm)

BAKHUYZEN Ludolf
Emden 1631 – Amsterdam 1708
Im Hafen von Amsterdam
Port of A.
cv 43.7×57.5 (111×146 cm) sg d 1697

BATONI Pompeo Girolamo
Lucca 1708 – Rome 1787
Selbstbildnis *
Self-portrait
cv 26.8×22.0 (68×56 cm) sg d 1765 ins

BERCHEM Nicolaes
Haarlem 1620 – Amsterdam 1683
Laban verteilt die Feldarbeit
L. shares out the agricultural labour
cv 54.7×65.4 (139×166 cm)
sg d 1643
Italienische Landschaft *
Italian landscape
cv 20.3×28.0 (60×71 cm) sg

BERENTZ Christian
Hamburg 1658 – Rome 1722
Stilleben mit Büchern und Gefässen *

Still life with books and vases
cv 25.8×53.9 (65.5×137 cm)

Berrettini see **PIETRO DA CORTONA**

BILIVERTI Giovanni
Maestricht 1576 – Florence 1644
Mythologische Szene
Mythological scene
cv 81.9×65.7 (208×167 cm) sg d 1633

BOCKHORST Jan van
Münster 1605 – Antwerp 1668
Odysseus erkennt Achill unter den Töchtern des Lycomedes*
Merkur verliebt sich in Herse
Ulysses recognizes Achilles among L.' daughters; Mercury falls in love with H.
canvases 48.8×74.0 (124×188 cm)
Dädalus und Jkarus → no 139
Daedalus and Icarus
cv 63.8×52.4 (162×133 cm) attr

BOEL Pieter
Antwerp 1622 – Paris 1674
Stilleben mit Hund, Pfau und Gänsen
Totes Federwild mit Eule und Welschem Hahn
Still life with dog, peacock and geese; Game with owl and cock
canvases 55.1×83.5 (140×212 cm)

BOTH Jan
Utrecht c 1618 – 1652
Italienische Herbstlandschaft
Italian landscape in autumn
pn 29.9×45.3 (76×115 cm)
Hermes als Argustöter
Hermes, killer of Argus
cv 45.7×40.2 (116×102 cm) sg probably in collaboration with Jan Baptist Weenix (Amsterdam 1621 – Huys ter Mey [Utrecht] c 1660)

Boudewyns see under **Bout**

BOURDON Sébastien
Montpellier 1616 – Paris 1671
Römischer Kalkofen *
Roman furnaces
cv 67.7×96.9 (172×246 cm)
Ruhe auf der Flucht
Rest on the flight into Egypt
cv 14.6×18.9 (37×48 cm)

BOUT Pieter
Brussels 1658 – 1719
Italienische Landschaft
Italian landscape
cv 43.7×58.7 (111×149 cm)
figures by Adriaen Frans Boudewyns (Brussels 1644 – 1711)

BURRINI Gian Antonio
Bologna 1656 – 1727
Die Geburt Christi
Nativity
cv 26.0×19.3 (66×49 cm)

Brueghel Jan see under **Rubens**

CAGNACCI or CANLASSI Guido
Sant'Arcangelo di Romagna 1601 – Vienna 1681
"Mater dolorosa"
cv 41.7×46.1 (106×117 cm)
Hl. Maria Egyptiaca von Engeln getragen
St. Mary Egyptian carried by angels
cv 74.8×56.3 (190×143 cm)

CARAVAGGIO Nachahmer (Follower of C.)
Seventeenth Century, Germany
Lautenspieler
Lute player
cv 43.3×31.9 (110×81 cm)

CARRACCI Annibale
Bologna 1560 – Rome 1609
Bildnis eines bärtigen Mannes
Portrait of a bearded man
cv 20.9×17.7 (53×45 cm)

CARRACCI Ludovico
Bologna 1555 – 1618
Taufe Christi*
Baptism of Christ
cv 58.3×46.1 (148×117 cm)

CASTELLO Valerio
Genoa 1624 – 1659
Rinaldo und Armida
R. and A.
cv 52.4×55.1 (133×140 cm) attr
attr also to Francesco Maffei (Vicenza c 1602 – Padua 1660)

Castiglione see **GRECHETTO**

CIGNAROLI Giambettino
Verona 1706 – 1770
Geburt Christi
Nativity
cv 18.9×28.0 (48×71 cm)

CLAESZ. Pieter
Burgsteinfurt c 1597-8 - Haarlem 1661
Stilleben
Still life
pn 24.0×20.5 (61×52 cm)
sg d 1636

CODDE Pieter
Amsterdam 1599 – 1678
Knabenbildnis → no 143
Portrait of a child
cv/pn 20.9×15.7 (53×40 cm) sg

COYPEL Charles Antoine
Paris 1694 – 1752
Herkules und Omphale*
Hercules and O.
cv 70.5×52.0 (179×132 cm)
sg d 1731

CRAYER Gaspar de
Antwerp 1582 – Ghent 1669
Maria von Heiligen verehrt*
Virgin worshiped by Saints
sketch; cv 29.1×21.6 (74×55 cm)

CRESPI Giuseppe Maria (Lo Spagnolo)
Bologna 1665 – 1747
Der Bethlehemitische Kindermord
*Massacre of the Innocents *
cv 60.2×83.5 (153×212 cm)

DESMARÉES George
Österby 1697 – Munich 1776
Selbstbildnis mit der Tochter Maria Antonia*
Self-portrait with his daughter M. A.
cv 62.6×46.5 (159×118 cm); ins; on rv sg d 1760
Bildnis Kurfürst Ferdinand Maria von Bayern
Portrait of the Prince Elector F. M. of Bavaria
cv 126.0×98.8 (320×251 cm)
Reiterbildnis Kurfürst Karl Albrechts später Kaiser Karl VII
Equestrian portrait of the Prince Elector K. Albrecht the future K. VII
cv 143.7×113.8 (365×289 cm)
Reiterbildnis Kurfürst Maximilian III. von Bayern
Equestrian portrait of the Prince Elector M. III of Bavaria
cv 143.7×113.8 (365×289 cm)
sg d 1758
Bildnis des Kurbayerischen Hofarztes Erhard Winterhalter, Schwiegersohn des Künstlers, mit Familie
Portrait of the court physician of Bavaria, E. W., and his family
cv 63.0×46.9 (160×119 cm)
sg d 1762
Bildnis des Kurbayerischen Hofmedailleurs F. A. Schega
Portrait of the medal-maker of the Bavarian court F. A. S.
cv 34.3×26.4 (87×67 cm)

DESPORTES Alexandre-François
Champigneul 1661 – Paris 1743
"Déjeuner gras"
"Déjeuner maigre"
canvases 28.7×36.2 (73×92 cm) sg; the first d 1741

DEUTSCHE SCHULE (GERMAN SCHOOL)
Eighteenth Century
Bildnis Kurfürstin Maria Anna (Gemahlin des Kurfürsten Max III. von Bayern)
Portrait of M. A. wife of the Elector M. III of Bavaria
cv 98.8×65.7 (251×167 cm)

DOMENICHINO (Domenico Zampieri)
Bologna 1581 – Naples 1641
Susanna im Bade
S. bathing
cv 104.3×129.5 (265×329 cm)

DOUFFET Gérard
Liège 1594 – 1660
Christus erscheint Jacobus
Christ appearing to St. James
cv 89.4×66.5 (227×169 cm)
sg ins
Bildnis eines rotbärtigen Mannes
Portrait of a man with a red beard
cv 39.4×30.3 (100×77 cm)
d 1624 ins

102

DROOCHSLOOT Joost Cornelisz.
Utrecht (?) 1586 – 1666
Plünderung eines Dorfes
Sacking of a village
cv 26.8×38.2 (68×97 cm)
sg d 1635

DUCK Jacob
Utrecht c 1600 – c 1660
Raucher in einer Kaschemme *
Smokers in a tavern
pn 14.6×12.2 (37×31 cm) sg

DUYSTER Willem Cornelisz.
Amsterdam 1598-9 – 1635
Lagerszene
Kartenspielende Offiziere
Encampment; Officers playing cards
panels 13.4×17.7 (34×45 cm) originally oval

DYCK Anthonis van
Antwerp 1599 – Blackfriars (London) 1641
Bildnis des Marinemalers Andries van Eertvelt → no 140
Portrait of the marine painter A. v. E.
cv 68.1×89.0 (173×226 cm)
sg d 1632 (?) ins
in collaboration with st assistants
see also Rubens

EVERDINGEN Allaert van
Alkmaar 1621 – Amsterdam 1675
Felsküste im Sturm
Rocky coast in a storm
pn 23.6×36.2 (60×92 cm)
sg attr

FALCONE Aniello
Naples 1600 – 1656
Schlachtenbild 2380, 2381
Battle scenes
canvases 29.5×39.4 (75×100 cm); reverses sg ("Andrea Falcone")

FERRI Ciro
Rome 1634 – 1689
Maria mit Kind und der hl. Martina *
Virgin and child with St. M.
cv 53.9×61.0 (137×155 cm)

FLÄMISCH (FLEMISH PAINTER)
act c 1630
Spanischer Edelmann
Spanish nobleman
cv 46.5×32.3 (118×82 cm)

FURINI Francesco
Florence 1603 – 1646
Artemisia *
cv 55.9×42.5 (142×108 cm)
Hl. Sebastian *
St. S.
cv 66.9×52.8 (170×134 cm)
Geburt der Rahel → no 145
Birth of Rachel
cv 74.4×91.3 (189×232 cm); rv sg

GHERING Anthonis Günther
act c 1662-8 Antwerp
Das Innere der Jesuitenkirche in Antwerpen mit der Ausmalung von Rubens vor dem Brand im Jahre 1718
Interior of the Jesuits' Church in Antwerp painted by R., before the fire of 1718
cv 32.3×37.8 (82×96 cm)
sg d 1663

GOUDREAUX Pierre
Paris 1694 – Mannheim 1731
Bildnis des Kurfürsten Karl Philipp von der Pfalz *
Portrait of Prince K. P., Elector of Palatinate
cv 90.2×64.2 (229×163 cm)
sg d 1724

GOYEN Jan van
Leyden 1596 – The Hague 1656
Gehöft mit Ziehbrunnen *
Farmhouse with well
pn 16.9×22.0 (43×56 cm)

GREBBER Frans Pietersz.
Haarlem 1573 – 1649
Paris mit dem Apfel
P. with the apple
pn 33.5×28.7 (85×73 cm)
sg d 1634

GRECHETTO (Giovanni Benedetto Castiglione)
Genoa c 1600-1 – Mantua c 1665
Noahs Aufbruch
Departure of Noah
cv 40.9×66.1 (104×168 cm)
Ein Dromedar geführt von einem jungen Mohren
Haustiere mit Gerätschaften
Dromedary and young Moor; Domestic animals
canvases c 65.0×98.4 (c 165×250 cm)

GREUZE Jean-Baptiste
Tournus 1725 – Paris 1805
Junges Mädchen *
Young woman
cv 16.1×13.0 (41×33 cm)

HAARLEMER SCHULE (SCHOOL OF HAARLEM)
Seventeenth Century
Bildnis eines Kaufherrn
Bildnis der Gemahlin eines Kaufherrn
Portraits of a trader and of his wife
canvases 47.6 and 49.6×34.3 (121 and 126×87 cm); the second d 1617 ins

HACKAERT Jan
Amsterdam 1629 – c 1700
Allee in hochstämmingem Laubwald mit Jagdgesellschaft *
Forest path with hunting party
cv 26.8×23.2 (68×59 cm)
figures by Adriaen van de Velde

HAEN David de
Rotterdam 1602 – Rome 1622
Dornenkrönung
Crowning with thorns
cv 46.5×53.1 (118×135 cm)

HEEM Jan Davidsz. de
Utrecht 1606 – Antwerp 1683-4
Früchtestück *
Composition with fruit
cv 26.4×36.2 (67×92 cm)
sg d 1653

HELT-STOCADE Nicolaes de
Nijmegen c 1614 – Amsterdam 1669
Bildnis des Baumeisters Georg Pfründ
Portrait of the builder G. P.
cv 23.6×16.9 (60×43 cm)

HOET DER ÄLTERE (THE ELDER) Gerard
Zalt-Bommel 1648 – The Hague 1733
Aeneas bei der Königin Dido
Antonius und Cleopatra
A. and queen D.; Anthony and C.
panels 17.7×24.0 (45×61 cm) sg

HOLLÄNDISCH [DUTCH PAINTER]
act 1700
Marine *
cv 33.9×50.8 (86×129 cm)

HONDECOETER Melchior de
Utrecht 1636 – Amsterdam 1695
Hahnenkampf *
Fighting cocks
cv 43.3×56.7 (110×144 cm) sg

HONTHORST Gerrit van
Utrecht 1590 – 1656
Der verlorene Sohn → no 141
Prodigal son
cv 49.2×61.8 (125×157 cm)
sg d 1623

HUYSUM Jan van
Amsterdam 1682 – 1749
Früchte, Blumen und Insekten
Fruit, flowers and insects
pn 31.9×24.0 (81×61 cm)
sg d 1735

JORDAENS Jacob
Antwerp 1593 – 1678
Satyrn und Nymphen *
Satyrs and nymphs
cv 100.0×96.5 (254×245 cm) sg

KEIL Bernhard
Helsingör 1624 – Rome 1687
Bildnis eines schlafenden Mädchens
Portrait of a sleeping girl
cv 24.4×37.8 (62×96 cm)

LAER Pieter van
Haarlem 1599 – ... c 1642
Faschingsscherz
Carnival
pn 20.9×31.1 (53×79 cm)

LAIRESSE Gerard de
Liège 1641 – Amsterdam 1711
Allegorie auf das Leben eines Künstlers
Allegory of an artist's life
pn 28.0×22.4 (71×57 cm) sg
Dido und Amor *
D. and Cupid
cv 52.0×66.1 (132×168 cm)

LARGILLIÈRE Nicolas de
Paris 1656 – 1746
Reichgekleidete Frau *
Lady in ceremonial dress
cv 35.0×25.2 (89×64 cm)
rv sg d 1710

LEBRUN Charles
Paris 1619 – 1690
Heilige Magdalena *
The Magdalene
cv 30.3×23.2 (77×59 cm)

LEMOINE François
Paris 1688 – 1737
Jagdgesellschaft *
Hunting party
cv 83.1×73.2 (211×186 cm) sg

LE NAIN Mathieu
Laon 1607 – Paris 1677
Der Maler mit Modell *
Artist with model
cv 20.5×24.0 (52×61 cm)

Lingelbach see under **Wynants**

LISSE Dirk van der
Breda c 1600 – The Hague 1669
Schlafende Diana
Sleeping D.
pn 21.3×16.1 (54×41 cm) sg
Landschaft mit tanzendem Pan
Landscape with P. dancing
pn 18.5×33.5 (47×85 cm) sg

LOTH Johann Ulrich
Munich c 1600 – 1662
Die büssende Magdalena
The penitent Magdalene
cv 34.6×47.2 (88×120 cm)
Evangelist Matthäus *
St. Matthew the Evangelist
cv 49.2×66.9 (125×170 cm)
Der reuige Petrus
The penitent Peter
copper 9.4×12.2 (24×31 cm)
sg d 1641

LOTH Johann Carl
Munich 1632 – Venice 1698
Schutzengel Raphael
Raphael, the angel guardian
cv 116.5×76.8 (296×195 cm)
Verspottung Noahs
Noah derided
cv 55.1×69.7 (140×177 cm)
Der sterbende Seneca
The dying S.
cv 73.2×105.1 (186×267 cm)
Aussetzung Moses
M.' exposure
cv 50.4×77.2 (128×196 cm)

LUCCHESINO (Pietro Testa)
Lucca 1611 – Rome 1650
Allegorie: der Lohn des Fleisses
Allegory: The reward of diligence
cv 51.2×76.0 (130×193 cm)

LUTI Benedetto
Florence 1666 – Rome 1724
Erziehung Mariens
Education of the Virgin
cv 55.5×43.3 (141×110 cm)
sg d 1715
Hl. Karl Borromeus
St. Charles Borromeo
cv 42.5×62.6 (108×159 cm)
sg d 1713 ins

Maffei see under **Castello**

MAINGAUD Martin
act 1692 – 1710 Munich and Brussels
Reiterbildnis Kurfürst Max Emanuel von Bayern
Equestrian portrait of the Prince Elector Maximilian E. of Bavaria
cv 145.3×116.5 (369×296 cm)
sg d 1710

MARATTA Carlo
Camerano 1625 – Rome 1713
Maria mit dem Jesuskind und Johannes
Virgin and Child with St. John
oval cv 38.6×31.9 (98×81 cm) attr

MEULEN Adam Frans van der
Brussels 1632 – Paris 1690
Ludwig XIV. vor Dinant
L. XIV before D.
cv 76.8×136.2 (195×346 cm)
Einnahme von Lille
Capture of Lille
cv 88.2×125.6 (224×319 cm)
Beschiessung von Oudenaerde
Bombardment of O.
cv 89.4×126.0 (227×320 cm)
Belagerung von Tournai
Siege of T.
cv 76.0×135.8 (193×345 cm)
Einnahme von Dôle am Doubs
Capture of D. on the D.
cv 76.0×127.9 (193×325 cm)
Belagerung von Lille
Siege of L.
cv 76.4×122.0 (194×310 cm)

MEYER Georg Friedrich
Strasbourg 1735 – Ermenonville 1779
Parforcejagd
Forced hunting
cv 23.2×28.3 (59×72 cm)
sg d 1768

MIEL Jan
Antwerp 1599 – Turin 1663
Armenspeisung
Volksszene
Poor people eating; Folk scene
canvases c 26.4×19.7 (c 67×50 cm)

MIGNARD Pierre
Troyes 1612 – Paris 1695
Heilige Familie
Holy Family
cv 64.6×40.6 (164×103 cm)
attr

MILLET Jean François (Francisque M.)
Antwerp 1642 – Paris 1679
Klassische Landschaft *
Classic landscape
cv 46.5×70.5 (118×179 cm)

MOMMERS Hendrik
Haarlem c 1623 – Amsterdam 1693
Hirtenstück
Pastoral scene
cv 42.5×58.3 (108×148 cm)

MONNOYER Jean-Baptiste
Lille 1636 – London 1699
Blumenstilleben *
Still life with flowers
cv 62.2×46.9 (158×119 cm)

MONOGRAMMIST A J B (Abraham Janssens?)
Die Erweckung des Lazarus
Raising of L.
pn 87.4×72.0 (222×183 cm)
sg d 1607 attr (?)

NEEFFS DER ÄLTERE (THE ELDER) Peter
Antwerp c 1578 – c 1660
Inneres einer gotischen Kirche
Interior of gothic church
pn 19.3×25.2 (49×64 cm) sg

NEER Aert van der
Amsterdam 1603-4 – 1677
Mondscheinlandschaft *
Landscape by moonlight
cv 24.4×29.9 (62×76 cm) sg

NEER Eglon Hendrick van der
Amsterdam 1634 – Düsseldorf 1703
Landschaft mit Schäferszene *
Hagar, Ismael und der Engel
Landscape with pastoral scene; H., Ishmael and the angel
panels 19.7×16.1 (50×41 cm)
sg d 1697, 1698

NEYN Pieter de
Leyden 1597 – 1639
Kanallandschaft
Landscape with canal
pn 18.1×27.6 (46×70 cm)
sg d 1633

NICKELE Jan van
Haarlem 1656 – Kassel 1721
Schloss Benrath 2170, 2171
B. castle
canvases c 29.1×37.8 (c 74×96 cm)
sg d 1715 and 1714; rv ins

NIEDERLÄNDISCH (PAINTER OF THE LOW COUNTRIES)
act c 1620
Der Anatom
Anatomist
cv 34.3×26.8 (87×68 cm)

NIEUWELANDT Willem II van
Antwerp 1584 – Amsterdam c 1635
Viehmarkt
Animal market
pn 14.6×19.3 (37×49 cm)

OOSTERWYCK Maria van
Noodorp (Delft) 1630 – Uitdam (Monnikendam) 1693
Blumenstück
Flower composition
cv 67.7×53.1 (172×135 cm)

Orbetto see **TURCHI**

OSTADE Isaak van
Haarlem 1621 – 1649
Bauernstube
Country kitchen
oval pn 16.1×21.3 (41×54 cm)
sg d 1641
Winterlandschaft mit Eisvergnügen *
Landscape with winter games on ice
oval pn 16.1×21.3 (41×54 cm) sg

PANNINI Giovanni Paolo
Piacenza 1691 – Rome 1765
Architekturbild: Vertreibung der Händler aus dem Tempel
Architekturbild: Christus heilt Kranke am See Bethesda *
Architectural view with cleansing of the Temple and Christ healing the blind man of Bethsaida
canvases c 38.6×53.5 (c 98×136 cm)

PAUDISS Christoph
*Lower Saxony 1618 –
Freising 1667*

Rast auf dem Wege zum Markt *
Rest on the way to market
cv 61.8×92.5 (157×235 cm) sg
Diogenes
cv 30.3×24.0 (77×61 cm)

PEETERS Bonaventura
Antwerp 1614 – Hoboken 1652

Marine *
pn 21.3×38.2 (54×97 cm) sg

PELLEGRINI Antonio
Venice 1675 – 1741

Festlegung des Besiegten
Capture of the vanquished
cv 133.9×48.8 (340×124 cm)
Einzug des Kurfürsten Johann
Wilhelm von der Pfalz *
*Solemn entrance of Prince
J. W., Elector Palatine*
cv 139.0×213 (353×541 cm)
Hochzeitslager des Kurfürsten
Johann Wilhelm von der Pfalz
und der Maria Anna Loisia de
Medici *
*Wedding feast of Prince J. W.,
Elector Palatine*
cv 133.9×211.8 (340×538 cm)
Die Krönung des Siegers
Crowning of the winner
cv 133.9×48.8 (340×124 cm)
Allegorie
Allegory
cv 137.0×43.3 (348×110 cm)
Die Schrecken des Krieges
Horrors of war
cv 137.0×87.4 (348×222 cm)

PESNE Antoine
Paris 1683 – Berlin 1757

Mädchen mit einem Gemüse-
korb
Girl with basket of vegetables
cv 36.6×28.7 (93×73 cm) sg

PICKENOY Nicolaes Eliasz.
Amsterdam c 1590 – c 1655

Männliches Bildnis
Portrait of a man
pn 44.1×33.5 (112×85 cm)

POELENBURGH Cornelis
Utrecht 1586 (?) – 1667

Ruhe nach dem Bade *
Rest after bathing
copper 12.6×16.1 (32×41 cm)
sg

POST Frans
Leyden c 1612 – 1680

Brasilianische Landschaft *
Brazilian landscape
pn 20.9×27.2 (53×69 cm)

POUSSIN Nicolas
Villers 1594 – Rome 1665

Anbetung der Hirten *
Adoration of the shepherds
cv 38.6×51.6 (98×131 cm)

PRETI Mattia
Taverna 1613 – Valletta 1699

Der verlorene Sohn *
The prodigal son
cv 50.8×66.9 (129×170 cm)
Hagar und Ismael
H. and Ishmael
cv 73.2×58.7 (186×149 cm)
Maria Magdalena
Mary Magdalene
cv 50.4×40.6 (128×103 cm)

PYNACKER Adam
Pynacker 1621 – Amsterdam 1673

Landschaft mit hochstämmigen
Bäumen *
Landscape with tall trees
cv 18.9×14.6 (48×37 cm)
Die einstürzende Brücke
Ruined bridge
cv 44.5×63.8 (113×162 cm)
sg (frm) d 1659
Italienische Landschaft
Italian landscape
cv 31.5×29.1 (80×74 cm) sg

**REMBRANDT HARMENSZ.
VAN RIJN**
Leyden 1606 – Amsterdam 1669

Bildnis eines jungen Mannes
Bildnis einer jungen Frau
Portraits of a young couple (?)
canvases 44.1×39.4
(112×100 cm) school

RICCI Sebastiano
Belluno 1659 – Venice 1734

Versuchung des hl. Antonius *
Temptation of St. Anthony
cv 35.8×28.3 (91×72 cm)

ROTARI Pietro
Verona 1707 – Leningrad 1762

Schlafendes Mädchen und Jüng-
ling → no 147
Weinendes Mädchen *
*Sleeping girl and youth;
Weeping girl*
canvases 41.7×33.1
(106×84 cm)

RUBENS Peter Paul
Siegen 1577 – Antwerp 1640

Versöhnung Esaus und Jakobs
*Reconciliation of Esau and
Jacob*
cv 130.3×111.0 (331×282 cm)
Martyrium des hl. Laurentius
→ no 138
Martyrdom of St. Laurence
pn 96.1×68.5 (244×174 cm)
Die geistlichen und weltlichen
Stände legen vor Christus
Rechenschaft ab
*Religious and temporal au-
thorities submit to Christ*
pn 79.9×58.3 (203×148 cm) st
Die Apostel Petrus und Paulus *
The apostles Peter and Paul
cv 95.7×74.8 (243×190 cm) st
Gefangennahme Simsons
Capture of Samson
cv 46.5×52.4 (118×133 cm) st
in collaboration with
van Dyck (?)

RUISDAEL Jacob Isaacksz. van
*Haarlem 1628-9 –
Amsterdam 1682*

Waldlandschaft mit sumpfigem
Gewässer *
*Forest landscape with marsh-
es*
cv 24.0×38.2 (61×97 cm) sg
Winterliches Dorf bei Mond-
schein → no 144
*Village in winter by moon-
light*
cv/pn 14.2×12.6 (36×32 cm) sg

RUYSDAEL Salomon van
Naarden c 1600 – Haarlem 1670

Kanallandschaft *
Landscape with canal
pn 28.7×42.1 (73×107 cm)
sg d 1642

SANDRART Joachim von
Frankfurt 1606 – Nuremberg 1688

Januar
Februar → no 132
April
Mai
Juni
Juli *
August
September
Oktober
November
Dezember
*January, February, April, May,
June, July, August, Septem-
ber, October, November, De-
cember*
canvases 58.7×48.4
(149×123 cm);
the first, the fifth and the
sixth sg d 1642; the third and
the tenth sg d 1643; the ele-
venth d 1643
Jakobs Traum *
Jacob's dream
cv 54.3×48.4 (138×123 cm)
Fischzug Petri *
St. Peter's miraculous catch
cv 93.7×130.3 (283×331 cm)
sg d 1646
Weibliches Bildnis
Portrait of a woman
cv 26.4×20.9 (67×53 cm)

SCHÖNFELD Johann Heinrich
Biberach 1609 – Augsburg 1682-3

Pyrrhus-Schlacht
The battle of P.
cv 65.7×91.3 (167×232 cm)
Das Gastmahl des Belsazar
Balthazar's feast
cv 54.3×81.1 (138×206 cm)
attr

SEGHERS Daniel
Antwerp 1590 – 1661

Putten Bachanal (Marmorrelief
darstellend)
*Marble relief with bachanal-
ian putti*
pn 18.1×26.8 (46×68 cm)

SEGHERS Gerard
Antwerp 1591 – 1651

Martyrium der hl. Dympna und
Gerbert
*Martyrdom of Saints D. and
G.*
cv 69.3×81.1 (176×206 cm)

SNYDERS Frans
Antwerp 1579 – 1657

Jesus und Johannesknabe *
*Jesus with the young St.
John*
cv 77.6×117.7 (197×299 cm)
sg (frm)

SWANENBURGH Jacob Isaacsz.
Leyden 1571 – 1638

Architekturbild St. Petersplatz
vor Erbauung der Kolonnaden
Berninis *
*Architectural view of St. Pe-
ter's Square before the build-
ing of Bernini's colonnade*
pn 22.4×42.1 (57×107 cm)
sg d 1632

**TENIERS DER JÜNGERE
(THE YOUNGER) David**
Antwerp 1610 – Brussels 1690

Drei musizierende Bauern
Three peasant musicians
pn 16.1×23.2 (41×59 cm) sg
Aussicht der Galerie des Erz-
herzogs Leopold in Brüssel
1819, 1839, 1840, 1841
→ nos 135, 136, 137
*View of the Gallery of the
Archduke L. in Brussels*
canvases 37.8×50.4
(96×128 cm)
Wirtsstube 451, 441
Tavern interior
panels 22.0×31.5 and 28.7
(56×80 and 73 cm)
sg d 1645 and 1643

Testa see **LUCCHESINO**

TURCHI Alessandro (L'Orbetto)
Verona 1588-90 – Rome 1648

Madonna mit dem hl. Rochus
Virgin with St. Roche
cv 91.7×62.2 (233×158 cm)

UDEN Lucas van
Antwerp 1595 – 1672

Gebirgslandschaft mit Bucht
und Hafenstädtchen
*Mountain landscape with bay
and sea port*
pn 15.7×22.8 (40×58 cm)

VACCARO Andrea
Naples 1598 – 1670

Geisselung Christi *
Scourging of Christ
cv 74.0×57.5 (188×146 cm) sg
Hl. Magdalena
St. Magdalene
cv 39.0×28.7 (99×73 cm)

VELDE Adriaen van de
Amsterdam 1636 – 1672

Die Überfahrt *
The crossing
cv 24.8×30.3 (63×77 cm)
sg d 1667
Landschaft mit Viehherde
Landscape with herd
cv 14.6×16.5 (37×42 cm)
sg d 1671
see also under Hackaert and
Wynants

**VELDE DER JÜNGERE
(THE YOUNGER) Willem van de**
Leyden 1633 – London 1707

Seestück bei abziehendem Ge-
witter
Marine with storm ending
cv 24.8×35.4 (63×90 cm) sg

**VENEZIANISCH
(VENETIAN PAINTER)**
act c 1650-60

Venezianischer Admiral Lazaro
Mocenigo *
The Venetian A., L. M.
cv 92.1×54.3 (234×138 cm)

VERNET Claude Joseph
Avignon 1714 – Paris 1789

Brennende Hafenstadt
Seehafen im Nebel bei Son-
nenaufgang
*Seaboard city in flames; Sea-
port in the mist of sunrise*
canvases c 22.0×53.9
(c 56×137 cm);
the second sg d 1748 ins
Seesturm
Storm at sea
copper 20.1×25.6 (51×65 cm)
sg d 1772
Seehafen in Abendleuchtung *
Felsenküste im Gewittersturm *
*Seaport in the evening light;
Rocky coast in a storm*
canvases c 45.3×64.2
(c 115×163 cm) sg d 1770

VERSPRONCK Jan Cornelisz.
Haarlem 1597 – 1662

Weibliches Bildnis
Portrait of a woman
cv 31.1×24.4 (79×62 cm)

VIVIEN Joseph
Lyons 1657 – Bonn 1734

Selbstbildnis *
Self-portrait
pastel 31.5×25.2 (80×64 cm)
sg d 1730 ins
Bildnis Louis, Dauphin von
Frankreich
Portrait of L., D. of France
pastel 52.0×40.9 (132×104 cm)
sg d 1700
Bildnis Herzog Ludwig von Bur-
gund, Sohn des Dauphin und
der Maria Anna Christine,
Tochter des Kurfürsten Fer-
dinand Maria von Bayern
*Portrait of L., Duke of Bur-
gundy, son of the D. and M.
A. C., daughter of F. M. of
Bavaria*
pastel 38.6×31.5 (98×80 cm)
sg d 1700
Bildnis König Philipp V. von
Spanien, Sohn des Dauphin
und der Prinzessin Maria An-
na Christine von Bayern
*Portrait of King Philip V of
Spain, son of the D. and Prin-
cess M. A. C. of Bavaria*
pastel 38.6×31.5 (98×80 cm)
sg d 1700
Bildnis Maria Anna Christine,
Tochter des Kurfürsten Ferdi-
nand Maria von Bayern
*Portrait of M. A. C., daugh-
ter of Prince F. M. of Bavaria*
pastel 52.0×41.3 (132×105 cm)
sg d 1700
Bildnis Kurfürst Max Emanuel
2302 → no 146
*Portrait of the Elector, Prince
Maximilian E.*
pastel 51.6×40.9 (131×104 cm)
Kurfürst Max Emanuel von Bay-
ern 54
*Prince Maximilian E. of Ba-
varia*
cv 94.5×68.1 (240×173 cm)

Vlämisch see **FLÄMISCH**

VLIET Hendrik Cornelisz. van
Delft c 1611 – 1675

Kircheninneres
Church interior
pn 23.6×20.9 (60×53 cm)
sg d 1656

VOS Cornelius de
Hulst 1585 – Antwerp 1651

Bildnis eines schwarzgeklei-
deten Mannes
Portrait of a man in black
pn 26.0×20.5 (66×52 cm)
d 1615 ins attr

VROOM Hendrik Cornelisz.
Haarlem 1566 – 1640

Hafen von Amsterdam → no 142
The port of A.
cv 38.2×79.1 (97×201 cm)
sg d 1630

Weenix see under **Both**

WERFF Adriaen van der
*Kralingen-Ambacht 1659 –
Rotterdam 1722*

Der zwölfjährige Jesus im Tem-
pel
*Jesus disputes with the doc-
tors in the Temple*
pn 32.3×22.8 (82×58 cm)
sg d 1708

Christus am Ölberg
*Christ in the Garden of Ol-
ives*
pn 32.3×22.8 (82×58 cm)
sg d 1711
Dornenkrönung
Crowning with thorns
pn 32.3×22.8 (82×58 cm)
sg d 1710
Christus am Kreuz *
Christ on the Cross
pn 32.3×22.8 (82×58 cm)
sg d 1708
Auferstehung Christi *
Resurrection
pn 32.3×22.8 (82×58 cm)
sg d 1713
Himmelfahrt Christi
Ascension
pn 32.3×22.8 (82×58 cm)
sg d 1710
Pfingstfest *
Pentecost
pn 32.3×22.8 (82×58 cm)
sg d 1711
Marienkrönung
Coronation of the Virgin
pn 32.3×22.8 (82×58 cm)
sg d 1713
Kurfürst Johann Wilhelm von
der Pfalz → no 133
*Prince J. W., Elector Pala-
tine*
cv 29.9×21.3 (76×54 cm)
sg d 1700
Maria Anna Loisia de Medici,
Gemahlin des Kurfürsten Jo-
hann Wilhelm von der Pfalz
→ no 134
*M. A. Luisa, wife of Prince
J. W., Elector of Palatinate*
cv 30.3×20.9 (77×53 cm)
sg d 1700

WILLAERTS Abraham
Utrecht c 1603 – 1669

Familienbild
Family portrait
cv 51.2×76.8 (130×195 cm)
sg (frm) d 1659

WOUWERMANS Philips
Haarlem 1619 – 1668

Schlachtenbild
Battle scene
cv 20.5×30.7 (52×78 cm) sg
Hirschjagd
Stag hunt
cv 32.3×55.1 (82×140 cm) sg

WYCK Thomas
Beverwijk 1616 – Haarlem 1677

Südlicher Hafen
Southern port
cv 30.7×43.3 (78×110 cm) sg

WYNANTS Jan
*Haarlem (?) c 1630 –
Amsterdam 1682*

Landschaft mit Hirten und Tie-
ren
*Landscape with shepherds
and animals*
cv/pn 13.8×16.5 (35×42 cm)
sg d 166..
Strasse am Dünenrand
Road along the dunes
cv 14.6×16.1 (37×41 cm) sg
figures by Adriaen van de
Velde
Landschaft mit Viehtrieb *
Landscape with herd
cv 60.6×77.6 (154×197 cm) sg
figures by Adriaen van de
Velde
Abendlandschaft mit Reiter und
Jäger
*Evening landscape with knight
and hunter*
cv 60.6×77.6 (154×197 cm) sg
figures by Johannes Lingel-
bach (Frankfurt 1622 – Am-
sterdam 1674)
Landschaft mit Vieh und Bauern-
paar
*Landscape with animals and
two peasants*
cv 11.4×14.2 (29×36 cm)
sg d 1672

Zampieri see **DOMENICHINO**

ZUGNO Alessandro
Venice 1709 – 1787

Iphigenie wird vom Hafen in
Aulis zum Tempel geleitet
Opferung der Iphigenie
*I. led to the temple from the
port of A.; Sacrifice of I.*
canvases 23.2×13.8
(59×35 cm)